Advanced

M000287580

Flying Kites is a perfect title for this soaring collection of writing and art from prison. The writers and artists in this beautiful volume provide both heartbreaking and heart-healing evidence that the creativity and resiliency of the human spirit rise above the dehumanizing conditions of incarceration. The editors provide a thoughtfully nuanced organization to this inspirational and notably diverse collection of the talent that burgeons behind bars.

—Deborah Appleman, Ph.D.
Hollis L. Caswell Professor of Educational Studies, Carleton College

Recent books:

Appleman, D. (2019). *Words no bars can hold: Literacy learning in prison.* WW Norton & Company.

Williamson, P.,& Appleman, D. (Eds.). (2021). *School, not jail: How educators can disrupt school pushout and mass incarceration.* Teachers College Press.

In *Flying Kites* the voices of the incarcerated soar across the firmament, bearing witness to the grave injustices of the prison industrial complex. This powerful anthology reveals the hope and promise that quality literacy education offers to society, especially those who are ensepulchred in the dark alchemy of our prisons and youth detention centers. It is a book that needs to make its way into the hands of educators everywhere as a testament to the human spirit and the triumph of self and social transformation towards a compassionate and justice-seeking greater-good.

—Peter McLaren, Ph.D.
Distinguished Professor in Critical Studies
The Donna Ford Attallah College of Educational Studies, Chapman University

Recent books:

McLaren, P. (2020). *He walks among us: Christian fascism ushering in the end of days.* DIO Press.

McLaren, P. & Jandric, P. (2020). *Postdigital dialogues on critical pedagogy, liberation theology and information technology.* Bloomsbury Academic.

Flying Kites

Narratives of Prison Literacies in Essays and Art

Mikel W. Cole, Ph.D., Stephanie M. Madison, Ph.D., Adam Henze, Ph.D., & Jim Sosnowski, Ph.D. (Eds.)

ISBN 978-1-64504-221-1 (Paperback)

ISBN 978-1-64504-222-8 (E-Book)

Library of Congress Control Number: 2022938189

Printed on acid-free paper

© 2022 DIO Press Inc, New York

https://www.diopress.com

Cover design: Anwar Hanano

This book is part of *Literacies as Resistance*

Series Editor: Judith Dunkerly-Bean and Julia Morris

ACKNOWLEDGMENTS

This book exists because of the collective effort of many people, and we would like to take a moment to thank everyone whose contributions have shaped this book.

First and foremost, we want to thank every person who demonstrated the courage and perseverance to submit their creative works for consideration in this collection. We received over a hundred individual pieces from dozens of authors, and while we were unable to accept every piece that we received, we recognize that each submission is a precious distillation of hard work and hope.

We would also like to thank everyone who helped distribute the call for papers into carceral spaces across the country. These individuals ranged from scholars and teachers to interpreters and friends, but this book could not have happened if they were not already doing work in these spaces and forging relationships with these authors.

We are grateful to DIO Press for their belief in our vision and their investment in this book. We are especially thankful to our series editor, Dr. Judith Dunkerly-Bean who opened doors and moved the publication machinery along to ensure this book made it into your hands.

We are also grateful to scholars and colleagues who took the time to read initial drafts and offer their feedback, especially Dr. Deborah Appleman and Dr. Peter McLaren who generously agreed to share their thoughts about the book on the cover.

Finally, we want to acknowledge El Refugio at Stewart Detention Center whose work with immigrant detainees has inspired us and facilitated our own access to the individuals detained there. All of the royalties from the sale of this book will be donated to support the work they continue doing to support detainees and their families.

Table of Contents

Foreword xiii

Introduction xix

Section 1: **That Life** 1

Chapter 1
Why I Write 3

Chapter 2
Reading the Road Ahead 5

Chapter 3
Still Judging Books 19

Chapter 4
A Poem's Worth 21

Chapter 5
Snapshots 37

Chapter 6
From Texts to Phone Calls 41

Chapter 7
47 Cent Stamp 49

Section 2: **Education Inside** 51

Chapter 8 53
Nepali Alphabet

Chapter 9 67
Stick-up Guy

Chapter 10 73
Shaping What Counts

Chapter 11 95
Selfies Speaking Out

Chapter 12 111
Not Always "Being Bad"

Chapter 13 131
Education is a Foundation

Section 3: **Hope for Tomorrow** 137

Chapter 14 139
Orange is the New Truth

Chapter 15 165
Opportunities for Hope are Created

Chapter 16 177
Sunday Morning

Chapter 17 181
Epistemic Assets

Chapter 18 197
Postcards and Chemistry Books

Chapter 19 215
Art and Resilience

Foreword

Jerry Blassingame

Prison, a place where people are legally held as a punishment for a crime they have committed, sent there after being assessed, judged, and examined by a group of their own community members. Could anything good ever come out of a place that society has deemed the belly of the beast, a place where many citizens are destined to spend the rest of their lives to die? Youths are sentenced during the best and most impressionable years of their lives and finally released without access to the resources needed to stay out of prison. As a young black man, who against all odds came out of prison and created a successful life, I know first-hand that there is no rehabilitation, only punishment.

There is an unmistakable feeling of doom when you are arrested, especially for your second felony arrest. In March of 1994, I was arrested on felony charges while out on probation for a prior felony offense. My first felony resulted in a 4-month prison sentence and five-year probation at the age of 22. The consequences to these offenses would be immense; however, after several weeks in the Greenville County Detention Center, I was able to make bond. I made it back to my streets, where I intended to finish my degree in architecture, but late nights at the club and all-night parties are not a good mix for school.

I often wondered; *how did I get here?* I had two lives fighting in parallel: one as an architecture student and one as a drug dealer, identities and lifelines at war with each other. My precarious and tumultuous childhood left me with trauma, grief, and most importantly, resiliency. My plans were never to be a drug dealer and spend time in prison. I was once a child who looked forward to his sixth birthday party that

my mother was planning for me.

Celebrations, birthdays, and life milestones became a luxury that were not often indulged after the murder of my mother. My mother's killer had been her jealous and violent boyfriend, who brutally murdered her while I was hiding in the next room at the age of five. My grandmother fled with me and my siblings, while my mother lay dead and my grandfather lay wounded from a gunshot inflicted while my mother's killer fled.

No one could or would address the trauma I endured while hearing my mother screaming and gun shots ringing out at the time of her murder. My grandmother took me and my four older siblings to live with her and my grandfather. My grandfather was wounded but survived the gunshot wounds. A few years later my grandfather passed away, leaving my grandmother with five school aged children to raise while she coped with her own losses.

My memories from this time are hazy and spotty, but school became a resounding source of enjoyment for me. School was an escape for me. I loved reading time, art, and physical education. I developed a love of reading and writing while in the fifth grade. Mrs. Rish would read every day after lunch to my class. She was an excellent orator and read with genuine enthusiasm, spurring my lifelong passion for writing and literature. I was determined to be a student who excelled in school and eventually in middle school all of my hard work, determination, and resiliency paid off. I consistently made honor roll and only missed a total of three days of school throughout middle school.

The protective chrysalis school provided did not protect me from the other challenges that life continued to throw. I developed unhealthy coping habits for the trauma and PTSD I had harbored since my mother's murder. Despite my unhealthy coping mechanisms, no one suspected I was struggling. My teachers continued to love me and advise me throughout high school. A teacher of Industrial Arts, and personal mentor, encouraged me into going to vocational school my junior and senior year. This move allowed me to acquire a scholarship to college to study architecture. My grandmother was aging, and a college education is notoriously expensive, even with scholarships and financial aid.

My second year in college, I discovered a part time job as a 'watchout' for drug dealers. Eventually, the money became too enticing to

pass up and I dropped out of college to sell drugs. I got married but was not the husband or father I should have been as my life continued to spiral out of control.

By the time March of 1994 came around, I was on my second arrest and out on bond waiting to be taken to trial for one of the 11 pending charges against me. The trial ended in a hung jury and the judge revoked my $150,000 bond, demanding I wait in jail until tried on all charges. For almost five months, I was in jail awaiting trial. County jail is an interesting place depending on where you are housed. I was housed in a pod with several other men. This solitude forced me back into reading and writing.

At first, I wrote everyone that I could think of just to pass the time away. Eventually only a few would return my letters. My sister was one of the faithful writers. The problematic and shocking part was how religious in nature all of her letters were. I did not want to hear about Jesus. Eventually, she convinced me that I needed religion, and I reluctantly started to read the Bible. We started to have interesting exchanges about the Bible, leading me to become a Christian while being sentenced to 20 years for several felony drug convictions.

Needless to say, I was devastated and cried for the first three days while at the reception and evaluation center waiting for bed space in a state prison. As I got myself together, I proclaimed that if I was going to do 20 years, I was going to do it with Jesus. I would spend literally at least six hours a day studying and reading the Bible along with other literary material. My job in the prison was as a Teacher's Assistant, so I spent time tutoring men in math and helping them to get a GED. One of my favorite things to do was to teach men how to read. I knew how important it was to see those words jump off the page into their minds.

In my heart I knew that I was not going to serve my whole sentence. My daily confession was, "I will not be here long." I realized that it's not enough to just confess. Faith without works is dead. I had to imagine myself being on the outside. What good would I do as a free man? Could I continue the good work that I was doing inside the prison? Could I help others find employment, housing, education? Putting my pen to work again, I began to reach out to the world to look for opportunities. Church groups would come in, and I would tell them about the plan I had to start a non-profit upon my release.

Eventually, I became a penpal to a Sunday School at the Clemson United Methodist Church. The Adult Sunday School Class took me on as a "class project." They would write to me regularly, becoming the highlight of my week when I would receive a letter from one of the class members. Immediately, I would respond with a reply and eagerly await a response. We would share our favorite Bible verses, talk about family, and I would dream about freedom. I was blown away! I was actually communicating with doctors, professors, and other prominent leaders of the community. They encouraged me so much that I could start to see my vision of freedom, success, and resiliency ahead of me.

My daily routine while in prison was critical to my success, both in healing myself and my relationship with God. I would get up every morning and read the Bible and journal. My journaling naturally evolved into the vision for Soteria. I found the verse in Habakkuk, "Write the vision down and make it plain, so that those who read it may run with you." Wow, that was enough for me. I dedicated almost every day of my sentence to reading and writing. The nonprofit I penned while serving my sentence has become a 21-year-old organization, and one of the requirements for the men in our year-long program is daily journaling. This process catapulted me into my destiny and purpose, so I made sure the men and women we serve are required to do it while in our program.

I was motivated and building great momentum by the time I enrolled in Columbia International University. The Sunday School class paid for my first semester. By this time, I was working as a cook in the Abbeville County Prison. My hard work and dedication paid off, and I was a trustee working outside of the traditional prison system. I had only completed two years of a 20-year sentence. Some would consider that a miracle. I served 18 months faithfully for Abbeville County and was paroled in March of 1999 after completing only three and a half years on a 20-year sentence.

Twenty-one years ago, I walked out of prison. Every one of those days, I dedicated time to journaling and writing the vision for the nonprofit I founded upon my release. So, I understand what it takes to become successful before anyone else acknowledges the journey. Everything I'm doing now was written in a prison cell as I cried out to God for forgiveness and direction. I'm thankful for the men and women who will allow you to peer into their lives as you gaze upon

the pages of this book.

You are about to embark on a journey, one that will humanize our criminal legal system and take you deep into the hearts of broken people. People who have lived a life of trauma and pain. When you are poor and cannot afford therapy, self-medication is the only remedy. We forget about those who have undiagnosed illnesses that cause hallucinations or even suicidal thoughts. We forget about those just trying to survive. So many Americans are thrown away, discarded, and given up on. We all have issues, but some can afford to pay to avoid consequences. It is true that privilege has kept so many out of the legal system.

This book is what happens when we find ourselves. Time is, indeed, a healer! If we are looking for answers on how to stop recidivism, we have finally found a solution. Go to those who know the truth. Listen with your heart as you read the stories and testimonies of those who survived and lived to talk about it. This book is a treat for the sceptic and an antidote for the pessimist.

We all make mistakes, but we are all quick to judge. What if you were judged by the worst thing you ever did in your life? We are all broken and need to be mended. We are all discarded and need to be reclaimed. This book will take you on a journey through the lives of so many who have finally found what they were born to do, despite the labels and experiences that have been held against them. Against all odds, they have found purpose. They have found peace in a place that was meant to destroy them. They are now pouring themselves out into the pages of this book. Come on a journey with me into confinement and you will see. You will see that concrete and steel cannot imprison the Heart.

Jerry Blassingame

It has been said that you never truly know someone until you've walked a mile in their shoes. This has been the reality for Soteria CDC—a ministry born from the personal experiences of a life redeemed while in prison. As Jerry Blassingame was serving a 20-year sentence, he gained an understanding of the troubles facing men and women when they are released from prison. He connected with other incarcerated individuals and eventually saw himself as a prime candidate to help change the patterns. He formed an idea for a ministry that would

speak to men re-entering society, teach them life skills, and help them rebuild themselves and their communities. That ministry is Soteria CDC.

Introduction from the Editors

In her collection of essays *Playing in the Dark* (2007), author Toni Morrison argues that the theme of resistance to and liberation from confinement is at the heart of virtually every celebrated literary work in the English canon in the United States. She writes, "The flight from the Old World to the New is generally seen to be a flight from oppression and limitation to freedom and possibility" (p. 34). While numerous white authors in American history have positioned themselves as abolitionists in the battles against slavery, internment, and incarceration, Morrison states that the yearning to be free of bondage is so pivotal to the narrative of the "American Dream" that many writers cannot escape from it in their uses of metaphor and plot. A primary aim of Morrison's critique is to examine the ways that whiteness and Blackness are perpetrated in the American literary imagination, but her analysis also holds significant relevance for advocates of an under-examined literary genre in the United States: narratives about incarceration. Given how prevalent these themes (i.e., bondage and liberation) are in American literature, it seems surprising that the topic of prison is so often misrepresented in public art and media.

From the years of slavery and convict leasing to the rise of the modern penitentiary system and prevalence of immigrant detention, the historical foundation of the American carceral system stands as a behemoth in contrast to the justice systems of other countries. While only composing 5% of the world's population, the United States, "Home of the Free," is responsible for 25% of the world's incarcerated

population (Pfaff, 2017), representing the highest incarceration rates and largest incarcerated population in the world. Consequently, the United States also has the dubious honor of possessing the largest immigrant detention system in modern history (Nowrasteh, 2020). Despite the deep entrenchment of the prison-industrial complex in American society, public perception about prison is often shaped by the stories told about prison in popular culture. Legal scholar Daniel LaChance (2016) claims that the decisions of policy makers are less commonly influenced by research about prison and more commonly by depictions of prison in media and literature. He argues that, in some ways, it is more vital for researchers to study television shows like *Orange is the New Black* and *Prison Break* than the legislation that actually makes up the American carceral system. And though inspiring films like *The Shawshank Redemption* often capture the attention of the public, most popular media about confinement is written *about* incarcerated people and not *by* incarcerated people. The story of the United States is indeed the story of confinement and liberation, yet the voices of people confined by the American justice system typically remain unheard.

This book is a collection of works covering a variety of genres that might be categorized as prison literature or confinement literature. For advocates invested in the intersections between literacy education and the school-to-prison pipeline, there is an important distinction between the two terms. Marc Lamont Hill defines confinement literature as "any work of fiction or nonfiction that deals with the fundamental issue of human captivity" (2013). Prison literature, on the other hand, is any work of fiction or nonfiction that was written while the author was imprisoned—which may or may not be dedicated to the subject of prison. David Werner (1984) adds:

> Prison literature is that literature which sees life as limited physically, psychologically, or spiritually. Herein is seen the basically revolutionary nature of the course; the prison of society's rejects can be seen as the primary focus for a literature of self-awareness and salvation, insofar as the confinement of the prison leads to a freedom of the spirit possibly not otherwise attainable. (pp. 20-21)

The pieces we hoped to solicit for this book were somewhere in between these definitions. We invited incarcerated and formerly incarcerated writers to submit essays and art on the topic of literacy learn-

ing in spaces of confinement. Our aim was to privilege the voices of people who have first-hand knowledge of prison literacy practices, but who are often discounted in academic discourses about confinement. Specifically, we hoped to solicit submissions from incarcerated writers who have been searching for a platform to showcase their writing. Many of the most commonly studied works of prison literature are by writers considered "political prisoners," such as Nelson Mandela and Martin Luther King Jr., and we as editors wanted to provide a platform for incarcerated writers who haven't had the media spotlight shined on their writing. We created a Call for Papers and distributed it to our friends and peers involved in literacy outreach in hoping it would reach writers through barriers of steel, stone, and razor wire. In American jails and prisons, notes and letters are commonly referred to as "kites," and we crossed our fingers as we let the wind carry our invitation away from us.

We received hundreds of essays, stories, and poems for consideration, and reviewing each piece gave us an idea of how immense the barriers are for incarcerated authors to publish their writing. Some submissions were typed on antiquated computers and printed out. Some submissions were stacks of looseleaf paper with each word carefully handwritten in pen. Some submissions were transcribed and submitted by a kind administrator of the facility willing to serve as a liaison. Others were sent in by family members who wanted to highlight the literary contributions of their loved ones. Several submissions accepted in this anthology were essentially co-authored works between incarcerated writers and literacy researchers. As editors, we initially debated to what extent we should include submissions by non-incarcerated authors, but with the restrictive processes of U.S. prisons—as well as enhanced security measures brought on by the COVID-19 pandemic, such as modified lockdowns and programming postponement—we decided to err on the side of inclusivity. Ultimately we decided to accept quality submissions from any author as long as they were earnest in giving a platform to incarcerated writers who have shareable knowledge about literacy learning practices in places of confinement. To close out the collection, the editors all contributed chapters about literacy education in various detention spaces in the United States.

Throughout the editorial process, we drew on both our academic background in literacy education and our humanitarian work in vari-

ous carceral systems, including immigrant detention centers, juvenile detention centers, and the adult prison system. Thus, we accepted the invitation with the aim of creating an anthology that would be relevant to both an academic audience as well as any reader who appreciates engaging prison memoirs. As editors of this book, we also made a conscious decision not to look into the backstories or criminal histories of any writer who submitted to our anthology. Our concern was that knowledge of our contributors' cases would cause us to judge each submission based on the crime attached to the author and not the quality of their work. Although we debated the merits of investigating potential authors included in this book, we eventually agreed that we did not want to fall into the trap of gatekeeping the visibility of writers who have made mistakes. We made this decision with the understanding that some contributors may have been involved in crimes that include victims whose families may still be searching for healing and justice. Although this book is centered on the voices of incarcerated people, we recognize there are countless families in the United States who are impacted by violent crime and the systemic inequities that exacerbate it. Our aim in producing this anthology was to argue that all people deserve access to quality literacy education, and we believe that both society and the criminal justice system would be transformed if this vision came to fruition. Our hope is that the communities that surround both offenders and the offended support our advocacy for inclusive and accessible literacy programming for all people.

This book highlights both self-taught literacy practices and formal educational programs inside incarcerated spaces. Several studies showcase the benefits prison writing programs have on incarcerated individuals (Appleman, 2013; Brooks & Johnson, 2010; Rothman & Walker, 1997). Literacy programs help incarcerated learners reconfigure their identities in powerful ways in that they report feeling more agentive and return to prison less frequently than incarcerated people who do not participate in literacy programs (Hartnett et al., 2011). The hybrid formatting of this collection explores literacy learning in a kaleidoscope of ways, encouraging readers to consider the intersection of literacy learning in the American prison-industrial complex.

In *Section 1: That Life*, we begin with multiple perspectives of the events that led to people's incarceration as well as multiple perspectives of what literacy looks like while living in spaces of confinement.

The trappings of "that life" range from a childhood surrounded by drugs and violence to an adulthood filled with addiction and desperation. Being "about that life" might imply a sense of inclusion or a sense of connection with others who have had common experiences. Sometimes people are born into "that life;" but sometimes "that life," as told from inside the walls of incarcerated spaces, happens fast and by surprise.

Then, in *Section 2: Education Inside*, we explore the ways in which programming and mentorship can foster healing and compassion. The contributors in this section share a deep understanding of the ways in which literacy and language can serve as a form of power. These literacy practices are considered a ticket to life in mainstream society, a privilege not granted to everyone. Yet within the context of literacy education in confined spaces, individuals often find empowerment by turning their attention inward to examine and disentangle complicated emotions, finding forgiveness for themselves and for others.

Finally, in *Section 3: Hope for Tomorrow*, we end by extending the discourse of incarcerated literacies to stories of humanity, creativity, and possibility. Even in circumstances of cruelty and neglect while living in incarceration, the contributors describe instances of connection and the reclamation of human dignity. Their notes, letters, art, and poetry are not merely projects to pass the time; rather, they represent the resilience and persistence of individuals who have not given up hope.

As an editorial team, we reviewed the submissions and authored our chapters without a rigid agenda. We didn't know where our invitation for contributors, the "kite" we set free, was going to land. It was the stories that were graciously shared with us that shaped this book. We now offer these stories to a broader audience so that we may all bear witness and stand in solidarity with those whose words, finally, are shown in the light.

References

Appleman, D. (2013). Teaching in the dark: The promose and pedagogy of creative writing in prison. *The English Journal, 102*(4), 24-30.

Brooks, A., & Johnson, R. (2010). Exposed yet unrevealed: Reflections on the poetry of women prisoners. *Gender Issues, 27*(3-4), 146-164.

Hartnett, S. J., Wood, J. K., & McCann, B. J. (2011). Turning silence into speech and action: Prison activism and the pedagogy of empowered citizenship. *Communication and Critical/Cultural Studies, 8*(4), 331-352.

Hill, M. L. (2013). A world without prisons: Teaching confinement literature and the promise of prison abolition. *The English Journal, 102*(4), 19-23.

LaChance, D. (2016). *Executing freedom: The cultural life of capital punishment in the United States.* University of Chicago Press.

Morrison, T. (2007). *Playing in the dark.* Vintage.

Nowrasteh, A. (2020). *Eight people died in immigration detention in 2019, 193 since 2004.* CATO Institute. https://www.cato.org/blog/8-people-died-immigration detention-2019-193-2004.

Pfaff, J. (2017). *Locked in: The true causes of mass incarceration-and how to achieve real reform.* Basic Books.

Rothman, J. C., & Walker, R. (1997). Prison poetry: A medium for growth and change. *Journal of Poetry Therapy, 10*(3), 149-158.

Werner, D. R. (1984). Teaching the prison to prisoners: Developing a college program in incarceration literature. *Journal of Correctional Education, 35*(1), 20-22.

Section 1

That Life

"The first thing you have to understand in here is that you never
understand anything in here."
−Leonard Peltier

"All around us, there are men and women made invisible, their spirits
wiped out by policies that we don't notice."
−Reginald Dwayne Betts

"We leave something of ourselves behind when we leave a place, we
stay there, even though we go away. And there are things in us that
we can find again only by going back there."
−Pascal Mercier

Chapter 1

Why I Write

David A. Pickett

I write because I am supposed to write. Because I am in a writing class, and I have been assigned homework. Because I am locked up in prison, and there is a long tradition of writers in prison: because of The Ballad of Reading Gaol, because of "Letter from a Birmingham Jail," because of In the Belly of the Beast, because of This is Where I Am. Because I grew up poor, and the world needs to hear from people who grew up poor.

I write because I am not supposed to write. Because I grew up poor, and the world does not want to hear from people who are poor, or at least people who were poor and did not become rich. Because I am in prison and am supposed to do nothing to bide my time, embrace my punishment in silence and sorrow, disappear from the human world and never be seen or heard from again. Because I am white, and male, and there have been far too many white men talking too loudly and for too long. Because my crimes were heinous, and by them I have forfeited my rights to speak and to be heard.

I write because I want to be heard by those who cannot hear me: my mother, my grandfather, my uncle, who are dead; my father, who never knew I existed; my family, who will not speak to me; the world, who does not want to hear me, know me, know I exist, or am human, or have anything to say. I write because I cannot get wood, or clay, or stone, to birth the shapes in my mind. I write because paint is too expensive and too bulky, and what would I do with a bunch of damn paintings anyway? I write because knitting and crocheting annoy me, and what would I do with a bunch of damn scarves and hats anyway?

I write because it's one of the few (legal) ways I can earn extra money in prison.

I write because my life had so much potential, and I threw it all away. I write because I can never be a Silicon Valley titan, an astronaut, a physicist, a millionaire, a college professor, a good father, a productive member of society with a positive net worth. Because writing is a way to salvage something from the ruins, to scavenge a few gold coins from the shipwreck. I write because I want to live forever, but can't. Because others can't write—because Armenia, Auschwitz, Biafra, Bosnia, the Gulag, Iraq, Rwanda, Syria, Yemen, 9/11, dementia, famine, madness, plague, suicide. I write because I have always written, because I want to write, because I don't want to write, because I don't know how to not write. Because, in the end, writing is all I have left, the first thing I ever truly owned and the last thing that I will lose. Because the world will end, and sooner than you think.

David A. Pickett

David A. Pickett is a poet and writer currently incarcerated in Minnesota. He has been an active participant in the Minnesota Prison Writing Workshop for several years. His work has won awards in the Pen America Prison Writing Contest and has been published in Creosote, Grasslimb, Poetry, and elsewhere.

Chapter 2

Reading the Road Ahead

Susan Barber

My father drove the dented Mustang to the jail. It was only a juvie jail, but he wouldn't park near the main doors, near the barbed wire that was balled up like steel yarn around the exercise yards and the visiting rooms. I spotted him slunk low in the seat, visor down, the car not too clean, but also not too dirty. This about summed it up; no one would ever notice him.

He popped the car door for me when I walked out. "Nice of you to show up." The radio crackled and he turned it down. "Maybe you want to stay a bit longer? I've been waiting an hour."

I stared out the window while he drove out of the parking lot, staying carefully in the lines, and onto the empty road leading back to the highway. It had started to rain, and the old wipers dragged across the windshield making the view even more murky than usual. I felt him rake me over with his cold eyes. "C'mon. What did you expect?"

I didn't answer and he pointed at the glove compartment. A bottle of Jack Daniels.

"How would you have been able to get money if I'd gone in?" He let the obvious answer hang in the air for a while. "Anyway, I've got something for you at the house. She cooked last night, too."

This was my father's idea of how to end a successful adventure. A bottle of JD and picking up some girl along the way. The girls were easy enough about joining him, but they never stuck around for too long. My father had that effect on people, especially women.

The drive home took four hours, and streams of rainwater streaked down the windows, blurring any chance of seeing the mountains or

what else might be going by. The only sound besides the whining engine was the weak scraping of the wiper on my side, and I had to look out my father's window to see anything.

The Mustang struggled over ruts and steep curves for a half mile before we could see the house. Our backdoor let out onto a rocky balcony that overlooked the deep ravine. The cold, black water braided itself between rocks and trees, flowing slowly downhill, until about a mile to the west it levelled out as it reached the flatlands. At night, we occasionally heard wolves down by the water, howling and scrapping for food.

We pulled in beside the house, and I paused to stretch my legs after I got out of the car. Lights from the mill two miles away gave off a weak glow, and there were no stars over the forest. The only light came from inside the house. She was in the living room watching TV.

She looked at me while addressing my father, "Oh. So this is Jason?"

My father said, "He's okay. Doesn't even look the worse for wear."

Later she came to my room, but I sent her away. I just wanted to lie on the bed. Not have to be on watch. There had been too much to listen for. The rustling of clothes, the low angry murmurings, the groans of nightmares. Hearing nothing, seeing nothing, and especially feeling nothing was the only way to be in this world. And I lay there, open eyes, unseeing, and concentrated on the absences. No light, no heat, no cold. No touch or taste. If there was nothing, then nothing was wrong, and I could live with nothing being right. Null existence was best, everything set at zero, and when I got there, the nothingness gathered me up in its gentle arms. I fell asleep. No dreams. Then somehow it was mid-morning, and the sun flared around my heavy curtains.

When I got up, the girl was gone. My father picked up last night's glasses and plates. "What are you looking at?" my father shouted. "Get yourself dressed. We have to go see some people."

I didn't move. The last time we went to see some people I was behind bars for three months. He came towards me quickly with heavy steps, and I backed up towards my room. His voice bellowed down at me. "You got a problem?" He didn't wait for an answer. "Until you have something to put on the table, we do it my way."

I went into my room and gave the bed a good kick, but I did

what he said and got dressed. And this is how life went back to being what it was, the only way I could remember it being. There were days of nothing and nothing and nothing, and then my father hatched a new plan. We went to see people, did road trips, saw more people. If he made good money, we went home. Something either happened, or nothing happened. Time stretched onward, immense skies passed overhead, seasons warmed or cooled, and our lives continued above the dark, cavernous ravine.

* * * * * * *

My father was out on the morning the truant officer and a cop yelled up at the house from the driveway. I shook myself awake and went out. They told me that I had forty-four days of unexplained absences after I'd left jail, and if I didn't get in the car and go with them, they could have my father arrested. I was about to say he wasn't home, but then I figured I'd better go with them and let him sort it out later. The cop did a slow approach to the school as though he were looking for escaped prisoners.

I didn't have to stay in the office long; the secretary signed the paperwork and then told me to go to Ms. Brighton's class. The classroom was intensely lit with no place to hide. The teacher was in her chair, and I lowered my eyes. I had the same desk as last year; I sat down and stared straight ahead. She didn't address me, nor come over to talk.

In September I'd been assigned to her classroom. She was a new teacher at the school, and new to northern British Columbia. I never met anyone like her, in our town of Pike's Mill, or anywhere else. She seemed too much of herself still, and not enough of a teacher. She hadn't learned yet to protect herself. Instead, she was up there, her back against the chalkboard, and smiling too much, slow and never suspecting the worst in people.

I'd been held after school in her class, making up homework, and a teacher across the hall, Mr. Sennick, pushed into her room. "You may think you've got it all figured out," he said to her. "But with some of them," he jerked his head in my direction, "you'll have to cut your losses anyway."

I was surprised by the indignation in her voice. "All the students are making good progress." She turned back to the papers on her desk.

Mr. Sennick jabbed his finger at her. "Maybe he'll tell you what

happened when the truant officer decided to make a house call last year."

"I'm sorry," she said. "I've got a lot of marking to do here."

Her face was white as she turned over papers and folded her hands. After he'd gone, she threw down her pen and looked at me. Then she rolled her eyes, and I felt the corners of my mouth twitch.

A few days later, she was eager to go over my writing again. I cursed my carelessness. She started reading aloud, her finger tracing under the words. "It was red and red and red, but also golden yellow, orange and royal blue, flowers, too. He took down all the colours with him, and the wind shook out the rest. Nothing really mattered. I stood, rooted to the ground, awaiting the finishing gunshot.'"

She handed the papers back to me and searched my face. "Okay, here's my take, for what it's worth. The combination of beauty and violence is intriguing... in a good way. It's more sophisticated than expected."

I knew she was waiting for me to say something. I wanted to say something. I turned back to the paragraph she had read and studied it.

She added, "It's good in a lot of places. It feels like you have two distinct voices here."

I stared at the paper and realized she believed it was a story. It felt safer that way, to see it as something made up, and I didn't mind her talking about it.

She passed the paper back to me but didn't let go of it. Looking right at me, she said with sincerity, "We're good, right? Between us, I mean, everything's okay with you and me?"

I was thinking about my story and everything I couldn't say, then I realized she was talking about Mr. Sennick, the principal, and everyone at the school. It struck me that she was angry at them. I stood up and nodded again.

I carried the paper home and searched inside of me like a flashlight and shone it all around. I thought about the two voices in my head, one a low static, continuously nattering in the background. The other one, I heard after school, in the woods, when I was quiet and alone. The disturbing, nightmarish elements were part of the setting of my life, while the other voice needed shelter and a space to think, until it could be strong enough to speak for myself.

The story had taken place in a field, far off the main highway. Ear-

lier that afternoon, my father's patience had worn thin. We'd been waiting in a diner that smelled of pork grease and rancid butter. Then my father swore under his breath and banged his lighter on the table before he lit a cigarette. My father didn't look up as Tommy slid into the booth.

"Ah, Jesus, I tell ya," Tommy said, "it was no good. Not even from the start." He licked his lips, wanting to get it all out, quickly but cleanly. "There were cops there already, just as I came up. Nothing I could do. I'm not lying." His voice squeaked too much for someone who was telling the truth.

We didn't take the highway but drove on a road to the north that cut through some hilly farmland before it reached a junction with the same highway further west. No one was following us, and we passed no oncoming cars.

When my father told Tommy to get out of the truck, he started blubbering. My father reached under his seat for the barrel of the revolver. Tommy stood out away from the truck in a tractor path meandering through neglected farmland that was now ablaze with wildflowers. He didn't run, he just stood there. He took the shots, like he knew he was going to have to take a couple of punches and then it would all be over and we'd all get in the truck and go home. My father lit another cigarette and told me to get the shovel out of the back. I spit on my hands but there was no saliva in my mouth.

The wildflowers came out of the ground clumped together like baskets you might see for sale in the grocery store. It was hard work, and I had to stop every five minutes to wipe the sweat out of my eyes. The groaning stopped sometime while I was digging.

My father didn't comment on how long it was taking. After I'd tossed the clumps of flowers back on the fresh mound, my father strolled over and blinked at the carpet of insane colour all around us.

"Huh. Sure is pretty."

* * * * * * *

Over the weekend my father brought me along to a couple of car dealerships outside Edmonton. My old man had his method, that's for sure; precise planning combined with an instinctual awareness of how best to exploit any weakness. On a Sunday, only the dealership would be open and not many other people would be around. After he

found the right place, we circled the block, found a locksmith not too far away, then went back to the dealership. My father had settled on a beaut of a truck—a blue Dodge Ram, fully loaded—and once he'd decided, we moved ahead.

He didn't spend much time talking to the guy; my father did the test drive, copied the key, and had it back in less than half an hour. But after they closed, I had to go back. I wasn't happy about walking over, even with sunglasses and hood over my head, into the lot. I had seen the cameras up on the showroom rooftop, pointing all over. There was even barbed wire up on the surrounding walls. All that was missing was a guard in a tower. I kept weighing what was worse, getting caught stealing the truck or going back to the Mustang without it.

"What are you waiting for?"

Another option, I thought to myself. Right now there were only two—rejecting or going along with my father's plan. The first choice would get me a serious beating, and the thought had occurred to me lately that in my father's eyes I might even be expendable. He'd been going off more and more on his own, meeting some friends and doing business themselves. His rising anger was palpable and he turned in his seat.

"You gonna paint it?"

He sat back. "I don't know yet."

"The roll bars, the cab spotlight..."

"I know, I know. I'll work it out. Now get the hell out of the car!"

Avoiding a fight was definitely the lesser of two evils, and I set aside trying to find another choice.

In the end, they had pulled the truck into a closed area and my father was pissed enough about that. He seemed to think my hesitation had somehow brought it upon him. Once he had gotten that truck in his sights, it became a part of who he was, the only thing that meant anything to him.

It almost surprised me that Monday morning I was back in school and not in an exercise yard. I had Ms. Brighton's class second block, and she had said she was glad to see me. Her voice told me she meant it.

In such a small town, everyone knew where everyone else lived. As the days lengthened, I often walked the long way home. I had been on Ms. Brighton's street and recognized her car in the driveway. I stared at

the house, then noticed that her neighbour's pickup truck was parked so close to the fence that it was pushing it over. Her neighbours also probably borrowed tools and didn't return them. It was an easy guess from there that she tutored their kids in the evenings and helped the parents fill out social assistance and unemployment forms. They didn't know the half about her.

* * * * * * *

Over the next weekend I made myself scarce while my father worked in the garage, occasionally entering the house to take a phone call. He would yell at me to shut off the TV and then yell into the phone. I could tell he was putting together his next job.

Although my lungs were bursting as I climbed, I didn't stop until I saw the open sky over the stone cap break through, and I remembered to look around. Bears coming out of hibernation would be competing with other animals for food. Normally wolves only challenge bears or humans in a pack. But one time, I stood and watched as a wolf came snapping at a bear, getting the bear riled. The bear forgot the precipice, and the wolf drove it backwards until the bear fell. Strangely, the wolf didn't seem to want the bear for food. Rather, it seemed to want to outwit the bear.

I balanced myself with one hand on the rock ledge and stared into the crack in the mountain for a long while and thought about the laws of nature and the laws of men. How compelling it was to think there existed the possibility of escape with no repercussions. Not to have to give up that which was most precious about yourself, or that which you loved most in this world. Never again to be held in the trigger hairs of cold wrath.

* * * * * * *

On the last day of school, the kids left at noon. Desks and textbooks still needed to be organized, and teachers wandered in with cups of coffee and plates of food from the staff room. I stayed to help Ms. Brighton with loading boxes, dismantling shelves, and moving belongings down to another classroom at the end of the hall. I felt the least I could do was to make it easier for her. When all the teachers left at the end of the day, she thanked me, and then paused.

"Promise me you will finish school."

I searched her eyes to see if she had guessed what I was planning. It scared me to think she knew me that well. She had defended me, stood up for me, and my first thought was that now she wanted payback. But then I stopped. I had to stop thinking like that.

I took a deep breath. "It will probably take me a little longer, Ms. Brighton. I... I might be going away soon."

She wasn't going to be put off. "But you will promise to finish, some day?"

I wanted to tell her how much I had learned from her and that no diploma could be as important as that. If the words could have left my head, I could have put into terms just what knowing her had meant to me. Doing this for her would benefit me most. At the same time, it made me grin because I knew that this is what she most truly wanted from me.

Finally, I said, "Yes, I promise. I will finish."

* * * * * * *

That morning of the picnic, my father mumbled something about having a little job to do, but I skipped out of the house while he was still working in the garage. I carried a blue notebook under my arm, most of the writing I'd done during the night. The sun was shining; an astonishingly blue sky flashed between the trees.

By the time I got to Ms. Brighton's house there were already ten kids setting out paint cans and more were drifting in. I immediately offered to take the most difficult job, up on the rooftop. Mount Renata shone to the northeast, and to the south I could make out a herd of deer, brown specks scattered over the land.

When I finished the last window, Ms. Brighton gave me the thumbs up and said how great everything looked. I couldn't remember enjoying painting as much. Then we brought down the ladders and closed the paint cans as the barbecue sizzled. Ms. Brighton passed around the pie and flashed a smile my way. I realized we were all sitting there, like civilized people appreciating the good food. It seemed like just a few weeks ago we couldn't get within a mile of each other or a fight would break out. Afterwards, we lingered, hating to break it up, even though the sun had now splashed crimson bands across the horizon. Some of the kids said nice things before they left. I stopped

to retrieve my blue notebook. My head was too full, and I knew it wouldn't come out right. Ms. Brighton made it easy.

"So, you'll probably be working this summer," she said. "You could do worse than paint houses!"

"Yeah."

"I believe you could do a lot of things."

I shrugged. "I don't know. I'm not bad at fixing cars. I can build stuff too."

"And academic stuff'!" She laughed but with much kindness.

"Okay, I'll try." The words were stuck in my throat, and the notebook stayed in my hand.

Her eyes lingered on me and then looked down the street. "Is that your ride?"

Nothing on the street had changed; the houses sat in the gathering dusk, the voices of students still trilled in the background. But, the universe was suddenly realigned and my face went cold. She cocked her head at me and then turned to follow my gaze. The blue pickup truck made a slow, measured approach and slid into the space beside the curb across from her house. The food was coming up my throat and I told myself to breathe.

As my father stepped from the cab and crossed the street to us, the chatter behind us stopped and someone swore. "Jesus! Man."

"Wha..?"

Several people were moving in a hurry, and pulling others away.

"Jason, do you know this man?"

I could hear her low question but his boots took slow and deliberate steps while I knew he was taking in the details. I also knew her instincts were not going to help her. Everything was wrong—her goodwill, willingness to suspend judgment, waiting to learn more. Regular people just couldn't add it all up quickly enough. Few decent people could.

"What's this."

"Teacher," I said.

"Hunh." His face twisted and he looked away, around the neighbourhood and back up at the house. I felt her next to me, working through an impossible conflict. My stomach couldn't decide whether to heave or bear down. One thing was clear; it was all on me.

But then she set her jaw and said, "I'm Jennifer Brighton, Jason's

English teacher." She offered her hand.

My father's face changed to an amused regard. He wasn't expecting this. Usually indignation overruled decent people's reaction to this kind of rudeness. The adrenaline was still cramping my guts, and I was watching my father to get clues on how it would play out.

"Well. My boy's teacher."

Ms. Brighton waited with admirable fortitude, when she should have paid attention to more primitive urgings to run in the house and bar the door. She did not remove her hand, and he finally looked at it and shook it.

"What are you teaching him, teacher?" My father was grinning harshly.

Unconsciously she rubbed her hand on her jeans. "Oh, English," she breathed out. "You mean, what have we done? Many things, poems, plays, novels." It was ridiculous, but her voice was getting stronger. It was to be an impromptu parent-teacher conference, and she seized on this reliable bit of etiquette.

 "Well, that's good. Real good."

I said as forcefully as I dared, "Time to go."

Ms. Brighton looked at me but my father was intently fixed on her. "My boy's never told me about you. Keeping secrets from dad, I guess."

"We're going to the truck."

The slightest shadow crossed my father's face. Ms. Brighton's brow knit together as she recollected bits she'd heard, trying to find some way of understanding.

My father broke into a disarming grin. "You know, you remind me of someone. I can't think of who that is right now. It'll come to me."

There could be no half-measures. I didn't wait; I let my elbow knock into my father's arm as I walked by him on the way toward the pickup truck.

He slipped into a self-deprecating voice. "Oh, I have a few business concerns between the northern towns."

I opened the door and quickly felt under the driver's seat until I found what I wanted and moved it under the passenger seat. The keys were still in the ignition, and I drove the truck into the driveway.

"So that's why Jason missed so much school?" she was saying.

Her face had high colour, but she asked, "Mr. Turner, this is an

important time in Jason's education. Everyone says what an improvement they've seen this year."

"Well, there's an idea. I guess I never got much education myself." Without seeing his face, I knew he gave her a wry smile. My father checked out the house again. "Nice evening. Nice of you to have the kids over."

Relief swept over her features and she relaxed her arms. "Well, they did a huge job for me. It was greatly appreciated."

"We're going, now," I said loudly. "Get in."

My father turned and narrowed his eyes at me. "What's your hurry, boy." Then he appeared to think of something. To Ms. Brighton, he said, "We have a great view of the sunset over at our place. C'mon over and have a beer. Kick back, take it easy. Jason will get you back whenever you say. I have to get up early myself tomorrow."

"Oh!" She turned and looked around at the mess. "I don't think I can."

"You probably don't know many people here, or have many friends."

"Oh, another time maybe."

"Aww. Nothing's going to happen to a few paint cans. You worked hard today. I'd like to hear more about my boy's progress."

The sun was weakening and the birds setting on the power line were becoming dark silhouettes. I deliberately ground the gears and my father jerked his head around, and I made sure I ploughed into her neighbour's tree. The blue notebook I'd so carefully compiled slipped from my hand and fell out the door when he backhanded his fist into my face and pushed me to the passenger seat. In the side mirror, I saw her hand go up to her mouth. Sheets of paper shot out from under the tires. That was the last time I saw her, battered by the colliding pieces of my life.

* * * * * * * *

At first, I stared out over a stark prairie, mostly reflecting a punishing light off the hard-packed snow. Later, the distance was shorter to other concrete walls but within those confines, a tenuous garden had been planted by more privileged occupants. Whether it was the fragrance of roses in summer or relief from the intractable nature of immovable objects, the outdoors connected me again to living things. That is one version of the story of how I recovered some semblance of myself.

The ten years I spent behind bars allowed me to hone many job skills but there was slow progress in other areas, like emotional stability, social interactions, and communication. For the longest time I kept her voice out of my head. For what it's worth, I did eventually get my high school equivalency diploma; I had made good on my promise.

In the maximum security facility, I waited for the right person to come along. Eventually I met a psychiatrist who was a real person, someone who could grasp other people's perspectives. With time, Dr. Kronen determined how things had unfolded, and when he was on the right track, I would give him a few more details. At my first appeal, Dr. Kronen testified to my traumatic childhood and the intense crisis that precipitated my choosing to protect my teacher. After that I decided to share the rest.

* * * * * * *

It was dark then on the gutted road. I braced my feet on the dash as the truck heeled violently. In sight of the river he cut the engine.

"Get out."

I opened the door and moved away from the car.

"Me and you have business."

"You're right about that," I said.

"I've lost all patience, boy. Thought you were learning, getting smart. But it never went that way with you. Now I see how things are. Enough."

He reached under his seat for the gun. I took it out of my waistband and moved around to his side of the truck. I could see his jaw working.

"So that's the way it's going to be."

I nodded. "Start walking." I waved the gun in the direction of the ravine.

He crossed to the river bank.

I said, "No. In the water."

My father said, "You planned this."

I didn't answer.

"It doesn't have to be this way."

"What other way do you think it can be?"

Nearly below our house now, my father's voice sounded unfamiliar. "Not like this."

I hated him then like everyone else hated him and knew I could make him do whatever I wanted. If I told him to lie in the freezing water for an hour he would have to do it.

"The water's cold." He broke down and sobbed once.

Until I met my teacher, I had no idea I could be different. Ms. Brighton taught me to see the best in things, trust in the idea of goodness. To feel compassion for those less fortunate and to withhold judgement. But now, I wasn't sure. I was back to a simpler set of rules. I suddenly wanted to say to her, education is not safety; it is confusion. I saw it in her face, at the end of the driveway. It takes another kind of knowing to survive war, deprivation, poverty, abuse. You learn to be selfish, not to trust anyone, to use every opportunity to advance yourself. No uncertainty. This world is a gritty reflection of a good world, but in my world, I am good.

My father put his head in his hands and wept. He started pulling himself towards me with his arms. An electric charge of revulsion found its way to my hand. The explosions surprised me, splitting the air, sending birds up from the brush. The two gunshots continued to echo deep up into the ravine, and I slowly sat down on a boulder with my feet already numb. There was nothing more; that was it. In the night, the water between my boots was all the darker for the black blood that flowed between us.

Susan Barber

Susan Barber is a writer and an educator. She is drawn to stories about injustice, violence and hard truths, with characters searching for catharsis and personal redemption, often in the face of the incomprehensible. She's written two dozen short stories along the way and is working on a couple of full length novels. "Reading the Road Ahead" is an excerpt from a novel that she wrote as part of her PhD thesis; "The Nepali Alphabet" was also gathered from an unpublished novel she needed to write first.

Chapter 3

Still Judging Books

James Adrian

Why do you look so surprised? You thought prison would define me?
You thought my potential would get lost in this crime spree,
or the magic in my pen would mysteriously run out of ink,
& I would never find a way to articulate what I think?

I am a product of your environment, young, gifted, and black.
They expected me to give up because the education I lack,
but never once did surrender ever enter my mind,
mentally busting knuckles & stereotypes with one line,
finding knowledge like buried treasures in inmates' heads,
building my resume with conversations with the so-called dead.
Then again, these are my friends, who probably made a bad choice.
So under these circumstances maybe I was chosen to be their voice.

But look at us now, Momma, how do we look?
Could we still be your son who picked up a gun & turned into a crook?
Could we be your neighbor or maybe your little brother
who was defending his girlfriend or maybe his significant other?
What if these state blues I'm wearing was actually a suit?
You would swear up & down that everything I'm saying is the truth.

So, here's some physical books that are missing their covers.
Can you give them some titles to satisfy their mothers
not criminal, crook, inmate, or even felon.
How about challenged young men who didn't notice their talents?

You wouldn't be more out of touch with reality if I created you myself thinking I wouldn't stack the deck in the game of life before the cards were dealt.

The power I possess could never be suppressed behind these cold steel doors

because it's been plenty of nights I wrote poems on those cold segregation floors.

Then, like the rose or the phoenix, I rose to the occasion,

but in your eyes, you still trying to judge a book before reading the pages.

James Adrian

James Adrian is from Ann Arbor, Michigan. He is a juvenile lifer who has been resentenced and has been incarcerated since he was 17 years old. He writes to inspire and motivate the have-nots and those whose voices have been silenced. He started writing to make his mother proud of him and to leave something of value behind when he dies. He desires to give back to his community and make a difference in the lives of those affected. He is a souljah of the struggle.

Chapter 4

A Poem's Worth

Literacy Lessons from a Prison Classroom

Adam D. Henze

When a poetry class in a maximum-security prison is dismissed for the day, often there is a procession of writers who take a moment to pass by their teacher and explicitly thank them "for their time." It is a delicate parade that has humbled me over the years.

An arms-folded Foucauldian scholar might say that over-politeness is just an indication of a performative discipline instilled by the prison system. But I can attest through my experience that these thank you's are said with soft eyes and solemn voices. Moments like these encourage me to consider the value of poetry. My class spends an hour every week assessing the worth of poems, and in turn I wonder what lessons my students have learned about worthiness.

Some students tell me they take my class instead of attending Narcotics Anonymous because they get more catharsis from their notebook than from counseling. It seems like a loaded statement, but who am I to argue with their claim? Other students tell me that class helps them express themselves better when they write letters to their family. A few of my students have created a working vocabulary bank of new words they have learned from reading poetry and talking about peer reviewed articles. Prison staff tell me some women come to my class because there is another woman they want to sit close to. I shrug and say that's how some of my friends started liking poetry too. Some administrators say that educational programming is good for prisoners because it gives them something to do to stay out of trouble. During these occasions I think about time as a commodity. Time is something you "spend" in prison, which leads some people to ask of my students:

why are you spending time writing poetry in prison?

I'll share a story about one interaction I had with an administrator that still earnestly makes me chuckle. One evening I arrive at the education building, and a woman I have never seen before meets me in the hallway with a fistful of keys. The usual coordinator I work with is out sick, so she leads me to my classroom and unlocks the door. "What class is this?" she asks.

"Poetry," I say shyly.

She squints her right eye and tilts her head to the left. "Poultry?" she asks in a high register. "Like chicken?" She wiggles her elbows ever so slightly.

I smile. "No, no," I say. "Poetry. Like reading and writing a poem." I gesture like an orator speaking at a podium.

She grimaces even more severely than when she conceptualized poultry class as a thing. "Poetry class?" she asks with a wince, and then walks away before I answer. This anecdote always makes me smile. I imagine that *poultry* class made some sort of sense to her. Barely. Maybe I was teaching incarcerated women to cook or sustain an urban farm. But poetry class? In prison? That is too silly to conceive.

While my run-in with a befuddled prison turnkey is a fun story to tell at cocktail hour, it is sadly not an outlier tale. There is a pattern of numerous gatekeepers in my life who have been skeptical of the value of using poetry as a pedagogy: school principals; classroom teachers; college professors; academic journal editors; festival planners; conference organizers; journalists and other media producers; let alone, my parents' friends. Even when I write about poetry for academic publications I am encouraged to provide substantive rationale for why I am doing so. I often wonder if my colleagues have to earnestly defend practices like studying math or history.

Over the years I've grown resentful of the question, "Why teach poetry in prison?" But given the rare opportunity to contribute a chapter to a book on literacy and incarceration, I recognize the importance of using my time to advocate for poetry as a vehicle for literacy learning in incarcerated spaces. I have seen the way my students clutch their journals to their chest when exiting our classroom and heading back to a locked dorm. I have seen them delicately unfold a precious piece of paper from their pocket and ask me, "Is it good?" Obviously, deep literacy learning is occurring beyond the basic A-B-C's, and my

aim for this chapter is to consider how poetry can help readers and writers achieve a greater sense of self. In the next section, I will provide some historical context for why people are scared of poetry. Then I will analyze poetry education as a critical literacy practice, using Sylvia Scribner's "Literacy in Three Metaphors" (1984) as a conveniently titled framework for discussion. Finally, I will provide some parting thoughts on fostering a poetry community behind locked doors.

In Defense of Poetry and People

I have been teaching on the inside for almost fourteen years, and I must confess that prisons still scare me. To be clear, I am not afraid of people incarcerated in prison. I am not afraid to have a cup of coffee with a student wearing prison scrubs and share some stories about my personal life. I am not afraid of walking in the yard alone or talking with a stranger in common spaces like the chapel or a dorm. Yet, I am afraid. My peak moment of fear hits me every time I am driving in my car toward a facility, and I first see a glimpse of that behemoth steel or stone structure peeking over a cornfield in the distance. I am afraid of the prison as a hulking construct. I am afraid of the prison as a systemic institution as represented by a warehouse wrapped in razor wire.

I mention this because I imagine some of my students feel a similar jolt in their chest when they pass by a school building. Schools are also arcane structures filled with rules and scolding authorities. And somewhere tucked within the "ivory tower" is the enigmatic practice of poetry, which even seems to scare people within those institutions. People are commonly taught to fear poetry. This is why many new students slink quietly into class on the first day of the semester without saying a word. Other students are more forward, confessing they are scared to contribute to the conversation out of fear of saying "something dumb." This ever present insecurity has encouraged me to spend the first class session asking students why they are afraid of poetry and unpacking their experience with literacy learning in school.

Such initial classroom discussions often reveal that the wariness of poetry is a learned attitude formed by people who feel disenfranchised by the education system. These discussions also indicate that the greater public feels alienated from the habit of reading and writing verse. In the book *The Hatred of Poetry* (Lerner, 2016), author Ben Lerner stated that the long held distrust of poetry is a reoccurring

narrative, pointing to Plato's *Republic* as the "most influential attack on poetry in recorded history" (p. 17). He summarized that Plato felt "there was no place for poetry in the Republic because poets are rhetoricians who pass off imaginative projections as the truth and risk corrupting the citizens of the just city, especially the impressionable youth" (Lerner, 2016, p. 17). This assertion has serious implications for scholars because Plato's essential claim is that we must "defend language as the medium of philosophy from the unreason of poets who make stuff up as opposed to discovering genuine truths" (Lerner, 2016, p. 18).

Incarcerated people are also denied a proper place in the Republic, and I believe this denial of status is related to an assumption that incarcerated people "make stuff up" and do not know "genuine truths." Like poetry, the stories of incarcerated people are also often dismissed as "imaginative projections" of "truth." Tales of their experiences are often silenced out of fear of "corrupting the citizens of the just city, especially the impressionable youth." The stigma of truth telling in prison is perfectly illustrated by a joke common among corrections officers:

Q: How do you know when a prisoner is lying?
A: When he opens his mouth.

As poet Muriel Rukeyser (1997) once said, "Anyone dealing with poetry and the love of poetry must deal, then, with the hatred of poetry, and perhaps even more with the indifference which is driven toward the center" (p. 9). Rukeyser's sentiment on indifference is intriguing to me, as a poet who teaches creative writing in incarcerated classrooms. When I first started teaching in a juvenile detention center as a young educator, my expectations were colored by depictions of prison in popular media. I knew I was going to be entering a brutal environment where my students would be subjected to hatred from people inside and outside the detention center. And yes, I have seen plenty of vitriol from powerful people inside prisons. But more commonly, I see indifference, "which is driven toward the center," in Rukeyser's words. Over the past 15 years, I've seen many of my students' stories met with shrugs from staff. TV shows told me that my biggest obstacle would be mean people, but more commonly I've had to defend my poetry

program to gatekeepers who don't really care.

Interestingly enough, I am also sometimes challenged by fellow advocates and prison educators who see my dedication to poetry as misguided. One debate with a friend comes to mind in particular because our common interest is attending poetry slams and festivals. She said that while reading and writing poetry is important, my impact would be greater if I taught a basic composition course that focused on developing skills like writing a resume or participating in a job interview. This is a limited viewpoint of poetry for two reasons. First, the attitude assumes that poetry is an inaccessible avenue to practicing practical academic skills. My poetry students learn to speak confidently about their histories, identities, accomplishments, and goals, which I believe is invaluable practice for writing a resume or participating in an interview. Second, the attitude assumes that the sole purpose of literacy learning is creating "opportunities of life" for readers, while neglecting the importance of improving "quality of life." Some of my students tell me that they have found a reason to "make it through the week," because poetry class is just a few days away.

Considering the scrutiny poetry has faced spanning from ancient Greece to the modern day, it is no wonder I am constantly tasked with defending the value of using spoken word as a vehicle for exploring the world. There have been countless defenders of poetry throughout history, ranging from Romantic Percy Shelley to rapper Mos Def (Aptowicz, 2008). Perhaps poets with identities riddled with stigma can take solace in that fact: even something as beautiful as poetry is deemed worthless by a large swath of society.

Still, I want my colleagues to understand the value of using poetry as a vehicle for critical literacy learning. Poetry is elusive, and its efficacy is hard to pin down on measured assessments. It is challenging to express the effectiveness of poetry without telling stories of classroom successes. When there is a struggle to clearly define what exists around us, poets often turn to metaphor to present concepts as clear images. Ideally, Scribner (1984) provided three metaphors for literacy: literacy as adaptation; literacy as power; and literacy as a state-of-grace. These three metaphors will be explored more thoroughly in the following sections. Scribner's framework has complicated common notions of literacy by considering how functionality is measured and questioning how diverse social demands change the execution of literate actions.

To better understand how literacy metaphorically operates as adaptation, power, and as a state-of-grace, it is important to ground our notion of what a poetry-infused critical literacy program looks like.

Literacy as Adaptation

Scribner (1984) began her three-pronged interpretation of literacy by introducing the notion of "functional literacy," which is "conceived broadly as the level of proficiency necessary for effective performance in a range of settings and customary activities" (p. 9). In my classroom, I often tell students that I don't really care if they adopt the practice or identity of "being a poet." Rather, I believe that the habit of writing verse will instill some transferable literacy skills that students can pick up and use in other spaces. My assumption is that if poetry can help a student craft and deliver their testimonies, then it can also help them develop literacy skills that are transferable to more common tasks, like writing a cover letter to a potential employer and talking to them during a job interview. In Scribner's terms, this is *literacy as adaptation*.

I will attempt to provide an example of "literacy as adaptation" by sharing a story from my experiences as a prison educator. One day a student approaches me before class to ask if I will be willing to help her with a non-poetry-related project. I recognize that a request like this comes with a great effort. One of the most complicated aspects of teaching in incarcerated spaces is offering technical support to students between class meetings. In many cases there are security-related barriers that prevent students from contacting instructors for help via email or letter. I can tell the request is important, even though the student seems withdrawn in her asking. She explains that a woman in her dorm has recently died and that she was asked to prepare a eulogy to read aloud.

"Could you help me revise this?" she asks, handing me a piece of paper. "And maybe help me practice it a couple times? I'm so nervous."

Although crafting a eulogy has never been part of my creative writing curriculum, I assume she is asking me because she saw some transferable skills from our creative writing course. My poetry class challenges students to construct testimonies and speak them fearlessly in front of their peers. The vivid nature of poetry gives students an opportunity to confront difficult emotions and put them into words to share with others. I agree to meet with the student and a couple of

her peers before class, and over the next couple weeks we provide feedback on her volume, tone, and rate of speech. After a little practice, my student delivers a powerful eulogy in front of a large gathering of her peers. I am proud of her, but I was confident she would do well. She has always spoken with conviction when she reads her poems in the classroom.

Poetry writing promotes the practice of literacy as adaptation, because there are numerous possible actions to take during the construction of a poem in a classroom setting which may change depending on the situation. For example, the literacy practice of "revision" can involve reading a text critically, marking and annotating a text, providing written and vocal feedback about a text, listening to how a line of text sounds spoken out loud, and ultimately rewriting unsuccessful concepts within a text and reworking the spatial relationships between words on a page. Furthermore, the literacy practice may task students to employ different literacy skills if the revision takes place in-person in a peer-review circle or perhaps online using a peer evaluation tool. Poetry writing complicates the standard notion of literacy because prowess involves developing skills beyond functional reading and writing. In preparing a eulogy to honor the life of her friend, my student succeeded in constructing a literary identity she felt confident enough to share with the world around her.

The adaptive nature of poetry may also provide some insight as to why some people find the practice elusive. I have personally met my share of corrections officers and administrators who believe my students are hiding symbols and coded messages in their poems. Poetry critic Stephen Burt (2013) explained that poetry is difficult for some to define or conceptualize because literacy acts involving poetry constitute many different practices:

> Poetry isn't one thing that serves one purpose, any more than music or computer programming serve one purpose. The Greek word [for] poem just means "a made thing," and poetry is just a set of techniques—ways of making patterns—that put emotions into words. And the more techniques you know, the more things you can make. And the more patterns you can recognize in things you might already like or love. (p. 1)

The abstract nature of poetry makes it a quality vehicle to promote literacy as adaptation, but its abstractness makes it equally hard to use

language to pin down its characteristics. Even Webster's Dictionary is coy about defining a singular function of poetry, as seen in their *Word History* blog entitled "A Poet by any Other Name" (Merriam-Webster, 2019).

> You cannot carry anything in a poem. You cannot use it to store books or shoes or paper clips. You cannot use a poem as a cutting board or as a mode of transportation. A poem will not protect you from a draft. A poem will not take dictation, nor will it protect your eyes in bright sun. A poem cannot keep you warm and you cannot use it to trim your hair. A poem is hardly a thing at all. Except, of course, that it is, as the millennia of poetry prove. And etymologically, a poet is a maker.

This is why I encourage my students to write about themselves in their poems. It challenges them to "make something" of themselves. Sometimes I think about my experience helping a student write a eulogy because she crafted more than just a speech. The writing and recitation of the eulogy established that she is an observant and thoughtful person. The eulogy implied that she is a kind and caring friend. Poetry writing has taught the student the skillful art of tempering lamentation with words, which, sadly, is a lesson many incarcerated people could find valuable.

Literacy as Power

Scribner's second metaphor is *literacy as power*. Commenting on Freire's notion of literacy as a tool for social transformation, she claimed, "Effective literacy education, in his view, creates a critical consciousness through which a community can analyze its conditions of social existence and engage in effective action for a just society" (Scribner, 1984). The literacy as power metaphor moralizes what it means to be literate by instilling a sense of ethos related to the notion of critical citizenship. As the quote demonstrates, being a critically literate citizen involves two criteria: developing the ability to "analyze" one's "conditions of social existence" and "engage in effective action" to improve one's own standpoint and the world. This posits a tension between creative writing teachers and the gatekeepers of the prison industry. If a writer becomes self-aware of their social existence as a prisoner, will they then lodge effective action against the forces of power that imprison them?

Being critically literate means having the aptitude needed to effectively assess networks of power to see how one's standpoint is related to others in a hierarchic society. McLaren and Giroux (1997) stated that a major limitation of critical discussion among educators is that discourse is often phrased in a way that limits the possible agency of participants to being confined within "the logic of capital." Advancing the language of critique is a crucial step toward overcoming gaps in achieving justice, because "pedagogically, language provides the self-definitions upon which people act, negotiate various subject positions, and undertake a process of naming and renaming the relations between themselves, others, and the world" (McLaren & Giroux, 1997, p. 16). I find poetry to be a useful tool for elevating discourses on education because, as Ramirez (2013) claimed, poetry is largely about naming things.

I will once again attempt to illustrate Scribner's point with a story. I believe there is no better example of witnessing "literacy as power" than watching a poetry open mic in a maximum-security women's prison. In a space where women are consistently told to be silent and compliant, suddenly an invitation is given to read their earnest testimony in front of a large audience. I have seen countless prison authors use these makeshift stages to "name things" present in their life stories, such as systemic racism, addiction, poverty, sexual abuse, domestic violence, food insecurity, and generational trauma.

One story comes to mind: the year is 2015, and I am watching my students perform their poetry in a packed prison chapel of 200 of their peers. One of my students decides to use her opportunity on stage to speak about some grievances she has with corrections officers assigned to her unit. I quickly look around to the officers in the chapel, but I am surprised to see their energy is reserved. If she would have stood up in the cafeteria and shouted the same grievances, she would have surely been scolded, restrained, and placed in solitary confinement. Since her message is being delivered with clever phrasing in a (somewhat) sanctioned space, her words are instead met with applause. After the performance I watch one corrections officer compliment her on her performance, and then remind her that she is no longer on stage—so she better watch her mouth.

The metaphor of literacy as power further complicates the understanding of why some people fear poetry. Yes, poems about flowers

and bumble bees are nice, but poems have also been historically authored to critique power. This dynamic helps explain why many poetry collections in prison libraries are limited to classic works and volumes from the Romantic and Victorian periods. The assumption is that imprisoned readers will find the content less relevant, which carries two implications. In the minds of prison administrators, it is less likely that readers will see themselves represented in the literature and therefore won't be moved to act against similar antagonists in their own lived experiences. In the minds of readers, poetry remains an irrelevant practice because the canon they have been shown does not attempt to speak to their worldview. Duncan-Andrade and Morell (2008) claimed that it is the responsibility of critical educators to promote the examination of texts that are closely related to the cultures and backgrounds of students, because relevant reading material tasks students with making sense of how they relate to people and places in their own homes and communities.

An unspoken fear about poetry is an assumed transference of literacy as a passive act toward a pedagogy that favors action and expression. Scribner (1984) was explicit that writers should develop the literacy skills required to "engage in effective action" against unjust forces (Scribner, 1984). Essentially, "action" in such terms means a critically literate individual is equipped to *traverse* injustices. Developing writing, reading, and communication skills in a way that treats societal injustices as problems to solve encourages students to consider how said skills can help them change spaces around them.

To return to the earlier example, I think it is vital to mention that the warden has stopped granting my request to host a "spoken word night," where students can perform their poems in the chapel in front of hundreds of their peers. Many guests who have attended these readings have described the experience to me as "powerful." However, prison staff sometimes see such power as a threat to law and order. Even though my students' poems were pre-approved by an appointed information officer, there is still a concern that a student may "go off script" in the middle of their recitation. These readings used to be a culminating event for all my classes, but ultimately the tradition has inevitably been nixed because administrators feel like participants might "incite a riot" if they are allowed a microphone and platform to speak freely.

Literacy as a State-of-Grace

Engaging literacy practices can help readers traverse adversity, but Scribner claimed that another element of literacy encourages readers to *transcend* the forces which oppresses them. This liberatory viewpoint of literacy education personifies the third metaphor of *literacy as a state-of-grace*:

> The power and functionality of literacy is not bound by political or economic parameters but in a sense transcends them; the literate individual's life derives its meaning and significance from intellectual, aesthetic, and spiritual participation in the accumulated creations and knowledge of human kind, made available through the written word." (p. 14).

Poetry promotes this sense of transcendence because writers are given the opportunity to use their writing to craft an idealized world. Anzuldua's (1987) critical work echoed this sentiment, claiming "I write the myths in me, the myths I am, the myths I want to become" (p. 93). Likewise, many of my students have used poetry as an avenue to envision the person they aspire to be. Some students use their writing to voice their commitments toward being a better parent or daughter, for example. Other students use the opportunity to envision what life will be like after their release, with hopes of being happy, drug free, gainfully employed in a rewarding occupation, and surrounded by loving friends and family. The poem is like a blueprint where writers can design their ideal self in a playful and imaginative space.

As in previous sections, I will use a story as an example of literacy as a state-of-grace. In the prison workshop I typically start each class by writing a prompt on the board. The prompt might ask participants to write about a childhood memory, for example, or invite participants to share their feelings on a current event. Sometimes I notice the class will then spend two or three minutes picking apart the prompt to make sure they understand the "rules." Does the poem need to rhyme? Does the poem have to be a real story? How long does it have to be? Despite my attempts to point out that the prompt is purposefully vague and open to interpretation, some students express anxieties about "doing it right."

One night I write a question on the board that tasks students to explain the meaning of the phrase "spending time," which is a prompt that could be interpreted many ways.

Before I even finish reading the prompt out loud, I see alarm bells go off in my students' heads. Hands go up in the air.

Since we are having some transparent conversations this evening, I decide to ask the class if they notice that they always obsess over the parameters of prompts that are clearly designed to be open-ended. My students tell me it's because when corrections officers give them instructions, they want to know every aspect of every single thing so they don't get in trouble.

"That's incarceration," I reply.

They agree. Then I ask them to think about why I might want to challenge them to fight that impulse in our classroom space.

"So you're messing with us?" one of my students asks.

"No, I'm trying to shake this place out of you, if only for a few minutes."

They smile and then start writing.

Suddenly, the poem becomes a problem to solve with multiple possible approaches. Then students share their unique poems aloud, all incorporating different pathways toward a solution.

Moments like these give me a better understanding of how literacy as a state-of-grace can impact incarcerated learning spaces. I am often surprised by the supportive dialogue my students foster in the classroom, and they tell me that my course is one of the only opportunities they have to exhibit kindness to one another in a shared space. Jocson (2008) found that dialoguing with students about writing serves as a "necessary reflection to ease the pain of experiences with courage and clarity" (p. 159). Poetry provides writers the opportunity to work through indignation by considering things that are fantastical, celebratory, funny, and loving. These sentiments can be difficult to find in locked away spaces, which is why poetry can be seen as a harbinger of goodness. As Audre Lorde (1984) claims, "This is poetry as illumination, for it is through poetry that we give name to those ideas which are—until the poem—nameless and formless, about to be birthed but already felt" (p. 36). When my students decide to take a necessary step in their lives, sometimes they visualize this step in the rough draft of a poem.

A liberatory poetry pedagogy can produce a tight-knit learning community who collectively feels an urgency towards social engagement. My story about the writing prompt suggests that writing com-

munities in prison can essentially help participants transcend the harshness of their environment. Rose (1994) explained that authors from marginalized arts communities, such as hip-hop culture, often craft narratives that vie for a relinquishing of oppression, a rise in status, recognition, inclusion, access, and acclaim. By showing students how to define their identities beyond the social crises that harm them, poetry can be a first step toward self-actualization. In Stovall's study (2006), poet and educator Avery R. Young articulated this notion in his message to his students, "Now that you've written a good poem, be good people" (p. 73).

The Delicate Parade

There may be a day you find yourself standing in the front of a classroom, awed by the delicate parade of students walking in or out of your teaching space. There may be a day that a student musters the courage to approach you at the front of the room. Perhaps they unfold a piece of paper from their pocket like a blossom in the morning and place it in your hand.

"Did I do this right?" is a question they may ask you. Maybe they will avert their eyes and shuffle their feet while waiting for you to read.

If you happen to find yourself in this scenario, I hope you pause a moment to consider the other questions they are afraid to ask you. Are they asking, "Am I worthy? Is my worthiness reflected in my writing on this piece of paper?"

I choose to teach poetry in incarcerated spaces because the practice provides an audience for this question. Poetry provides this student a nodding head and snapping fingers to accent their narrative. Poetry presents writers with a promise that there is a listener out there somewhere who is willing to hear their story. Poetry implies that our words are worthy of applause.

Many students first enter my classroom with an understandable fear of poetry. But over time, they start to see something oddly familiar about the practice. Poetry is misunderstood. Poetry is often written off or labeled a misfit. Poetry doesn't always follow the rules or fit into easily defined boxes. Upon this realization, my students begin to see themselves reflected in the practice of poetry. Every week I watch the way they enter my class, take their seats, and stare proudly at their work like they are gazing in a mirror. I hope my students see potential

in their poems, the same way that I see potential in them.

Adam Henze, Ph.D.

Dr. Adam Henze is a researcher, educator, and spoken word artist, and has shared his work in over 30 states, as well as Puerto Rico, Canada, England, Ireland, and the United Arab Emirates. He is a co-director of Slam Camp, a summer writing academy for teenage poets, and founding director of Power of a Sentence, a prison literacy program in Indiana. Adam received his Ph.D. from the Literacy, Culture, and Language Education department at Indiana University, and works as a Research Associate at the Indiana Institute on Disability and Community. His research interests include critical media literacy, youth literacies, prison pedagogy, and inquiry methodology. Adam currently serves as Director of Programming for Southern Fried Poetry, Inc., which hosts the longest-running annual poetry slam in the world. He is a Bureau Speaker for Indiana Humanities and was the Official Poet of the 100th Running of the Indianapolis 500.

References

A poet by any other name. (n.d.). *Merriam-Webster*. Retrieved 2020 from https://www.merriam-webster.com/words-at-play/the-history-of-the-word-poet

Anzuldua, G. (1987). *Borderlands/La frontera: The new Mestiza*. Aunt Lute Books.

Aptowicz, C. (2008). *Words in your face: A guided tour through twenty years of the New York City poetry slam*. Soft Skull.

Burt, S. (2013, June). *Why people need poetry* [Video]. TED Conferences. https://www.ted.com/talks/stephen_burt_why_people_need_poetry?language=en

Duncan-Andrade, J., & Morrell, E. (2008). *The art of critical pedagogy: Possibilities for moving from theory to practice in urban schools*. Peter Lang.

Jocson, K. (2008). *Youth poets: Empowering literacies in and out of schools*. Peter Lang.

Lerner, B. (2016). *The hatred of poetry*. Farrar, Straus and Giroux.

Lorde, A. (1984). *Sister outsider: Essays and speeches by Audre Lorde*. Ten Speed Press.

McLaren, P., & Giroux, H. A. (1997). Writing from the margins: Geographies of identity, pedagoy, and power. In P. McLaren, *Revolutionary multiculturalism: Pedagogies of dissent for the new millenium* (pp. 16-41). Westview Press.

Ramirez, A. (2013, November 26). Adriana Ramirez at TEDxHouston 2013. Houston: TEDxTalks. Retrieved from https://www.youtube.com/watch?v=zTKBQIQ2bCc&feature=emb_logo

Rose, T. (1994). *Black noise: Rap music and black culture in contemporary America.* Wesleyan University Press.

Rukeyser, M. (1997) *The life of poetry.* Paris Press.

Scribner, S. (1984). Literacy in three metaphors. *American Journal of Education, 93*(21), 6-21.

Stovall, D. (2006). Urban poetics: Poetry, social justice and critical pedagogy in education. *The Urban Review, 38*(1), 63-80.

Chapter 5

Snapshots

Kodi Faircloth

I am from Sudafed boxes,
from fast cars and easy money.
I am from drug-addicted parents
who were abusive, neglectful, and
selfish to their own needs.

I am a Summer Rose, full bloom.
I am delicate, beautiful,
but I carry many thorns.
I am from a brothel of bikers,
conceived in a whorehouse:
from Anne-Marie and Curly.

I am from a no-standards and
 carefree family
that always said
"no one gives a damn" and
"do what you want to do."
I am from the Hells Angels,
with a wild drug life.

I am from Raton, New Mexico;
I'm a mix of Mexican, Caucasian, and
 Native American.
I'm from Indian fry bread,

from tacos and jalapeños.
I'm from living wild and feeling fed up.

I am from the gun
that took my eyesight,
from the loss of my innocence
by being raped.

All I have are those memories
of my past life
 'til now.
I am from every moment of my memories.
They are snapshots, my secrets;
I am my lost family album.

Kodi Faircloth

Originally from Rattone, New Mexico, Kodi came to Oklahoma in a forced reconnection with her mother because her grandmother-in-law was dying from liver failure. Kodi went from Grandmother's proper home to living in squalor with her dope addict, barmaid / biker chick mother who attempted to kill Kodi because of the inheritance left by Grandmother. The shooting left Kodi blind. She was seven years old.

Her disability required Kodi to go to the state prison system's "medical facility" for women, which happens to be located in Oklahoma's highest security female prison. She's been forced to navigate without medical appliances or assistance in a violent, sighted space.

Still, she perseveres. She studies. She writes. She excels. And Kodi is a never ending inspiration to all the emotionally blind, sighted people around her.

Jax

I perform the menial task of being Kodi's eyes for the transcription of her thoughts to paper so that others can enjoy her work. The words are hers. My influence is really from my prior experiences as her teacher and mentor through both educational and creative writing classes. It is an honor to help her, though I should not have to do so. Kodi is well versed in accessibility assistants through phones or computers,

but neither are allowed here.

While at school, one of the other tutors and I modified materials to enable for tactile and / or audible interpretation of the lessons. We made models, used glue to leave an upraised outline around objects drawn on paper, and guided her hands to demonstrate relative or comparative sizes of objects being discussed. Keri and I read aloud from textbooks, computer education modules, and even tests themselves. Tests offered the greatest challenge for us because we could do nothing that offered a hint of a correct response or the assessments would be of no value. I learned to read and write braille and designed my own convict-engineered stylus to do it. I made an abacus for Kodi's use out of yarn and bread dough. Graphing was the hardest concept to teach; we made a raised platform Cartesian system and used yarn and tokens to plot lines and points.

Chapter 6

From Texts to Phone Calls

Aden Mejia and Johny Mejia

On Thursday, November 21, 2019 at 6:30 a.m, my mom's cell phone started its cheery ringtone. Unlike the rest of the world, she never switched to the silent vibrate mode. My sister and I were still in pajamas, about to get ready for school. But we snapped to attention and immediately were on alert with such an early-morning call.

Our dad was on the other end of the line. He said he was being pulled over by a police officer for a traffic violation. As soon as we heard the sound of his voice, we knew it wasn't good. Especially knowing what could come from it; we watch the news. We've always known what could come of it.

I felt so sick to my stomach, like I was being punched in the gut. It knocked the wind out of me. My mom and my sister, all of us were in shock. Nevertheless, we somehow got ourselves together and drove to where he was being pulled over. As she drove, my mom's finger nervously tapped the steering wheel. But it was already too late. The police had taken him in. By the time we got there, they were already towing his truck. I jumped out of the car before my mom had even put it in park and ran to the cop's car, still there on the side of the road. I asked him if they took my dad. As if he cared.

The feeling in my gut only got worse. I started to hyperventilate and cry. I looked at my watch and realized that my heartbeat was over 150 BPM. I was having a panic attack. Finally, I managed a few deep breaths and pulled myself together to calm down. I tried not to overthink, because anyone who knows me knows that I can get out of hand with that. I got back in my mom's car and sat for a minute,

thinking of everything that just happened in the last 15 minutes. Then I decided to text my dad.

6:48 a.m.

"Are you ok"

"you're gonna be ok"

"all of this is God's plan"

"say a prayer and everything will be ok"

I never got an answer back. At the time, I didn't realize that when you go to jail, they take all of your belongings. As I was beginning to think more clearly, I realized that I had a meeting in an hour that was, funny enough, in the same building where all of this was happening. But for some reason, I became so angry. I didn't show it, but I felt it. Like pin pricks all over my skin. The anger was for the people who run our government and the ones "in charge." How could they take an innocent man from his family? I didn't understand, but what I did understand was that I wasn't about to walk in a room full of the ones "in charge." I skipped the meeting. Not knowing what else to do, I decided to go to school.

That day was one of the hardest days that I've been through in my life. I tried to stay focused on school and not worry about what had happened, attempting to keep my mind occupied. It became clear to me that not thinking about my dad was impossible, and I decided to try to text him again.

12:35 p.m.

"Text me when u get out"

No answer.

1:59 p.m.

"love you, take care and be strong"

No answer.

I had a lot of hope that my words would reach him and offer him strength. And I had a lot of hope I would see him when I got out of school, that they would let him out. That day rushed by but soon came the next. The next day, we were finally able to talk to him and get the details of what happened and what he went through his first night ever in jail. Eventually, it became a semi-normal routine for the few weeks he was in the county jail. We would call, video call, and try to "virtual visit" as much as possible. At the same time, it was crushing for me to hear my dad so distraught. He hated it. He hated how nasty

the jail was and the lack of cleanliness. It was like no one cared. These phone calls had come to replace the texts that once kept us connected in our daily lives. Our words could no longer be revisited and reread in times of loneliness.

One day we tried to call, like we did all the other days, but this day he didn't pick up. It wasn't too concerning, being that there were other inmates needing to call their loved ones as well. Not to mention with the jail providing only three phones, two of which actually worked, it was hard for him to get to one. After the third and fourth time trying to call and him not picking up, we started to get worried. Three days later, we found out that he was no longer in the county jail and that he had been moved. But don't think that the jail told us; he finally was able to call us by borrowing money from another person being held in the immigrant detention center. We were stunned to learn he was almost four hours away from us. And we knew that this was bad. Once we were able to get ahold of him, he told us how they transported him and others.

The police officers woke my dad and other men in the jail in the middle of the night. The officers told them to pack, then put them in chains and marched them onto a bus, never telling them where or why. Not knowing this information, it seems, was a way to keep everyone scared and disoriented. My dad said that the 4-hour trip felt like an 8-hour one. He wasn't once able to use the bathroom and was told to hold it. He said that it was one of the worst experiences of his life. And he told me many times that he feels like he was treated like an animal and that no human should be treated like that. Once at the detention center, he found himself with a new group of detained people from different countries and speaking different languages. Eventually, my mom, my sister, and I decided to make a trip down there on the weekend and see him. This time we would be able to see him in person.

We got up real early and headed that way, to a place we never had heard of, only seen on TV. It was difficult to imagine my dad in that place.

After we drove past one or two cities, the scenery was just roads, roads, and more roads. Here and there, we would see a Dollar General or a Subway but nothing more. We finally found the town with a population smaller than my high school and with an enormous pri-

vately-owned detention center. There are more people in the detention center than in the entire town.

The first thing I noticed at the detention center was all of the barb wire and the large red entrance. As we walked through the heavy gates and down the paved walkway, I thought it was funny that the company had decided to spend money on potted plants for decoration. I opened the glass door for my mom and my sister, and in we went. We spotted a front desk and a few employees in uniforms, though none of them seemed to really care about the visitors or what we went through to get there. In front of the desk sat 15 chairs, 6 lockers, and 35 people waiting to see their loved one. Some of them drove down the coast or across 4 or 5 states to get there. At first, nobody knows what to do or how the process will go. There are no signs to read or directions to follow. You have to just watch and learn the rules; we were lucky because not everyone there spoke English well enough to learn these rules without help.

Once I realized what we were into, we learned there would be a wait for at least an hour. Then that hour becomes 4 or 5 hours, and visitors begin to get a feeling that they won't be able to visit their person. But if they're lucky and they do, a 5-step walk through the tiny metal detectors and a number tag assignment follows in quick succession. Next is a restroom break, also the one and only break. Passing through a heavy door, visitors finally are able to walk into a room of windows, phones, and cracked plastic chairs. Then they see their person on the other side of the glass. In this case, my dad. The guard tells you, you have one hour, then you start talking.

It was very emotional, being the first time we had seen our dad in person in almost 3 weeks. He was scared, we were scared, but we still came through and carried a conversation. His words were like a lifeline to us and ours to him. We tried to split the 60 minutes between the three of us, which was hard because Hispanic people's nature is to talk for hours at a time, but we did it. We tried to bring up the good times we had and tried to have hope for the future. We prayed together and cried together. We both put our hands to the window. That was the closest we could get to a hug. Eventually the guard came in and called us out of the room. We cried on our way out. But we were lucky to meet a family who was visiting as well. They recommended we go to an immigrant advocacy center's hospitality house down the street.

They were an organization for families like us who go through things like this. We had nothing better to do so we went.

We drove around looking for the house but being that there were less than 20 homes being lived in, it wasn't too difficult to find. Once we found it, we pulled in and walked up the ramp hoping to find other people. I had seen a lady inside through the window and we waved; they greeted us as if we were family. Hot coffee and cookies in hand, we sat down and the hospitality house workers shared information with us about their organization and their goals. They gave us information on how to visit 2 days at a time and said that we can have a room in the home if we decided to stay. We got their contacts and thanked them for being so kind and made the trip back home.

The next few weeks were rough, not having our dad with us. He would call and tell us the horror he had gone through that day. He would say that they would never turn the light off at night and that it was almost impossible to sleep. When it was "chow" time, the guards gave them a purple drink that would make them feel sick every time but always have energy after. To this day I still believe that there was something in that drink that shouldn't have been. One thing he would always say is that during the day, some people would sleep and be up all night talking. He hated it. In fact, he and some other inmates would complain daily about it to the officers and to the ones in charge, but they wouldn't do anything. Soon he picked up a job of cutting hair. It's something he always wanted to do but never could get to it. He made less than ten dollars a week doing it, but it gave him something to do. He would call and just tell us everything he did that day, his ups and downs, what he felt and how he handled it. We would just cry together and wish each other luck for the next day. Some days he would call crying saying he couldn't do it anymore, that he was done. Those were the scary calls. I would always pray, pray, pray to give him strength and to be strong during this time. I'd read him Bible verses that would relate to that day's struggle. I hoped the words stayed with him.

One day after school, he called me. He said that one of the guards pulled him into an office and told him that he was being deported that following Monday. This happened on a Thursday. I busted out into tears knowing that this was the end and that it would be a very long time before we could give him a real hug and see him on the same

side of the glass. The weekend rushed its way in, and we were back on the road. We called the hospitality house and let them know that we needed to stay the weekend. They welcomed us with open arms. Once we arrived in town, we headed immediately to the detention center. Went through the same long wait and the whole process. While we were waiting, we noticed one of the hospitality house workers sitting in a chair nearby, and we talked to her and got to know more about everything. We did the visit; dad had a new haircut, which was a great conversation starter, and he told us more stories and how he was so scared of going back "home." Once the visit was over, we headed to the house.

We arrived and noticed that there was a new group of workers. They settled us in and started getting to know us. They showed us our rooms and started cooking dinner—tacos with rice and beans. After dinner we sat and talked. We got to know each other and all that we have been through in life and how we all ended up at the same dining table having a good time. We all talked for over 5 hours! It felt great to get our mind off all the drama we had been through the past month and a half. I felt lighter somehow. Sharing our stories around the table meant a lot. But fun doesn't last forever. The morning came and it was time for the last time we would see our dad for a very long time. We packed and headed out the door at 9:00. We were the first ones there. We went in, signed in, waited, and then it was time for the visit.

The visit started like the others; dad got to talk to our new best friends from the hospitality house, who were there visiting other detained men. Soon after, it became very emotional. He started telling us to stay strong and never give up on him and to always call. We told him the same. We shared a few good memories we had with him and the hour soon came to an end. We all put our hands to the window while tears ran down our face, and we said our goodbyes over and over again. The guard came in and told us to leave but I just couldn't, it was too hard for me. We were all crying so hard that we couldn't even talk. And that was the last time I saw my dad.

I was screaming and sobbing, angry at this world, angry at how he was treated. I had to get out of there, everyone was already staring at me. I had to get out. I ran to the car. We cried the whole way home.

After a few days, my dad finally made it to Honduras, his birthplace. Luckily, it was where his parents and a few cousins still lived.

He was so taken aback at how his hometown had changed, how all the people he knew were gone. His home, his people, his land were all different. It wasn't what he knew. He said it felt like he was in a stranger's home. His home is here, the United States, with us. But he knew that the U.S. didn't want him and that he would have to make Honduras his new home. It took months before he got used to having a hole in the ground as his toilet. How he has to get his drinking water from a well and take showers outside and how he can see the night sky from the roof. That was just the tip of the iceberg. He had to change his entire way of life. My dad, who once was a normal guy who had a normal house and a normal job, watched football and cooked hamburgers on the grill, was now a man who worked for five dollars a day in a country where finding a dead body is the norm. He now raises pigs for a living.

We all talk every day. He tells us what new things he's learned and how he's adapting to his new way of life. Many times, he'll text us "Look what I caught!" along with a picture of the fish he caught from the river that day. Lots of the texts have been about our grandpa. He's very sick and my dad takes care of him. The texts say things like "look how bad dad is today." and "He can't breathe, and we have to go to the doctors." Those are very sad texts to get from him, watching him struggle as his own father slowly declines. But the scariest text that we got from him was "You almost lost your dad today, I got stung by a wasp and I don't have my EpiPen anymore, it's out."

Those are life and death texts. It scared us so much. We didn't want to lose our dad when he's over 2,000 miles away from us. But at the end of the day through these texts, there was always more good than bad. At least that's what we tried to make it. It's always fun to get a video from him about his pigs. He sends videos of his pigs that just gave birth and we all talk about how cute the baby piglets are. It's also been nice getting to talk to our grandparents. Texting has become so important in our lives, but in a different way than before my dad was taken. We don't text just to say hello or make a grocery store request. We text, call, and send videos to share our struggles and our strengths and how we are adapting to our new way of life. Sharing our stories with each other is almost like a form of therapy. It makes us feel the distance a little bit less. There are so many crazy things we have learned over the phone. We've tried to make light from this dark time and create something beautiful out of it.

Aden Mejia

Aden Mejia is a 16-year-old junior in high school who gained direct experience with the immigration system when his father was unexpectedly picked up by ICE. Aden is now an outspoken advocate for better treatment for immigrants who have been detained and removed from their families. He is active in sharing his story with others in the K-12 school system.

Johny Mejia

Johny Mejia is the father of two and is a native of Honduras. Before his unexpected and abrupt deportation, he was an employee at a carpet mill in the carpet capital of the world. He worked at this carpet mill for the past 20 years in the United States. He always strove to make sure his children would receive a better education than his own and would grow up in a safe and healthy environment.

Chapter 7

47 Cent Stamp

Jacob Beyers

You wrote me a letter of love and hope
all sealed up in a white envelope.
Just a simple letter to a faraway heart,
that's riddled with burden and torn apart.
Then you noticed you didn't have a stamp,
so you let that letter sit on the desk by the lamp.
One week went by, then two, then three,
after all, it's just a letter to me.
Just a letter you wrote and held in your hand,
but you failed to realize what it meant to this man.
Then one day while doing your bills,
you noticed something that gave you chills.
Oh shit, I forgot, I hope he's not mad,
I would've sent it sooner if a stamp I had.
So you ran to the post office to send your mail,
just a few words of love for your man in jail.
Well your man waited and waited but waits no longer,
too bad his poor heart wasn't harder and stronger.
Your man's heart died in that dark prison camp,
knowing his love wasn't worth a 47 cent stamp.

Jacob Beyers

Jacob Beyers was born in Evansville, Indiana on July 14, 1986, to Patrick and Lisa (Owen) Beyers. He was a devoted son, brother, uncle, grandson, nephew, cousin, partner, and friend and had a heart full of love for so many people. He had an infectious smile and could make anyone laugh with his quick wit and goofy sense of humor. Jacob enjoyed reading and writing, music, had a love for history and philosophy, and a mind so inquisitive he never seemed to stop studying about and learning new things. Jacob was good at almost anything he tried to do and he had so many hidden talents, including drawing, writing poetry, and even rapping and beatboxing. Jacob was also an extremely gifted athlete. He played soccer, played hockey from age 5 through college, was a Golden Gloves boxer, and a nationally ranked BMX racer. In spite of all of his many gifts and talents he shared with the world, Jacob will always be most remembered for the kind-hearted and loving teddy bear that he was to all who knew him.

Jacob was my younger brother. The first paragraph of this is his obituary, which I wrote in September of 2020 after we lost Jacob September 14, 2020 in his battle with the disease of addiction. He wrote this poem while he was in prison in a letter to my parents, and I didn't get to read it until after he passed away. I miss Jacob very much, and it will always hurt, but it gives me peace that I get to continue to honor his life by telling his story. Thank you. —Katherine Beyers

Section 2

Education Inside

"Consequently I have enough light, even after the usual twelve o'clock lights-out, to read or study by. I don't really have to sleep now if I choose not to. The early hours of morning are the only time of the day that one can find any respite from the pandemonium."
—George Jackson

"The fact is, we need prisons that are more like schools, and schools that are less like prisons."
—Salvatore Striano

"I will continue striving to learn to write. But it is like learning to swim on land. I'll learn as much as I can."
—Jack Henry Abbott

Chapter 8

The Nepali Alphabet

Susan Barber

Maggie tried to remember—what exactly was she thinking at that moment? The female guard had unlocked the inner wooden door and Val led the way into the gatehouse. As the metal bars clanked cha-chung behind them, Maggie's pulse had quickened. A sharp feeling of shame surged through her now and she knocked her fist against her forehead. On entering the jail, she recalled peering around the guard so she could see. She truly believed this was just what she needed. As she crossed the threshold, she glanced over her shoulder and saw the outline of the head jailer. He nodded, and then she stepped down into the jail courtyard and hurried, hurried, inside to "check it out."

As they navigated the deep concrete courtyard between its rivulets of sewage, a dozen women sat cleaning rice. Maggie nearly tripped on a brick. They appeared otherworldly, even haunting, and Maggie's attitude sobered significantly. Someone gave a shout, summoning the other women from the back dorm where they cooked and slept, and they streamed out to meet them. Nagondidi, the senior prisoner, reached them first. It could have been two migrating tribes finally coming together. Their independent evolution, customs, and diet made them strange to one another, and they halted by the outhouse, sniffing and staring. Maggie remarked how Laxsmi whinnied and hid herself, while others had animal savagery in their faces. Gita squeezed Val's breast and gave her a playful shove, but Devi rebuked her. The poorest women with babies and toddlers and Santimaya with her five year old girl, Zumbra, gestured towards their mouths. Clearly, some of them did not want her to come in, but the women knew that they

must. The head jailer had said so.

Maggie now reminded herself that visiting Val was something she had wanted to do since Val had written, saying she had done something "incredibly stupid." Best friends since college, it was unlikely that Maggie could refuse, but there was more to it. Maggie and Colin's engagement last year had naturally created a distance between them, and she was ashamed to admit that Val had gradually drifted off her radar. Then somehow Maggie went from her and Colin moving to Taipei, getting great teaching jobs, and planning their wedding, to Colin confessing one night that he had found the "true" woman of his dreams. Maggie barely got out of bed for a week and searched around inside herself. She had nothing, no armor and no weapons to mobilize a recovery. After a month in the hospital back home, and four months on antidepressants, she could barely see the point of soldiering on.

And then the letter from Val. Unbelievable. It struck her that Val was actually worse off than her. She read the letter four, five, ten times. If only to find out how bouncy Val, positive, life-loving Val, was managing, Maggie packed her bags and flew to Kathmandu to see for herself.

Maggie landed in late August when the monsoon had mostly passed and the tourists would be drifting in. She did not know what to expect when she arrived at the jail. Maggie offered amusing stories about how she had learned to discreetly bribe the head jailer. A Swiss couple told me, "Just fold a 20 rupee note behind the foil in a cigarette pack."

Val smiled and then looked past her to the grass lawn over Maggie's shoulder.

"Aren't you impressed that I can get you out into a private visiting room?" Maggie joked. In her interactions with the head jailer, Maggie found out that the whole jail knew about Colin and her "heart pain," that Val thought she was a saint for coming to visit, and that the head jailer was worried about Val, the solo foreigner, in the women's section.

Val said, "I need some skin cream. I'm breaking out in rashes from the water."

Maggie replied, "Okay. But it's so lax here, we can dress you up in a sari and you can just walk out." Maggie could see she shouldn't chide Val about things and so they talked about people back home.

* * * * * * * *

Now in September, Maggie couldn't believe she was still visiting Val nearly every day. The head jailer had heard about some of the women harassing Val and reprimanded them, stating how hard it was for Val. "Everybody feels badly inside," he said, and both Val and Maggie were good people. Val told her some of the women came back in tears, and things improved greatly. The head jailer carefully suggested that it would help if Val paid one or two women five cents a day to collect her water, wash her clothes and dishes, and anything else she wanted. Val needed to be part of the jail economy, and allow prisoners to earn some money. Maggie thanked the head jailer for his consideration which was the opposite of what she expected. She started to wonder what she could do, according to Nepali customs, to reciprocate.

Shortly after, Maggie and Val were visiting just outside the gate when the woman who dispensed the daily rice arrived. One by one, the women filed in to sign in for their ration. Maggie watched in fascination as they either initialed their name or pressed their thumb on an ink pad and then onto the ledger. Out of all the women, only Sarasvatri, Vishnu, and Maya could write their names. Then Maggie had her idea. If these women could learn to read and write, they might be able to get decent jobs when they got out and secure their independence. Literacy was a gift that would keep being returned to them, and even beyond, to their children. After she left the jail that evening, she walked directly to the shops and found a Nepali language book, notebooks, pens, and pencils. The odd, curling script derived from ancient Sanskrit captivated her. Like twisting sticks and whips dancing below a rigid line, none of the 35 letters of the alphabet had any similarity to the English-Latin script, yet it would be simple compared to learning Chinese pictographs.

With some trepidation, Maggie told the head jailer. He not only agreed, but even said she could go inside the jail so as many women as possible could learn, instead of the women coming outside. Stunned, Maggie could find no words to express her complete bafflement. "Just go slowly," he advised. "Let them get used to you first. "Sure?" she said as she glanced over at the metal bars.

A week later, she was stumbling into the courtyard, clasping her books as if they would protect her, definitely in a jail of her own making.

* * * * * * *

The autumn sky had cleared now but the sun was blocked by the main building. White birds flashed in the sunlight and turned dark as they darted to earth. Maggie had asked Val about their routine, knowing that the women collected water from a single, slow tap in the early morning, using it to hand wash their clothes or themselves outside. Fitting lessons in before noon was difficult; this was when they did small tasks, like rice cleaning, sewing, and knitting. After a mid-afternoon nap, their free time was her best chance.

Camped on a few stairs in a corner of the courtyard, Val filled Maggie in on who was who. Maggie wondered how Val had ever gotten used to the place. Some days, Maggie would gag when she came in. Piles of feces around the courtyard meant some workers had been inside to unclog the sewage and she had had to leave a few times. She had to admit she was having second thoughts about her decision to come to Kathmandu.

Maggie's eyes drifted across the scene in front of them. Laxsmi had tied a plastic bag to Gita's skirt and Zumbra and three other children came over to watch. As Gita pushed her way up the stairs into the gatehouse, Laxsmi chortled and finally Gita noticed the bag was there, scratching on the steps behind her. Gita turned furiously on the kids which made Laxsmi fall on the Indian woman, Roopa, howling. Zumbra dodged Gita's blow, and picking up a stick, scraped it down the slimy gutter. Instantly, a round-faced Tibetan woman caught up with Zumbra, and slapped her hard across the face, ranting about the stains on her laundry.

* * * * * * *

"Hey!" Maggie instantly stood up, but Val pulled her back down, and in the next minute, the kids resumed playing in the other gutter.

"Why does everyone hit the kids? Can't you talk to them?" Maggie demanded.

Val replied, "It happens. The kids get walloped, and then it's over."
"Yeah, but, that's excessive," Maggie fumed, her humor spoiled.

They could hear more shouts than usual emanating from the front gate, and women clustered en masse. Just then, a wave of women spilled backwards from the gate, as more keening started up within.

Then they saw her. She was a typical young wife, except her braid was unraveled and she was smeared with dirt. Her eyes blazed though, and they stepped away. Camila was her name. She paced up to Maggie and stopped. She hadn't counted on seeing a tall blond woman in pants.

They asked for details. "When did it happen, Didi?" She turned on them. "You want to know? Yes, I did it," she hissed. Maggie watched as Val edged in at the side. Camila felt their support. "I came home early, and I found them. I knew it! Her! A neighbour! In our bed!" Camila looked down at her palms.

The caked blood on her skirt was dried, and her hands were meshed with brown lines. The head jailer hadn't let her wash, making her wear the blood and forcing her to reckon with what she had done.

Gita threw her head back and laughed. "Itty bitty little woman with a big knife!" Someone snickered, but they knew the only time a prisoner would talk was when she was freshly arrived. They might even get the truth. "Was she really dead?" "In front of your husband?"

Maggie was amazed. No one else objected. Most were even admiring her. Then Maggie saw that even Val hung on every word. This was too much for her. Camila looked right through them. "They can arrest me. So what?" She spun around, cursing at the gate. "I have my justice."

Maggie's head was about to explode. "So why didn't you kill your husband then? He's the one you wanted to punish." Val looked at her in horror, her hand slowly going to her mouth.

Camila stiffened. She hadn't heard this one yet. Maggie added, "Why take it out on the woman?" Camila's eyes darted around and she screamed, "I knew her! She was—" Then her face whitened and three women stepped in to pull her away. The remaining ones stared at Maggie. Val caught her arm and said, "Are you crazy? Not another word!" Maggie said, "Oh my god, it's so stupid! This is all so stupid."

* * * * * * * *

Devi laughed at how slow Maggie was at cleaning out a cup of rice. They indulged her whim of doing low caste tasks after they realized she was intent on it. Maggie knew she needed to make amends. After Roopa commented on the stamps that were on Val's letters, Maggie had a plan. She waved some of the women over to her on a mat spread on the bricks. In their curiosity, they gathered around. She pulled out

a book and several notebooks, and they became excited about a new activity. They even offered to check her hair for lice and complemented its color.

"Val is your Didi?" "No, she is my friend." "You lost a husband?" "No, but we were planning to get married." "Oh, he's a bad man, no good." Maggie smiled and shrugged her shoulders. "Maybe. Some men good, some men bad, right?"

Maggie paused and said, "It is good for women to be able to support themselves, if they can read and write."

She asked them to help her. She started to drill herself, asking them to correct her, and they giggled as she read aloud to them, ka, kha, ga, gha. Others approached and said they had been to primary school and could sing the alphabet song. Gita came to sit several times, squinting at the book, but the others laughed her away. Soon, a hot competition developed between those who knew a few letters, to see who could guess first. Maggie tried to get them to match the sound with the symbol but it made no sense to them. Zumbra wriggled up between Maggie's knees straining to see, and then cheerily, the women sang out to the guards, ch, chh, j, jh.

The next day, Maggie was able to put letters with vowels to make words. Sounding them out, she asked Roopa to correct her. Santimaya came over and pointed up to the roof. They started talking about Gita's new boyfriend, a skinny guard who kept watch on top of the prison. Gita was working to get him sweet on her and it did not go unnoticed that she was nearly twice his girth and three times as strong. Whenever they saw her talking to him, the women went into paroxysms of hilarity with Gita becoming upset, but inside the dorm, she would laugh with them. Maggie sighed, but wanted to show them patience, so they would be patient in learning.

Then there was to be a puja in a few days. Vishnu called from the gatehouse, and Maggie was asked to get off the mat. They would be half the day in their kitchens, frying dough for the jail staff.

Maggie promised, "We are going to be writing letters soon!"

Roopa shrugged. "But Maggie. Who will write back to us?" She gave the mat a good shake and left Maggie swatting at a cloud of dust. Giving up her spot, Maggie moved to the hard steps, letting go of the book in her hand. Gita waited for them to leave before she approached. "Eh, Maggie?" Gita looked around and kept her voice

uncharacteristically low. "I need to learn. Okay?" She glanced at the book but her eyes swept the courtyard again. "You teach me to write. Shhh. Quietly."

Maggie handed her the notebook and pencil. Maggie looked at Gita's full face, flushed with color. If anyone could learn, Gita could. Maggie re-adjusted Gita's grip. A thicker pen or marker would be better, Maggie thought.

Gita's eyes closed tightly. "My name, Maggie. Let's start." "No, let's start at the beginning, with the alphabet. If you learn, you can live your own life someday." Gita considered this, and then lifted the pencil. She held her fist tightly on the paper but nothing happened. Maggie put her hand over Gita's and guided her through the first few letters. Callused and stiff from heavy work and cold water, Gita couldn't manipulate the instrument, so they made huge letters, half the page-size letters. Before long, Gita sighed and Maggie thought she was kidding before she saw weariness in her face.

The next day they tried again and Maggie encouraged her to write just a little longer, stretching it from three to five minutes. But some days, five minutes was too long. After a week, Gita still had no memory of the first letters. Maggie playfully kneaded Gita's tense arms and shoulders. To enhearten Gita, they focused on her name only. Five simple strokes. Then they just tried "G." She told Gita she could sign in for her rice allotment; not have to use her thumbprint anymore. "Like the others," Gita emphasized.

When it rained for several afternoons, Maggie prepared for the lesson by tracing out large-scale shapes, like curves, circles, and straight lines to improve her fine motor control. When Zumbra saw the colored pens, she scrambled to Maggie's side. Afraid Gita would be annoyed, Maggie set up a little space on the corner of the mat and gave Zumbra some shapes and pictures to trace with her favorite colors. After two weeks Gita still couldn't write "G."

Every time she came for her lesson she was confident. Maggie hated the way she became beaten down.

"Eh, Maggie, I think we stop for a while. Try again next week. O.K.?" "You are doing well! Children in schools study for years." As Gita left, Maggie heard her sigh. There was something profane about diminishing Gita's spirit. Maybe Maggie was a poor teacher, and she had taken for granted that everyone had this within them. Among

the other women, Gita was a warrior, a survivor. Her devil-may-care attitude was the tonic to others' resignation and helplessness.

Maggie sighed, and turned to gather up the pens. She glanced at Zumbra's papers: ka, kha, ga, gha. Gita, Gita, Gita, she'd written. Maggie gasped, and then opened the book. Asking Zumbra to copy the other letters, Maggie watched closely as Zumbra looked at the letter and followed the shapes.

"Koti ramro cha! Wonderful!" She spontaneously lifted Zumbra on her knees and hugged her, until Zumbra laughed and laughed. In the strangeness of such exuberance, Maggie quieted and smiled deeply into Zumbra's eyes. This was much too important to risk. It would have to be their unspoken secret. Zumbra herself might have found a way out of all this and Maggie was damn well going to pave the way. Zumbra had hope in her future.

Maggie put her finger to her lips and then Zumbra's. She showed her where in the dorm room by Val's belongings Maggie would leave her papers and pens. Gita had too robust a spirit, too much life already lived, to be cramped and contained by that one small pencil. Zumbra's mind was agile; she could imagine sounds contained by symbols. Those networks through her brain were still open and could be exercised.

Later, Maggie told Val what had happened. Maggie would need Val to keep an eye on Zumbra when Maggie went home for the evening, and also keep a lookout while she was teaching Zumbra. Val said, "I can teach her, too. Maybe we could alternate."

Maggie didn't answer immediately. "I think I'll just keep doing it. She seems to learn well the way it's been going." Val's face fell. Then Maggie had a thought. "Maybe you could work on the other women, convince them that they really need to learn how to write."

Val said, "Maggie, you get to go back to your hotel every night. It's not the same thing as being in here for god knows how long, every day. You don't get it. No one can think about anything else."

"But they need to look forward—"

"No one can think about anything but getting through the day! You're a fucking tourist!" Val leapt to her feet. Maggie almost added, yeah, and a little appreciation for my choice to come here would be nice. She counted to three and said, "Well, while we are talking about things… I should tell you. I have to think about heading home pretty

soon. You seem like you are doing okay, and lots of other visitors come to see you."

Val sat back down, and Maggie saw her eyes were filling up. Maggie was instantly sorry and intended to say, "Don't worry … I can stay a bit longer," but the words wouldn't come out. The truth was, she hoped Val would let her go.

Val surprised her by waving her hand over the courtyard. " It's going to get really cold soon. None of them have warm coats or blankets." She cried, "What are we going to do?"

* * * * * * *

Over the next few days, Maggie monitored signs of distress in Val. She watched as Val became childish with the others, possibly giving them the right sort of thing, especially the kids. At present, she was breathless with jumping rope and playing catch to take them out of themselves. In contrast, Maggie glanced at Gita beside her. Amazed by her resilience, Maggie imagined that Gita probably never believed she would learn to write; rather, she was confident it just would happen. Gita was healthy, still in her 20's and getting paid for doing chores for two women and heavy work in the jail. Wherever she landed, Gita would be all right.

As it turned out, Gita was good at explicating the women's cases. "Eh, Maggie. Most women here are baby cases. They didn't know they carried a baby, were even too young to know how they got a baby inside. After it was born, either they or their family encouraged the girl to drown the baby. Some babies were saved, like with Santimaya and Zumbra, and the mothers had to take their babies into the jail with them. The new girl, Parvati, the slow one? She told the police that she had a miscarriage, but they put her in jail anyway. Others killed their baby because they were raped, but it didn't matter."

"Wait," Maggie said, "are you saying rape is not illegal? With no birth control, sex education, or laws, how is this possible?" "Maggie, maybe in Kathmandu rape is against the law. But in many, many areas in Nepal, there are no police, and men do not go to jail. Sometimes it is too hard to prove. Sometimes the man just gives money to the father, but later the father kicks the daughter out, like with Maya. In Laxsmi's case, she and her son lived far outside of a village. She said she had nightmares that her dead husband came back. She slept with

him, and it happened five or six times. Then she was pregnant. People in the village demanded she go to jail because she had seduced her son. They almost beat her to death, so it was better for her to come to Kathmandu."

Maggie couldn't speak. It took everything to avoid looking over at Laxsmi. Gita continued, "Maggie, you know some women are substitute prisoners? Someone in the family commits a crime, and the family decides who will "bosni,"or sit in jail. Sarasvatri's husband carried cans of coffee with heroin inside to Europe and was caught. The Nepali police came to their house to find everyone up to their elbows in white powder!" Gita guffawed. "Sarasvatri went to jail for the whole family."

"Can't she bribe someone to get out?" "Oh, Maggie! It's such a big case. Maybe in five years. Yes, she has a chance. But, it's not so good for Ama." "The old lady?" Maggie was aghast.

"Yes, it's not so good. She is old and has a long sentence. Her son supported the family with hash, and the family couldn't let him go to jail. But old people should enjoy the end of their labour. Yet, this would be a hardship for her family. So, she made a deal. He must come to the jail every Mother's Day, get down on the ground and kiss her feet. He has come six times so far. With Vishnu, her father bribed a government magistrate and stole another man's land. The man got someone from the Kathmandu government to enforce the law, and Vishnu's father sent Vishnu to serve his time because she was not married and not interested in getting married. And then there's Roopa, and Devi and ..."

"Stop, just stop," Maggie said. "I don't want to know any more. Enough. Stop now please."

"Okay, okay, sorry, Maggie," Gita said. "I'm going to get water now. Okay Maggie?"

Maggie looked over the high walls at the five-story apartment buildings around the women's jail. People were also washing their clothes, watering their vegetable gardens, listening to the same radio music. Everything was wrong, like everything was upside down, the opposite of what it should be. Clearly then, she knew they were all in prison. Death, poverty, disease, what people can do to others, even parents to a child. She had chosen to come, and she had the right to

un-choose it. She didn't want any part of it, this feeling of becoming invisible.

* * * * * * *

A new woman lay in a heap on the cold bed of the courtyard. Some-one pulled her up off the ground, and finally they got her inside and out of the rain, into the side hallway where the women hung their laundry during the rainy days. Maggie first saw her there after lunch and noticed her again in the evening. It rained for two days and then it became much colder, near freezing. There had been no visitors for Val for ten days. And still the newcomer sat. Several women kept at her, to eat, to come into the dorm. She needed time. Laxsmi was right. When you first came in it was hard. Then it became intolerable.

On the first bright day, Maggie returned, and balked at rolling up her pant legs and wading across the flooded courtyard. No one had been out yet that morning. Then Maggie remembered the hall. She mused that one could spiral up inside the cloth saris, like a cocoon, and be warm and dry, emerge in spring transfigured, and flutter away over the highest walls. But, there was already a bulkiness within a hanging sari. Just as Maggie sensed Laxsmi wading over to her, Mag-gie distinguished the brown feet dangling. Bewilderment stopped her from turning to Laxsmi; instead she traced the sari up to the exposed iron rods running horizontally between the arched doors. She saw the long black braid.

"What ..." she said aloud. And then she closed her mouth; her skin went cold.

A knife was in Laxsmi's hand. Maggie dragged her gaze away from Laxsmi and stared at the blade. Maggie finally understood. Laxsmi struggled to suppress a cry, and then rubbed her face into Maggie's shoulder, gasping and wiping her eyes. Maggie could not look away as the woman's face slowly swung round. They stood a few minutes, witnesses of this end, and what this young woman had come to believe was a natural conclusion.

Finally Maggie told Laxsmi, nodding at her knife, "You'd better go cut her down now. Before the others see her." Laxsmi was too short, and Maggie had to saw through the cloth noose. Together, they car-

ried the body out of the hall to the gate, and they let the guards take her. As soon as they were back in the courtyard, Laxsmi let go and sobbed, "Nobody knew her."

* * * * * * *

After a dreary February and dismal March, the warm spring weather finally arrived. Farmers crowded the streets as they herded their sheep and goats to market, and cows still had coloured dye streaked across their backs from the New Year celebrations. Suddenly, everything was alive, and Maggie realized that she had probably spent more of her waking hours inside the jail than outside. Now that time was over.

Maggie could hear Val's voice in the head jailer's office. There was paperwork to be signed by the justice representative. All around Maggie were actors in their very real dramas, each struggling for some bigger piece of justice. Maggie could even hear Gita shrieking with laughter all the way from the gate to where Maggie waited on the outside lawn.

After the suicide, the head jailer had called the women into his office in groups of six, including Maggie. Notably, they all sat in silence together for several moments, staring at the candlelight in the middle of the table. Then several started to cry, and he calmed them. Maggie barely listened to his words; they were what anyone says to others when death has come unexpectedly. What she heard was the deep and honest voice of care, an acknowledgement that bad things happen, but they also pass. How few conversations there are like this, Maggie thought. How few women get to hear them, coming from a benevolent man who takes the time to put feelings into words. In the midst of so much inhumanity and evil, that this good can exist, was overwhelming to her. There was an imperfect perfection to it all. Maggie was moved by the light reflected in their eyes and swore she would never forget this moment.

Maggie turned to see a taxi driving across the grass right towards her. The taxi honked a few times, and a great shout went up in the jail office; a minute later, Val emerged, free. Maggie met her halfway and they had a great, tearful hug. Several of the guards came around them, clapping and cheering. This was Val's big moment, the nightmare was ending. Maggie stepped back and let Val take center stage. Behind Maggie, coming from a distance, inside at the gate, she could hear

voices calling, "Goodbye, Val! Bye bye, Val! Bye Val!" It was all too much suddenly. There could be no perfectly happy moment of walking away from all of this.

* * * * * * * *

This was a different room, absent of smell and sound, yet overrun by suffocating layers of thought. Maggie kicked off the blankets and opened her eyes before she realized she had been dreaming. Her hand was still suspended in front of her as she left off tracing figures in her sleep. The letters of the Nepali alphabet were nothing like Chinese, so she was starting at zero.

Curious about the sound each letter would make, she listened closely, and they spoke their names to her. Gita was using the pencil to dig in the soil. But Zumbra could learn; that was it.

Maggie's husband snored and then stretched on the bed next to her. She swung her legs out of bed, and walked to the back door to look up at the sky. A clear night. No moon, only stars. Just time etched across the universe in incomprehensible units of light.

They were all dead now, she reflected. That was for certain. Even Zumbra, and the babies born in the jail. Some may have walked out of jail on their own power, but outside, many would have faced greater adversity. Prostitution, more crime, a violent marriage. That day, more than 20 years ago, after parting with Val on the street, Maggie contemplated the different directions she could take. To her left, she could pick up her bag at the hotel and head to the airport. To the right, she could enter the Children's Aid Foundation and sign up to be a literacy volunteer. This did not seem like a choice, yet it influenced other choices. She returned home to do graduate studies and obtained a good job, promotions, bought a house, married, and started a family and, and, and, and… Her opportunities had been literally endless.

They were all dead now, yet they lingered as ghosts inhabiting her mind, haunting her as they had done from the first, preferring the shadow parts of her life. A certain laugh, a long braid, the sound of a metal gate closing. She wondered. Have I done enough? She was still surrounded by poverty that sickens the mind, justifying the desperate acts inflicted upon the innocent. It causes otherwise moral men to become bad fathers, husbands, and public servants. "Ke garne, Maggie? What to do?" they would say. Maybe she could have taught more, ef-

fected policy change, or taken her family directly to the darkest places. But how could they have flourished in a world of misery with no end?

Maggie stopped herself. She was still missing the point. Her precious mentors knew: it is very hard, often sad. They would tell her, you must not only have compassion for others, but also for yourself. To arm yourself against the imperfection and carry on. Offer forgiveness, and use it to ease burdens and embolden the benevolent. After all, what else can we do?

Susan Barber

Susan Barber is a writer and an educator. She is drawn to stories about injustice, violence, and hard truths, with characters searching for catharsis and personal redemption, often in the face of the incomprehensible. She's written two dozen short stories along the way and is working on a couple of full length novels. "Reading the Road Ahead" is an excerpt from a novel that she wrote as part of her Ph.D. thesis; "The Nepali Alphabet" was also gathered from an unpublished novel she needed to write first.

Chapter 9

Stick-up Guy

Sonia Weidenfelder

"I don't know about you, but I'm about this life. I'm a stick-up guy, it's what I do. So, I'm all about getting to my target, and x is my target. $3x + 2 = 8$. All right, first we gotta kick in the door, and we gotta get rid of that 2. When they add, we…" Joelle pauses and waits for a response and instantly the group answers, "Subtract." My orange-clad co-worker continues, "and life's all about balance, right? So what we do to one side…" The group answers, "We do to the other." "Yeah!" she cheers. "Now we're in the door, but we still gotta get this right-hand man, this 3, out of the way before we get to our target. What do we do?" Right on cue, the group says, "Divide!" "Yeah! By 3, right? So 6 divided by 3 is…" "Two!" "Boom! We got him!"

I've never heard anyone make algebra sound gangster before, but my friend's method works. Last year our graduation rate was around 30%. Joelle truly was "about that life." She really was a "stick-up guy," robbing and kidnapping before she was locked up. She didn't finish high school until she came to prison. Now she's tutoring algebra, taking college courses, and making plans for an entirely legal future when she is released. She's a perfect poster child for why education works, and prison isn't always a bad thing. She is also an excellent example of how trauma may lead to both illiteracy and criminal behavior.

Working as a tutor in education at the prison where I am incarcerated, I hear a lot of stories. Trauma seems to be a common theme among people who didn't graduate high school until adulthood. Some kind of life-changing event derailed their education. Sure, a few people seem to have just not cared, but for the vast majority, circum-

stances were beyond their control. This could mean almost anything: having a child at an extremely young age, having to care for younger siblings, being tossed from household to household, being debilitated by a learning disability, suffering a catastrophic loss, or just having a chaotic lifestyle.

I don't think anyone wakes up one morning and says, "I want to be illiterate and unemployable. I just won't finish school!" No, something happens. More often than not, the something is traumatic. There is a similar correlation between crime and trauma. No one wakes up one morning and says, "I want to be a terrible person. I'm going to get addicted to drugs, rob and hurt people, and ruin my life. Maybe I'll even end up in prison!" No, something happens. People are in abusive relationships that become more violent. They might suffer an excruciating loss and start drinking or abusing drugs to cope. Maybe they've developed an addiction they just can't kick, and to feed their habit they do things they never would have done sober. My point is this: many have been degraded to the point that they believe they are worthless and incapable of learning.

Because of this, most of my work tutoring my fellow inmates consists of encouraging and handholding. In our study group, we go over what they're working on, and then I spend the rest of our time together saying things like, "Yes! You've got it!" and "That's right!" One of the biggest hurdles educators face when working with inmates is not a lack of intelligence or motivation, it's a lack of confidence. A few individuals may lack the drive to do the work, but those are really few and far between.

So many people come to me convinced they will not be able to understand. I've heard, "I'm backwards. It won't make sense to me," and, "I just can't do math," and, "This is just too hard for me." All this comes from adult women who held jobs, raised children, and maintained households. They're astounded when they realize they can and do understand. They look at me suspiciously, as though I were trying to trick them somehow. When they receive their first graded assignment with an A on it, they bring it to me to look over, excited, but asking if there could be a mistake.

I also teach piano lessons privately on the compound, and I run into the same problem there. I show my piano students how to do something, and they proceed to carefully explain to me all the reasons

they won't be able to do it. I ask them to try anyway, and then they succeed on the second or third attempt. Ultimately, the people I work with are far more capable than they imagine themselves to be. Most of what I do as a tutor is help students understand that.

Most of my life I was told I should teach, and repeatedly I rejected the idea. I pictured a bunch of snot-nosed kids rolling their eyes and sneaking glances at the clock, counting the seconds until they could escape. Certainly I knew that teaching is a noble profession, but why should I subject myself to it? I had much better things to do with my time.

Then, a couple of years ago, I realized that my true passion isn't really music or art or cooking or any of the things that I love. It's in them, but they do not contain it. My true passion lies in things that are greater than the sum of their parts. For example, you can gather a canvas and paints and brushes and pile them all together and not have a painting, because a painting is more than the sum of its parts. There's that indefinable magic that makes a meal out of ingredients and a song out of letters and vibrations. I see God in the indefinable something.

Having realized that, I also realized this: showing people how to develop their own indefinable magic is even more rewarding than doing it myself. It is immensely satisfying building that little spark into a flame, watching someone's eyes light up with comprehension and the knowledge that they have potential. The greatest part of my job, both in quality and quantity, is empowering people.

Why is it that so many ended up beaten down, defeated, and convinced of their own incompetence at an early age? Is it possible for individuals to be more responsive to trauma in children and young adults, and thereby nip both illiteracy and criminal behavior in the proverbial bud? I don't have the answer. I do know that we, as family members and friends of children, teens, and young adults, can be more responsive. We can love and encourage; we can offer shelter and friendship. But in a society like ours, where independence is valued above community, it's easy to be condemned for interfering. Teachers, clergy, and other well-meaning individuals can easily cross boundaries unintentionally. After an inmate's experiences with the criminal justice system, it would be easy to lose confidence in government agencies. We shouldn't be relying on the government to be the first line of

defense against trauma, anyway.

Considering all this, I'm left asking myself if anything I can do will really make a difference. After being incarcerated, I know I will encourage and strengthen when I can. I won't be afraid to praise children lavishly and loudly when it's called for. I'll be available to listen when it's appropriate. Every chance I get, I'll tell everyone not to go where I've been and offer ideas for how to do things better. I'll hope that something, anything, is helping.

In the meantime, what's being done every day in education helps in a concrete, practical way. To illustrate how, let's look at Joelle again. Before incarceration, most of her income was obtained illegally. Imagine that Joelle is released from prison without the benefit of an education. She intends to make a better life for herself. She wants to do things the right way. Unfortunately, with no high school diploma, limited skills for a legitimate job, and a felony conviction, she very quickly finds it almost impossible to get a job. She applies for several positions and even goes on a couple of interviews, but is repeatedly passed over. She finally finds a job washing dishes in a restaurant. It really doesn't pay enough to cover the expenses at the sober living house where she stays, much less fines and restitution. Since she really wants to do better, she takes the job. She struggles and is in danger of not being able to make her payment to the court. Then an old friend contacts her on Facebook. He has a way for her to make a little money on the side, just this one time… Despite all of her good intentions, she falls right back into her old lifestyle because she doesn't know any other way to make ends meet. Whether or not she's ever incarcerated again, society is still in a worse state. The crime rate is higher, and the world is robbed of her specific gifts and talents. There are fewer taxes collected. Her parents grow older, and since she doesn't slow down enough to help them, their quality of life deteriorates. Her children continue to be raised without her, putting more strain on either her family members or the foster care system (and putting the children at greater risk of incarceration themselves). Everybody loses.

Fortunately, that's not what will happen to Joelle. Thanks to the principal, teachers, and inmates who work in education at our prison, Joelle graduated. She learned, as she says, "the power of a made-up mind." Thanks to this, even when she recently experienced a devastating loss, she didn't relapse. She learned that she's very intelligent and

that she's great at math. In fact, she was offered a job in education the same day she graduated. All of these very real accomplishments have led her to think about herself differently. She's stopped fighting and severed longstanding ties with people who refused to respect her new way of life. She's continuing her education. She loves tutoring and thinks she would like to pursue teaching in some capacity when she is released. Even though she doesn't plan to be released for a few more years, she already has a plan (and a backup plan) for her legitimate future. All of this was made possible by her change of perspective, which was largely made possible by education. Everybody wins.

Education in prison works a little differently from education in the free world. There's probably a little more cussing from the students, or at least it's not as much of a secret. The lunches, shockingly, are worse. We don't get summers off. The students largely seem to be more eager to please, more eager to learn, and more grateful for the opportunity. The staff seems to be more patient and empathetic (while being even less tolerant of nonsense). But in spite of the differences, I think the principles remain the same. Honesty and kindness are still the best policies. Teachers can (and should) still learn, and learners can still teach. Whether someone is coming to learn or teach, what he or she is doing is special and important. It matters, not just to the people you see every day, but to their families and their communities, to everyone whose life may be touched by one reformed "stick-up guy." If we sincerely desire to heal the world, education in incarcerated spaces has to be one of our greatest priorities.

Sonia Weidenfelder

Sonia Weidenfelder was born in 1982 to loving, supportive, Christian parents. She recalls an almost picture-perfect childhood with her parents, brother, and sister. She was a Missouri Bright Flight scholar and a member of the National Honor Society and the National Society of Collegiate Scholars. After high school she attended the University of Missouri Central and the University of Tulsa. She is the proud mother of a brilliant, beautiful, kind teenager. She is also an accomplished musician and a recent contributor to a visual art exhibit in Tulsa. She is currently in Oklahoma serving a sentence of life with the possibility of parole. Her faith is what keeps her strong.

Chapter 10

Shaping what Counts

Jim Sosnowski

"The students are afraid to get made fun of because of their pronun-
ciation…They get told that they have broke-ass English and don't
want to experience that."
−Angel (Language Partners Instructor)

Angel's comments were shared during a conversation between in-
structors concerning the teaching practices and policies that were
being used in Language Partners (LP), a prison-based, peer-taught,
adult English language and literacy program. Some instructors felt
the program was too prescriptive, citing policies and pedagogies with
assimilationist agendas that have historically marginalized and erased
language practices that did not align with white, middle-class ways of
speaking. Other instructors argued the LP students were marginalized
on a daily basis because they did not speak English and they felt an
obligation to help alleviate those negative experiences if they could
through teaching the students English.

Many teachers, like Angel, are well aware of the difficulties that
the language-minoritized students that they teach face when their
students leave the classroom. In many ways, teachers often view their
classrooms as a sanctuary from the oppressive forces that students ex-
perience in their daily lives. They can also be places where teachers
can help language-minoritized students learn to better navigate and
understand the myriad linguistic borders that they find themselves
crossing on a daily basis. However, oftentimes, in hopes of protecting
their students, teachers feel pressured to push them towards adopting

standardized language and literacy practices (Flores et al., 2018). In this process of "helping" and "protecting," teachers can become complicit in the reproduction and maintenance of the negative language ideologies that they are trying to help their students navigate.

Historically, schools and formal educational spaces have contributed to shaping societal discourses concerning which language and literacy practices are more highly valued. In the U.S., practices which most closely align with white, middle and upper-class literacy practices have been privileged in formal education spaces. Dyson (1993) refers to these privileged practices as *sanctioned literacies* and argues that literacies should not be considered objectively neutral practices, but recognized as ideological positions. Through privileging particular language and literacy practices in educational settings, the literacies that language-minoritized students bring to the classroom are positioned as deficient. A goal of formal education then becomes to erase these "deficient" practices and move students towards more "appropriate" and "acceptable" practices (Paris & Alim, 2014).

Similar to how teachers and academics have questioned how to best serve language-minoritized students, the LP instructors were asking questions of their program. In fact, Angel's comments were only part of what was an ongoing debate amongst the LP instructors and program volunteers, questioning whether what they were doing in their program was doing more harm than good. This ongoing debate was the impetus for this study, as LP instructors and volunteers partnered through participatory action research to understand how they could best serve their students and whether or not they contributed to the marginalization of their students.

This study, focused on Language Partners (LP), a language and literacy program that was situated in a state-run, medium security, male correctional center in the U.S. Midwest. We sought to examine how understandings of language and literacy contributed to or challenged linguistic and social hierarchies often associated with educational spaces and language-minoritized individuals in the U.S. This study addressed the following questions:

1. What were the language ideologies that influenced the policies and practices which characterized the LP classroom?
2. How did these language ideologies shape which language and

literacy practices were valued in the LP classroom?

3. How did privileging particular language and literacy practices contribute to perpetuating deficit perspectives of the LP students?

Theoretical Framework

Monoglossic Language Ideologies

Kroskrity (2006) defines language ideologies as "beliefs, or feelings about language as used in [a person's] social worlds" (p. 496). However, as Kroskrity explains, for many people, even though language ideologies have a strong influence over how a person views language and its use in society, in many cases people do not recognize their own beliefs about language. Yet, even when not explicitly recognized, language ideologies shape people's understanding of language and literacy (Gee, 2015b).

Of particular interest for this study is the concept of monoglossic language ideologies. García and Torres-Guevara (2009) explain that, "a monoglossic language ideology sees language as an autonomous skill that functions independently from the context in which it is used" (p. 182). The very composition of language is shaped through monoglossic ideologies as language comes to be interpreted as an autonomous and bounded system composed of distinct static sets of codes (Makoni & Pennycook, 2006; Pennycook, 2010). Additionally, through this positioning of languages as distinct and bounded systems, monolingualism becomes constructed as the societal norm where the mixing of named languages is often perceived as unnatural and problematic, a sign of a linguistic deficit (Flores & Schissel, 2014). While prevalent throughout society, monoglossic language ideologies are not simply individual choices or preferences. On the contrary, these ideologies are part of a larger global design that has operated historically to privilege language practices originating from colonial centers over those utilized by colonial subjects, providing a means of hierarchizing society through language (Mignolo, 2012).

In contrast, concepts such as *translanguaging* (García & Leiva, 2014) and *bilanguaging* (Mignolo, 2012) interpret language through a heteroglossic lens. These concepts construct language as something

that "is beyond sound, syntax, and lexicon, and beyond the need of having two languages" (Mignolo, 2012, p. 264). Theorizing her own experiences with language, Anzaldúa (2012) describes language as a "homeland" and makes the claim that "I am my language. Until I can take pride in my language, I cannot take pride in myself" (p. 81). Anzaldúa's ideas emphasize that language is more than grammar and vocabulary and that taking on new linguistic practices constitutes learning to see the world in new ways.

No longer seen as a reified object, language can be understood as a "fluid, complex, and dynamic process" (Flores & Schissel, 2014, p. 461) which is learned and practiced within distinct social contexts and for particular purposes (Johnson & Zentella, 2017). In discussing translanguaging, Sayer (2013) explains that through heteroglossic understandings, "language is a verb rather than a noun, a social act people do rather than a linguistic object that is possessed" (p. 69). Understanding language as a social act that is situated within contexts and social relations allows for the possibility to challenge beliefs in the need to separate languages or the ideological positioning of some practices as the idealized norms that are objectively superior (García, 2019). Analyzing the teaching policies and practices within LP through the lens of monoglossic language ideologies provided the opportunity to understand how language-based hierarchies were being created and maintained within the program.

Literacy Models

Influenced by monoglossic language ideologies, literacy is often conceived of as discreetly bounded, natural systems which exist and operate outside of particular social contexts (Gee, 2015a; Hall, 2005; May, 2014; Moll, 2014). Gee argues that "traditionally literacy has been looked at as primarily a mental phenomenon, the mental 'ability' to read and write" (p. 56). From this perspective, language and literacy are positioned as neutral objects that exist "in a vacuum, detached from social interaction, removed from social and cultural difference" (Wilson, 2000, p. 59) and are understood as universal sets of skills that take place within the heads of individuals (Street, 1997).

This traditional understanding of language and literacy aligns with what Street (1997) defined as the *autonomous model*. In this model, language and literacy are viewed as "primarily a static process that [in-

volves] the reader's knowledge of sound-symbol relationships" (Rivera & Huerta-Macías, 2008, p. 6). This understanding of language and literacy contributes to the creation of idealized practices that are seen as standard and operate with the assumption that readers and writers are neutral, objective, and rational (Scollons as cited in Gee, 2015a), while also constraining the types of practices accepted within formal educational settings (Dyson, 1993).

In contrast, the *ideological model* emphasizes the idea that "literacy is a social practice" with each type of literacy being "embedded in re-lations of power" (Street, 1997, p. 48). With this understanding, learn-ing new language and literacy practices is no longer a matter of trans-ferring discrete sets of codes, but instead involves being socialized into new practices through interactions with more experienced members who serve as mentors (Gee, 2015a; Hernandez-Zamora, 2010; Moll, 2014). Additionally, as social practices, language and literacy are not seen as neutral objects that benefit all equally, as notions of power and how particular practices are valued in society also need to be consid-ered (Gee, 2015b; Janks, 2010). An ideological model brings attention back to the idea that literacy education is a political act (Freire, 1975).

These lenses of monoglossic language ideologies and literacy mod-els provide a means to better understand how language and literacy were positioned within LP and how those beliefs shaped the practices and experiences of its members. Further, these ideas provide a lens to understand which and whose language and literacy practices were accepted and validated within the LP classroom.

Methods

The Story of Language Partners

Language Partners (LP) is a program that started in 2011 follow-ing a proposal by Ramon, an incarcerated individual who was taking for-credit courses as part of a higher education in prison program. Ramon argued that the higher education in prison curriculum should also include educational programming for individuals who wanted to further develop their English language and literacy practices.

Based on this proposal, a group of incarcerated men partnered up with university volunteers to design a program to address the needs

that Ramon had identified. Initially, twelve incarcerated men received training in communicative language teaching and began offering classes in January 2011. At the time of this study, and historically, LP served students from rural Mexico who identified Spanish as their dominant language. Each cohort met for approximately 18 months, a time that was not based on pedagogical goals or benchmarks. During that 18-month period, LP classes met every Tuesday and Thursday with each session lasting three hours. In each class, the peer-instructors were responsible for all teaching related responsibilities: creating lesson plans and activities, assessing students through homework and tests, giving feedback on writing assignments, helping select future students and teachers, and participating in professional development opportunities offered by university volunteers. The peer-instructors predominantly relied on *Focus on Grammar 2: An Integrated Skills Approach* (Schoenberg & Maurer, 2006) as the course textbook which served as the course curriculum.

The Research Team and Research Process

Traditionally, research has been modeled after the premise of outside "experts" who enter into communities to extract data and then retreat to their university or research institution. These traditional models have contributed to a top-down approach to research in which researchers "… observe and describe the world from above, from their own perspectives and categories" (Torres & Reyes, 2011, p. 42). Additionally, due to their formalized training and education, outside researchers are typically positioned as having more insight about the lives and conditions of the individuals they are studying than the people who make up those communities (Caraballo et al., 2017). This top-down research approach that positions community members as objects of study is representative of a "long history of dehumanizing and colonizing methods" which has more often benefited the researcher than the community being studied (Smith, 2012).

Contrary to traditional research methods, this study was organized around the principles of participatory action research (PAR) which shifts research away from being an exclusive practice towards an understanding of research as "tools through which any citizen can systematically increase that stock of knowledge which they consider most vital to their survival as human beings and to their claims as

citizens" (Appadurai, 2006, p. 168). Within PAR, community members become part of the research process as co-researchers, shaping everything from what questions are asked to the actions that are taken based on the research. A central focus of PAR is to "... [initiate] critical changes that produce greater social justice" (Cammarota & Romero, 2009, p. 54), leveraging the research process to directly impact the communities in which research is being conducted.

As a PAR study, the research team was composed of eight incarcerated men who served as peer-instructors in LP and me, a university researcher who had been a volunteer with LP since 2011. Each member of the research team was responsible for designing and implementing the study and analyzing the data. In January of 2017, we began conducting participant and non-participant observations of the classes to better understand our practices and classroom dynamics, observing almost every class session between January and May of 2017. Observation notes were rewritten into detailed field notes and distributed to all members of the research team to provide more opportunities for shared knowledge (Cammarota et al., 2016). During this period, we also collected class assignments, classroom handouts, and samples of student work to begin documenting the typical classroom practices and to get a sense of the underlying beliefs which shaped LP.

As a research team, we met monthly to consider what we were learning about our program. This first stage of analysis was guided by two lists of characteristics: "What LP is" and "What LP should be," which the group developed prior to the start of observations. These lists served as start codes, guiding both our observations and the initial stages of analysis. These monthly data analysis meetings provided the opportunity to engage in an iterative process of data collection and analysis, allowing us to reconsider the data that we were collecting, refine the questions that we were asking, and look for additional data that would further complicate our understandings of LP and the experiences of its members (Bogdan & Biklen, 2007; Lincoln & Guba, 1985).

This initial stage of classroom observations and data analysis led us to conduct in-depth, semi-structured interviews with 16 students, 10 instructors, and 5 volunteers. As a team we developed interview protocols for each group of LP members. These interview protocols were intended to provide an opportunity to create conversation about

the interviewee's experiences in LP and what LP represented to them (Dyson & Genishi, 2005). Therefore, even though the interviews were guided by the protocols, interviewers could also explore topics that emerged during the interview (Kvale, 1996). As with the observation data, we continued to meet monthly to discuss and analyze the data throughout the interview process.

Findings

Autonomous Literacy Model

Influenced by the course textbook, classroom observations revealed a curriculum that was built on an autonomous model of literacy in which language was abstracted from particular social contexts and taught in isolation (Street, 1997). When describing the LP curriculum, both volunteers and instructors pointed towards the course textbook, Focus on Grammar (FOG) (Schoenberg & Maurer, 2006), describing it as the de facto curriculum. Angel, an instructor, explained that the students' needs were "supposed to drive the curriculum but they don't really. What drives the curriculum is the next unit in the FOG book." In fact, each semester began with a planning meeting during which a semester calendar was created, outlining the class dates and the corresponding FOG unit that would be taught on each night. This calendar would be passed around the room and each instructor would select the unit that they would be responsible for teaching.

Hugh, a volunteer, described FOG as "a tool that predisposes [instructors] to engage in bad pedagogical habits" referring to how "it is easy to think that you are teaching language when you have a grammatical syllabus." Amber, another volunteer, shared similar concerns about the influence of the textbook when explaining that some of the lessons that she thought were the least enjoyable to observe were "… grammar heavy lessons which focused on rules and charts on the board," which, according to her, were not rare. This grammatical focus served as the curriculum but also shaped perceptions of what counted as language and literacy.

Multiple students communicated their appreciation for the textbook because they felt it provided a pattern of how to correctly write sentences and use the grammar. During interviews, both Manuel and

Carlos identified the grammatical charts as one of the most useful tools for learning English. Gilberto also found the grammar presentations in the book helpful, explaining that he could just follow the pattern in the book, and he would know what he needed to do. Ruffo went as far as equating the textbook to having another teacher and explained that he especially liked the activities in FOG which required him to unscramble sentences and the charts which outlined subject and verb agreement. To each of the students, the textbook served as an authority in the classroom, presenting what was supposed to be the idealized, grammatically "correct" way to construct sentences in English.

Many of the instructors also viewed the FOG textbook as a representative model of English. Following a series of activities that deviated from the textbook, Raphael expressed concern. Reflecting on his own experience as a student, he explained that FOG helped him to "use the correct word." He was concerned that using the book less would hinder the students from learning the forms and rules. Miguel added that he and Felipe had shared similar concerns in a conversation they had prior to the meeting. The FOG textbook was considered an authority which was supposed to help the students learn what was considered the ideal or correct English through the teaching of isolated grammatical rules, mostly based on the sequence laid out in FOG.

Restricting Language Practices

Language ideologies also operated in such a way that teachers attempted to restrict which language practices were permissible in the LP classroom. The classroom was framed as an official space in which only "standardized" English was appropriate and as such a space, the use of Spanish by the students was highly discouraged and monitored.

The appropriateness of Spanish in LP had been an ongoing debate in the years prior to the study with many instructors and volunteers arguing the presence of Spanish would hinder the students' development of English language practices. During a discussion in a for-credit course about the intersection of race, language, and education, Miguel and Joseph, two LP instructors, repeatedly referred to Spanish as a "crutch" and argued that students would never learn English if they always relied on Spanish. These claims reflect what Martínez (2010) argued has been "the default motivation for code-switching in the

popular imagination," attributing code-switching to "gaps in vocabulary, lack of education, improper control of language, and/or an overall lack of proficiency in one or both of the languages in question" (p. 126).

During a study planning session, Michael, another instructor, also expressed concerns over the use of Spanish. After referring to Spanish as a crutch, he explained that too often the teachers would "bail" to Spanish if the students did not understand. This theme continued in his interview where he claimed being open to allowing Spanish to be used in the classroom for teaching but thought it should be a last resort saying, "Try once in English, try again in English, and try a third time in English. If that doesn't work, then maybe try Spanish. But don't go directly to Spanish." In LP, Spanish was viewed as an obstacle, not an asset that would contribute to the students building additional language practices

This belief that Spanish could not be used to aid the students' development of English also surfaced through the policing of language use in the classroom. This linguistic policing was exemplified in an interaction between Eduardo, at student, and Miguel, an instructor. Just prior to this exchange, Eduardo was working with a partner to organize verbs as part of a pronunciation activity. While Eduardo's partner was at the board, he wrote a verb in the wrong location, leading Eduardo to interject and initiate the following exchange.

Eduardo: Otro lado. (telling his partner to write the verb in a different category)

Miguel: You said the other side.

Eduardo: (smiles and speaks English)

Miguel's statement indexed the classroom policy restricting Spanish, a message that was received by the student as evidenced through his decision to return to speaking in English. However, minutes later Miguel said, "Habla español si tú quieres." when telling the students to take a break. Miguel's actions limited when Spanish could be used, defining a linguistic border between academic and social spaces (Urciuoli, 1996). While Spanish was not permitted during official instructional time, it was permissible to utilize Spanish during the break, which was mostly spent outside of the classroom in the hallway.

The English-only policy was so prevalent that even LP volunteers who did not have experience teaching ESL were socialized into the

practice of enforcing it. Sheri-Lynn, a volunteer, explained that "nobody ever explicitly told me about the English-only rule. I inferred it from watching the classroom and had seen other [volunteers] shush students." Based on her observations, she participated in "shushing" students for using Spanish in the classroom. She explained that although she was not sure why the policy existed, as the only volunteer without a background in linguistics or language teaching, she assumed that the teachers and other volunteers were experts and knew best. Over time, she became more uncomfortable with the policy, but her experience is revealing of the dominance of the English-only ideologies in LP.

Impacts of Narrow Curriculums

Students Limited from Engaging in Content

While the curriculum was predominantly based on the FOG textbook, there were times when teachers attempted to "teach critical pedagogy" through building lessons around topics they felt connected to the students' lives. However, in the context of an English-only environment, this proved problematic, and the students' English proficiency was often a concern when choosing topics. Joseph shared a lesson he was planning focused on alcoholism, a topic which he felt affected many of the students personally because of their own addictions or because they had family members who struggled with alcoholism. Sharing his concerns, he stated, "I hope it doesn't seem like I have low expectations…" and went on to explain that he thought the vocabulary necessary for the lesson would be too "specialized." Even though Joseph felt the topic was relevant to the students, he could not imagine how they could possibly engage with the content because the language was more "advanced" than the decontextualized grammatical focus that the students typically experienced with the FOG textbook.

Other teachers shared similar concerns. Alex, a former LP student who became an LP instructor, recalled talking to one of his LP instructors and requesting a biology lesson. That instructor told him that it was not possible to teach a biology lesson because "the vocabulary would be too hard." Now as a teacher, Alex said he understood the instructor's response because he also thought the vocabulary would

be too difficult for the students. Orlando also lamented how difficult it was to design lessons relevant to the students' lives. In a message posted to a public forum used by LP volunteers, a volunteer described a conversation with Orlando that, in part, focused on "the special challenges of trying to plan such lessons among students with such uneven (English) speaking and writing skills." Though Orlando, and other instructors, believed it was important to engage the students in content-focused lessons which were designed to connect to their interests and experiences, adherence to English-only policies limited the students' ability to fully participate.

Throughout the interviews, many students expressed frustration that they could not share more of their ideas because they were not allowed to use Spanish. Raul described trying to get help in class, especially at the beginning of the program, through asking questions in Spanish but was told to speak English. He said he did not even know how to ask a question in English, which made getting answers very difficult. Oscar explained that he almost quit LP because he was so frustrated with not being able to use Spanish. He said that he "couldn't understand why they didn't get the opportunity to hear the explanation in their own language to help them get a better understanding of the word." Manuel reverted to waiting until class was over to ask his classmates questions back at their cells because he could not ask his questions in English during class. Galan explained, "There were times when the teachers would give instructions and they [the students] were paying attention but not understanding." Oscar also recalled often feeling confused in the class because of the English-only practices. He shared that teachers would be in front of the class for twenty minutes, the whole time speaking in English, and at the end, they would ask if the students understood but he would be so confused that he would not even know what to ask.

Representative of Oscar's experience, during a class session, Miguel reprimanded the students for not completing their homework by emphasizing, "You will only get out of the class what you put in" and then reiterated the importance of completing their homework. As the class moved on, Pablo, an instructor, sat and worked with one of the students who had not completed the homework. This student explained that he did not know what he was supposed to do. Miguel later shared that he had explained the instructions multiple times and

gave examples but only in English. For at least this student, the failure to complete his homework was a function of the English-only classroom policies which made it difficult, if not impossible, for him to understand the directions that were being given in class.

In their interviews, students acknowledged that they were supposed to be learning English but could not understand why they were not allowed to help that process through using Spanish, especially when they were confused or trying to ask a question about the content of the class. English-only policies limited the content that could be incorporated into the class and the ability for the students to participate in the ways that the instructors expected.

Engaging in Situated Literacies

Although in the LP classroom language and literacy were typically positioned as isolated sets of grammatical rules and skills, outside of class, students engaged in language and literacy practices that were much more situated. In response to a question in class asking students to share ways they saw their English improving, students gave examples of these situated practices. Students described reading the newspaper, watching TV in English, and speaking English while working or during "rec" time. In fact, some of these practices were happening before these individuals even became LP students. During the LP application process, Alex described how he would watch TV and identify language that he did not understand. He explained that while watching TV, "I also write what I understand. And the words that I don't understand. I look in the dictionary." Alex added that he felt learning English through watching TV was helpful because it replicated "real life situations." Each of the strategies employed by the students focused on learning English practices within social contexts.

At times, even correctional officers became unknowing allies to the students. Angel, an instructor, shared how impressed he was with how much Martín had improved his English and attributed it to his new job in the prison. Martín had been working in the "hub," the space in the center of each X-shaped prison block where the officers controlled the cell doors. Angel explained that Martín "was really being forced to learn and use the language" because of his job. These interactions with the officers provided Martín access to language models upon which he could expand his abilities.

Still for other students, engaging with language and literacy outside of the classroom was not only about further developing their practices but was also a means of materially impacting their situations. Students looked to commodify their developing practices, which was predominantly accomplished through the creation of various forms of greeting cards that were produced by the students. Evidence of this art-based literacy practice first surfaced during a meeting between instructors and volunteers. During the meeting, a hand-drawn card created by one of the LP students was given to a volunteer who was leaving the program. In addition to an ornately drawn peacock on the front of the card, the words "Thank you" were written across the bottom in addition to a thank you message on the inside (Image 1).

These cards were not only artistic but were also examples of how students were engaging in situated language and literacy practices. Raul explained he would create them for any occasion and that most

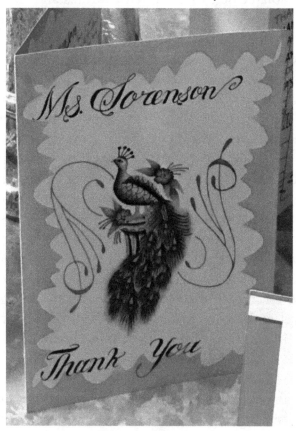

Image 1. Hand-drawn Card from an LP Student

of them were in English. Laughing, Angel confirmed that most of the cards that he had seen from the LP students were in English. He said he did not know how, but "the students find the language that they need." Indeed, Raul shared that when he first started making the cards he would have to ask people what to write and they would write it down for him; "I love you" or "I miss you." However, over time he learned enough about the literacies associated with the different cards that he did not have to ask anymore.

While these cards provided an opportunity for the students to further develop their language practices, this was not the students' central motivation in creating the cards. Raul referred to the greeting cards as his "business" because he "sold" them in the prison to help supplement his income while incarcerated. While they were not actually able to exchange money, commissary items substituted as the prison currency. A small card could usually be exchanged for about two dollars' worth of commissary items, but a larger card could earn up to five dollars.

These unofficial "businesses" were vital to the men being able to obtain everyday necessities such as soap, shampoo, deodorant, toothpaste, laundry soap, and a host of other items that were not provided by the prison and had to be purchased at the prison commissary. Raul explained that he did not have any financial support from his family, a trend that was common among many of the LP students because their families were in remote areas of Mexico, which made it difficult to add money to their prison accounts. Even if a student were able to secure a job in the prison, which typically paid fifteen dollars per month, it was not sufficient to cover the cost of the necessary items. The greeting cards served as means of providing for the students' material needs while also serving as a mechanism for building their language and literacy practices.

Contrary to how language was positioned in the LP classroom as a reified object composed of isolated grammatical, phonological, and lexical components, outside of the classroom students' language practices and development were situated within particular contexts and connected to their daily experiences and needs.

Implications

Each of us were involved in this research and cared deeply about the LP program. Our commitment to this program and our desire for it to

be a "liberatory" space is what drove us to conduct this research in the first place. The aim in this research was not to validate what we were doing but to critically examine what was being accomplished through LP, and while the mission statement and many of the members described LP as a "reciprocal learning environment" in which teachers, students, and volunteers all learned from each other, the practices and policies employed in LP made it difficult if not impossible to achieve this reality.

Instead of being a liberatory space, in many ways, the LP classroom was an extension of language policy in the U.S., replicating what many racialized children have and continue to experience in public educational spaces throughout the U.S. Historically, language policies have provided the rationale for assimilationist agendas, attempting to move the language practices of racialized individuals towards an idealized or "standardized" English and seeking to eliminate other language practices (García & Kleifgen, 2010; McCarty et al., 2015). Through these processes, the language practices and forms of knowledge that racialized children bring to the classroom have either been excluded completely or devalued in classroom spaces (Avineri et al., 2015; González et al., 2005). Practices and policies similar to those focused on the education of multilingual learners in public K-12 education contributed to the minoritization of the LP students by positioning them as deficient and unable to engage in curriculum that built on their life experiences until they first developed sufficient English proficiency.

Shaped by monoglossic language ideologies with roots in settler colonial histories (Mignolo, 2012), the policies and practices reflected in the typical daily LP experience contributed to rearticulating social and linguistic hierarchies. While literature focused on adult language and literacy education often emphasizes the need to value the life and linguistic experiences of adult students (August, 2006; Bigelow & Schwarz, 2010; Kurvers et al., 2009; Noriega, 2013; Rivera & Huerta-Macías, 2008), this study has demonstrated how these strengths that adult students bring to the classroom are largely erased or silenced through approaches which position language and literacy as autonomous and bounded objects that can be taught in isolation from their social contexts (Valdés, 2015).

Over the course of this study, it became evident that LP was dominated by an approach to English language teaching premised on the

ideology that language could be dissected into linguistic features and taught in isolation. Activities were focused on grammatical, phonological, and lexical units that were neither specifically connected to the students' lives nor the contexts in which they found themselves on a daily basis or even any particular fabricated context designed for the classroom. Instead, instruction often focused on activities that required students to perform tasks such as completing or constructing isolated sentences as a means of practicing and demonstrating their understanding of the targeted linguistic feature. Additionally, informed by English-only pedagogies, instructors and volunteers attempted to restrict the use of Spanish within the classroom space. Students themselves expressed how they were silenced and frustrated by the English-only curriculum because it made it difficult for them to understand directions and explanations or because they were not able to engage in discussions about topics that they found to be more interesting or relevant. Comments such as Orlando's about how difficult it was to practice critical pedagogy, and Joseph's reluctance to discuss alcoholism, underscored how LP's policies limited students' ability to engage with content beyond discrete linguistic units.

Auerbach's (1993) warning regarding English-only pedagogies in adult language and literacy education were borne out in LP. Auerbach cautioned that English-only approaches might actually slow English acquisition because "it mirrors disempowering relations" (p.14) which "may ultimately feed into the replication of relations of inequality outside the classroom, reproducing a stratum of people who can only do the least skilled and least language/literacy-dependent jobs" (p. 22). The LP students felt so frustrated at times because they were not permitted to utilize their full linguistic resources that they contemplated quitting or restrained themselves from seeking help until after class when they could freely talk with their classmates.

Additionally, this study provided evidence of how engaging language and literacy as a social practice could create opportunities in which forms of knowledge that were often pushed to the margins or completely erased could contribute to further developing the students' English practices. In their daily lives, students engaged in their own methods of developing their English proficiency which broke from the curricularized practices experienced in the classroom. Based on how they needed English to navigate their daily experiences, the stu-

dents sought out individuals who served as language models, allowing them to build the English language practices that they felt they needed (Hernandez-Zamora, 2010). These language models contributed to them being able to better interact with prison staff and other incarcerated individuals, but also allowed the students to transform their developing English abilities into economic capital to assist in meeting their needs in prison (Luke, 2004). Through engaging with more experienced English language users, and by focusing on more than learning isolated linguistic features, the students were able to go beyond what they could do on their own, contributing to the development of their own English language capabilities through these interactions and eventually no longer needing to rely on others to support them (Moll, 2014). However, these methods of learning and using English described by the students were often not recognized or valued in the classroom, in part because they did not align with the monoglossic approach to language teaching that dominated the LP classroom and contributed to deficit views of the students.

As Gramsci (1971) has argued, instead of language and literacy being a liberatory mechanism as it is often positioned, historically it has been utilized as an instrument through which hierarchies have been maintained. Whether it be in prison or out, it is important that processes oriented towards challenging hegemonic language ideologies be enacted and understood within the larger historical arc of how language and literacy have been utilized to perpetuate oppressive circumstances and the marginalization of racialized groups. A critical focus, identifying and challenging systemic ways in which power is replicated and maintained, needs to remain at the center of any project that aims to contribute to more equitable educational spaces. Flores (2013) contends, "Rather than treating language use as removed from ideological processes, dynamically lingual education must be centered on a denaturalization process that attempts to make the ideological underpinnings of all language use an explicit part of instruction" (p. 284). Without centering language ideologies and interrogating how language and literacy instruction have historically been utilized in the process of othering, even pedagogies and practices that are believed to be more humanizing, such as drawing from students' lived experiences and language practices, can be co-opted to contribute to a legacy of marginalization (Flores, 2014; Torre et al., 2012).

In similar ways to how a monoglossic, English-only curriculum serves to silence students, a narrow understanding of what "counts" as literacy also contributes to the formation and maintenance of deficit perspectives. The linguistic practices that individuals engage in with their families and in their communities are often dismissed or even blamed for a student's "lack of success" in school (Avineri et al., 2015; Gee, 2015a). This narrow view of literacy leads to a failure to recognize, as it did in LP, the socially situated ways in which students engage with and utilize a variety of language practices. Educators and researchers need to continue to look past the official curriculums and the reified understandings of language or risk missing the ways students are engaging in language practices in their daily lives in order to meet their needs. Failure to see and value these practices contributes to deficit mentalities which pathologize students by blaming them and their communities for not performing and achieving as expected. Further, by being restricted by these narrow curriculums, it is too easy for teachers to turn the gaze towards the students and away from their own practices and decisions, casting blame on the students for "failure" or a "lack of motivation," instead of seriously interrogating how their pedagogical choices in the classroom can privilege a select few students, while failing to meet the needs of the rest.

Jim Sosnowski, Ph.D.

Jim Sosnowski's research interests focus on the impact that language ideologies have on shaping practices and policies in adult language and literacy classrooms. He earned his doctoral degree in Curriculum and Instruction with a focus on Language and Literacy at the University of Illinois at Urbana-Champaign. He is currently the Co-Coordinator of Language Partners, a peer-taught, prison-based adult language and literacy program, which is part of the Education Justice Project, a higher education in prison program.

References

Anzaldúa, G. (2012). *Borderlands / La frontera: The new mestiza* (4th ed.). Aunt Lute Books.

Appadurai, A. (2006). The right to research. *Globalisation, Societies and Education, 4*(2), 167–177. https://doi.org/10.1289/ehp.971051306

Auerbach, E. (1993). Reexamining English only in the ESL classroom. *TESOL Quarterly, 27*(1), 9–32. https://

doi.org/10.1002/tesq.310

August, G. (2006). So, what's behind adult English second language reading? *Bilingual Research Journal, 30*(2), 245–264. https://doi.org/10.1080/15235882.2006.10162876

Avineri, N., Blum, S., Johnson, E., Brice-Heath, S., & Kremer-Sadlik, T. (2015). Invited forum: Bridging the "language gap." *Journal of Linguistic Anthropology, 25*(1), 66–86. https://doi.org/10.1111/jola.12071.66

Bigelow, M., & Schwarz, R. (2010). *Adult English language learners with limited literacy.* National Institute for Literacy. https://lincs.ed.gov/publications/pdf/ELLpaper2010.pdf

Bogdan, R., & Biklen, S. (2007). *Qualitative research for education: An introduction to theories and methods* (5th ed.). Pearson.

Cammarota, J., Berta-Ávila, M., Ayala, J., Rivera, M., & Rodríguez, L. (2016). PAR entremundos: A practitioner's guide. In A. Valenzuela (Ed.), *Growing critically conscious teachers: A social justice curriculum for educators of Latino/a youth* (pp. 67–89). Teachers College Press.

Cammarota, J., & Romero, A. (2009). A social justice epistemology and pedagogy for Latina/o students: Transforming public education with participatory action research. *New Directions for Youth Development, 123*(Fall), 53–65. https://doi.org/10.1002/yd

Caraballo, L., Lozenski, B., Lyiscott, J., & Morrell, E. (2017). YPAR and critical epistemologies: Rethinking education research. In M. Winn & M. Souto-Manning (Eds.), *Review of Research in Education* (Vol. 41, Issue March, pp. 311–336). Sage. https://doi.org/10.3102/0091732X16686948

Dyson, A. (1993). *Negotiating a permeable curriculum: On literacy, diversity, and the interplay of children's and teacher's worlds.* National Council of Teachers of English.

Dyson, A., & Genishi, C. (2005). *On the case: Approaches to language and literacy research.* Teachers College Press.

Flores, N. (2013). Silencing the subaltern: Nation-state/colonial governmentality and bilingual education in the United States. *Critical Inquiry in Language Studies, 10*(4), 263–287. https://doi.org/10.1080/15427587.2013.846210

Flores, N. (2014). Creating republican machines: Language governmentality in the United States. *Linguistics and Education, 25*(1), 1–11. https://doi.org/10.1016/j.linged.2013.11.001

Flores, N., Lewis, M., & Phuong, J. (2018). Raciolinguistic chronotopes and the education of Latinx students: Resistance and anxiety in a bilingual school. *Language and Communication, 62*, 15–25. https://doi.org/10.1016/j.langcom.2018.06.002

Flores, N., & Schissel, J. (2014). Dynamic bilingualism as the norm: Envisioning a heteroglossic approach to standards-based reform. *TESOL Quarterly, 48*(3), 454–479. https://doi.org/10.1002/tesq.182

Freire, P. (1975). Are adult literacy programmes neutral? In L. Bataille (Ed.), *A turning point for literacy: Adult education for development the spirit and declaration of persepolis* (pp. 195–200). Pergamon Press.

García, O. (2019). The curvas of translanguaging. *Translation and Translanguaging in Multilingual Contexts, 5*(1), 86–93. https://doi.org/10.1075/ttmc.00026.gar

García, O., & Kleifgen, J. (2010). *Educating emergent bilinguals: Policies, programs, and practices for English language learners.* Teachers College Press.

García, O., & Leiva, C. (2014). Theorizing and enacting translanguaging for social justice. In A. Blackledge & A. Creese (Eds.), *Heteroglossia as practice and pedagogy* (pp. 199–216). Springer. https://doi.org/10.1007/978-94-007-7856-6_1

García, O., & Torres-Guevara, R. (2009). Monoglossic ideologies and language policies in the education of U.S. Latinas/os. In J. Enrique G. Murillo, S. A. Villenas, R. T. Galván, J. S. Muñoz, C. Martínez, & M. Machado-Casas (Eds.), *Handbook of latinos and education: Theory, research, and practice* (pp. 192–193). Routledge.

Gee, J. (2015a). *Literacy and education*. Routledge.

Gee, J. (2015b). *Social linguistics and literacies: Ideology in discourses* (5th ed.). Routledge.

González, N., Moll, L. C., & Amanti, C. (Eds.). (2005). *Funds of knowledge: Theorizing practices in households, communities, and classrooms*. Routledge.

Gramsci, A. (1971). *Selections from the Prison Notebooks*. International Press.

Hall, C. (2005). *An introduction to language and linguistics: Breaking the language spell*. Continuum.

Hernandez-Zamora, G. (2010). *Decolonizing literacy: Mexican lives in the era of global capitalism*. Multilingual Matters.

Janks, H. (2010). *Literacy and power*. Routledge.

Johnson, E. J., & Zentella, A. C. (2017). Introducing the language gap. *International Multilingual Research Journal*, *11*(1), 1–4. https://doi.org/10.1080/19313152.2016.1258184

Kroskrity, P. (2006). Language ideologies. In A. Duranti (Ed.), *A companion to linguistic anthropology* (pp. 496–517). Blackwell Publishing.

Kurvers, J., Stockmann, W., & Van de Craats, I. (2009). Predictors of success in adult L2 literacy acquisition. In T. Wall & M. Leong (Eds.), *Low educated second language and literacy acquisition*. Proceedings of the 5th Symposium. (pp. 64–79). Bow Valley College.

Kvale, S. (1996). Thematizing and designing an interview study. In *Interviews: An introduction to qualitative research interviewing* (pp. 83–108). Sage.

Lincoln, Y., & Guba, E. (1985). *Naturalistic Inquiry*. Sage.

Luke, A. (2004). On the material consequences of literacy. *Language and Education*, *18*(4), 331–335. https://doi.org/10.1080/09500780408666886

Makoni, S., & Pennycook, A. (2006). *Disinventing and reconstituting languages: Bilingual education & bilingualism*. Multilingual Matters.

Martínez, R. (2010). Spanglish as literacy tool: Toward an understanding of the potential role of Spanish-English code-switching in the development of academic literacy. *Research in the Teaching of English*, *45*, 124–149.

May, S. (Ed.). (2014). *The Multilingual turn: Implications for SLA, TESOL, and bilingual education*. Routledge.

McCarty, T., Nicholas, S., & Wyman, L. (2015). 50(0) years out and counting: Native American language education and the four Rs. *International Multilingual Research Journal*, *9*(4), 227–252. https://doi.org/10.1080/19313152.2015.1091267

Mignolo, W. (2012). *Local histories/global designs: Coloniality, subaltern knowledges, and border thinking*. Princeton University Press.

Moll, L. (2014). L.S. *Vygotsky and education*. Routledge. https://doi.org/10.1017/CBO9781139878357.001

Noriega, D. (2013). *Why no literacy programs for 30 million in U.S.? Remapping Debate: Asking "Why" and "Why*

Not." http://www.remappingdebate.org/node/2138

Paris, D., & Alim, H.S. (2014). What are we seeking to sustain through culturally sustaining pedagogy?: A loving critique forward. *Harvard Educational Review, 84*(1), 85–100. https://doi.org/10.17763/haer.84.1.982l873k2ht16m77

Pennycook, A. (2010). *Language as a local practice.* Routledge.

Rivera, K., & Huerta-Macías, A. (2008). *Adult biliteracy: Sociocultural and programmatic responses.* Taylor & Francis.

Sayer, P. (2013). Translanguaging, TexMex, and bilingual pedagogy: Emergent bilinguals learning through the vernacular. *TESOL Quarterly, 47*(1), 63-88.

Schoenberg, I., & Maurer, J. (2006). *Focus on grammar: An integrated skills approach.* Pearson Education ESL.

Smith, L. (2012). *Decolonizing methodologies: Research and indigenous peoples* (2nd ed.). Zed Books.

Street, B. (1997). The implications of the 'New Literacy Studies" for literacy education.' *English in Education, 31*(3), 45–59. https://doi.org/10.1111/j.1754-8845.1997.tb00133.x

Torre, M., Fine, M., Stoudt, B., & Fox, M. (2012). Critical participatory action research as public science. In H. Cooper (Ed.), *APA handbook of research methods in psychology* (Volume 2, pp. 171–184). American Psychological Association.

Torres, M., & Reyes, L. (2011). *Research as praxis: Democratizing education epistemologies* (M. Torres & L. Reyes (Eds.); 4th ed.). Peter Lang Publishing.

Urciuoli, B. (1996). *Exposing prejudice: Puerto Rican experience of language, race, and class.* Waveland Press.

Valdés, G. (2015). Latin@s and the intergenerational continuity of Spanish: The challenges of curricularizing language. *International Multilingual Research Journal, 9*(4), 253–273. https://doi.org/10.1080/19313152.2015.1086625

Wilson, A. (2000). There is no escape from third-space theory: Borderland discourse and the in-between literacies of prisons. In D. Barton, M. Hamilton, & R. Ivanic (Eds.), *Situated literacies: Reading and writing in context* (pp. 54–69). Routledge.

Chapter 11

Selfies Speaking Out

Detained Youth Narratives Through Embodied Texts

Kristine Pytash and Lisa Testa

Dan McAdams (1993) writes, "If you want to know me, then you must know my story, for my story defines who I am. And if I want to know myself, to gain insight into the meaning of my own life, then I, too, must come to know my story" (p. 11). Our stories have power. They allow us to construct our identities, give us insight into our lives, and allow us to counter false narratives.

Part of the power in our stories comes from how we choose to tell our story. Being able to capture our stories through multiple modes of communication (e.g., image, audio, gesture, etc.) allows us to reveal unique aspects of our identities. Through the combination of image and text, in particular, we can illustrate and demonstrate through visceral means ideas about ourselves conveyed through more than just written language.

In this essay, we detail a composition lesson taught at a juvenile detention center in which youth curated a collection of selfies, wrote reflections about their representation of self, and then wrote "I Used To, But Now" poems. We feature the written reflections and poems from four boys, Lavon, Taka, Nathaniel, and Jay, (all names are pseudonyms) to explore how these four detained youth chose to represent themselves using digital technology and how they used this representation as an impetus for their personal writing.

Perspectives

Youth in juvenile detention centers bear the stigma of negative labels, often viewed as illiterate, or at best struggling readers and writers. While some literacy research has suggested that detained youth are two years behind their peers in literacy achievement, this research is based on standardized reading assessments (Drakeford, 2002), over-simplifying their engagement in literate practices, overlooking their deeply personal literacy practices, and failing to recognize their culturally relevant literacy practices. The result is that literacy becomes positioned as a skill, something they need to acquire, rather than part of who youth are as literate beings. Furthermore, this research creates a false impression that all youth in these settings are unable or un-willing to read or write. This has created educational consequences as education in juvenile detention facilities is characterized as prescriptive, skills-based instruction with a low-level curriculum (Karger & Currie-Rubin, 2013).

Our goal as educators is to push back on these deficit narratives (Kirkland, 2019) and to design and implement learning in detention centers that:

- Espouses research-based pedagogical practices
- Foregrounds youth's communities, cultures, identities, and experiences
- Provides youth opportunities to question, critique, and analytically make sense of their worlds
- Emphasizes literacy as a social and cultural practice that nurtures and supports all learners.

These principles guide our teaching and work with youth in juvenile detention facilities (Pytash, 2013, 2014, 2016; Pytash & Li, 2014; Pytash & Testa, 2019).

For this particular lesson, we were asking youth to consider selfies as a form of composition, using digital technology so that youth could explore how their body might be a composition. The idea behind this aspect of our instruction was grounded in theories that explore bodies as texts as "representations of self" (Perry & Medina, 2011, p. 63). In this sense, we were asking youth to reflect on how they would want someone else to interpret or read their selfie.

Furthermore, we based our teaching on embodied knowing, or

"ways of knowing formed by experiencing the world in a particular body" (Woodard, 2020, p. 7). For example, allowing youth to write about their selfies and their "I Used To, But Now" poems, we were asking them to consider how they have experienced the world because of their bodies. This is incredibly relevant to our work in detention centers as the majority of the youth we work with are minority males who have continually faced marginalization, victimization, and are criminalized because of their bodies.

Designing Identities

The detention facility is located in an urban area in the Midwest. It is a short-term, pre-and post-adjudication correctional facility. Because of the transient nature of youth within the system and because of privacy and confidentiality concerns, the detention center provided demographic data that gives a broad view of youth who have been detained over the calendar year, instead of the specific demographic data for this lesson. During the calendar year in which this program took place, 562 youth were detained with the average daily population consisting of thirty-six youth and the average length of detainment recorded as thirteen days. Of the 562 youth, 107 were female, and of that population, fifty-four self-identified as Black, seven as biracial, one as Native Hawaiian/Pacific, and forty-five as White. Of the 455 males detained, two identified as Asian, 310 as Black, thirty-four as biracial, one as Native Hawaiian/Pacific, and 108 as White.

As educators, we must carefully consider how we position ourselves in contested spaces. We identify ourselves as white female academics and educators. Kristy began teaching a writing workshop at this detention center eight years ago and has developed this space as a site for field experiences for preservice teachers in her education program. Additionally, Lisa began working four years ago with Kristy to design a Summer Learning Institute for youth at the detention center. We have a partnership with the staff, teachers, and guards at the facility. While we have done this work as an attempt to provide detained youth with a voice, we recognize the limitations inherent to working in an institution built on confinement and control. We draw on Milner's (2007) framework to consider our own positionality and to acknowledge that our experiences differ greatly from the youth at the detention center. Additionally, we understand the limitations of

working within the system of the detention center. Hinshaw & Jacobi (2015) argue "however noble the aims and values of our educational programs, they seldom literally 'break down the walls...'" and that we must consider the "extent to which our participation in prison programs makes us complicit in the larger prison-industrial complex" (p. 84).

In this chapter, we detail a lesson that we designed and taught to detained youth, the majority of the youth being minority males. We determined what would be taught and the writing assignments. We acknowledge the contradiction of wanting youth to tell their own stories, and then us writing about their lives and their work. While we would have wanted to write this essay with the youth featured, the rules at the detention center, particularly focused on privacy and confidentiality of youth's identities, precluded us from doing so. Youth do know that we are writing this essay and consent was obtained for their description of their selfie and written work to be published. The four youth in this essay self-identified as Black males, between ages of 15-16. We hope the descriptions of their work, as well as their writing artifacts, honor their representations of self.

The Lesson

While we tend to think of selfies as a relatively new social practice, people have created self-portraits since antiquity. From Egyptian and Greek sculptures to Renaissance painters, artists inserted their likeness into their works that illustrated important moments in history; today's youth may also seek to insert their image into our cultural conversations. We began the lesson by analyzing the photographs of Vivian Myers, an American street photographer who took the majority of her photographs in the 1950's through the 1970's. Her photographs were not published until after her death in 2009. At times, Myers cleverly inserted her likeness into her photos by situating her face in reflective surfaces featured in her photography. The photographs we selected all contained these types of self-portraits.

We used guiding questions to discuss her deliberate, rhetorical choices including:
1. Study the background. What's in the picture that you don't initially see? What does this once-unnoticed detail suggest?
2. What lies beyond the chosen subject—just to the right or the

left?
3. Why is this the way Myers choses to represent herself?

Youth noticed Myers' camera-hidden face reflected on the shining hubcap of a car she photographed. They noticed her stretched shadow looming across a photo she captured of a city scene. We asked students to consider what can we infer about her identity from the ways she chose to insert her image into her photography. Students shared observations that she may have liked being alone, that she was an outsider, and perhaps an "old maid." They provided explanations of how they arrived at those conclusions based on Myers' compositional choices.

We then asked students to take time and consider the aspects of their identities that people don't see and how they might work under multiple facets of identity related to the ideas discussed by examining Myers' self-portraits. We asked youth to consider how they may use Myers' ideas in their own self-portraits or "selfies." Youth then received a tablet to take their own selfie or self-portraits. It is important to note that the tablets did not have access to the Internet, which is strictly forbidden by the detention center. In addition, our responsibility to guard youth's identities was taken seriously and all images were destroyed after the students finished their visual and written compositions.

After youth took their selfies, they had the opportunity to use the digital tools found within the tablets to edit their images by adding filters, changing exposure, and experimenting with saturation of color. Youth then wrote artist statements in which they considered the following questions:
- Explain how this picture represents you.
- What do you want people to know about you from this picture?
- Who would you expect to look at this picture? How do you think they would understand it?
- Give it a hashtag; why that hashtag?

Finally, we wanted students to have an opportunity to write as a way to present another genre representing their identities. We decided to teach students the poem style, "I Used to, But Now" as an option for

structuring their poems; however, students were allowed to write in whatever style or structure they wanted.

Youth's Selfies and Writing

In this section we provide a description of each youth's selfie with their written explanation of their rhetorical decision making. Our goal is not to provide an analysis of their selfies or writing, but rather presenting what they did and wrote so that we aren't interpreting their intent. Therefore, we want the descriptions of the images and their own words to speak for themselves. We include their poems immediately following the description of their selfie.

Lavon. Lavon positioned his tablet on the table in front of him so that he was looking directly down at the camera. After taking his selfie, he used the filters on the tablet to bleach out the background and lighten aspects of the picture. He explained, "I created an all-white background and I am looking down at the camera. You can only see parts of my face because the lights are bright. It's like I'm going into the light of stars." When asked what he wanted people to know about him from this picture, he responded, "I was in jail, but nothing can change how you view yourself." The hashtag for his selfie was #gotothelights.

By: Lavon

I used to have friends
But now I keep to myself
I always fall
But I never lay down
I once needed people
But now I can take care of myself
If I could go back in time
I would stop myself from coming here
I never talk about my feelings
But I might make you understand
I used to talk a lot
But now I chill
I can't do 100 push ups

But I can do 65
I won't give up
But I might lose

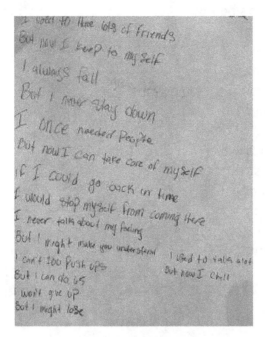

Image 1. Lavon's Poem

Taka. Taka decided to take a picture of himself smiling. Similar to Lavon, he used filters and digital tools to manipulate the lighting in his selfie. He blurred the background so that his face is the only clear image in the photo. Additionally, he used filters to make the lighting of his face more vivid. He explained:

I blurred the background of the jail. I focus on myself in the picture to show me more than my background. I want to show that I keep a smile on my face. I made myself look light because I am trying to show that I focus on the light of myself.

Taka wrote that he wanted to show people that no matter what he keeps a smile on his face and his hashtag was #keepyourheadup. He explained that "even in the worst circumstances, I keep my head up."

By: Taka

I used to always be mad
But now I try and stay happy.
I always yelled
But I never laughed
If I could I would go to the past
I would change my future

I can't trust a friend
But I can trust my family
I won't give up
But I might do better
I used to have zero points
But now I have 34

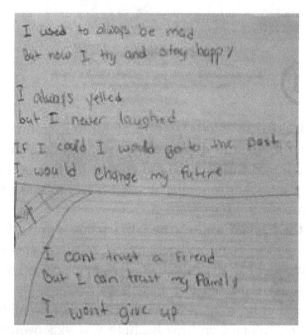

Image 2. Taka's Poem

Nathaniel. The windows of the classroom have bars but look into the detention center's community garden. For his selfie, Nathaniel decided to stand in front of a window so that the image captured both

the bars and also the plants outside. He wrote, "Plants grow like I grow. Green, healthy, strong, bright, and beautiful." He explained that he positioned himself in this way to show that "people can grow, be healthy and strong." Additionally, he wrote, "I am happy and strong."

By: Nathaniel

I used to hurt… But now I am heard
I always… laugh… But I never smile
I once was happy. But now I am down
If I could I would bring good times back.
I never bend break or fold
But I might fall
I can't fly to heaven
But I can imagine the gates
I can't think
But I can learn
I won't drown
But I can swim
I used to crash
But now I have to continue.

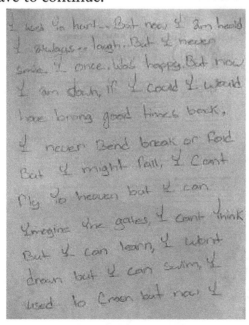

Image 3. Nathaniel's Poem

Jay. Jay positioned himself in front of the classroom wall with student work displayed in the background. He explained that his decision was based on the fact that "I am in jail." He is smiling in his selfie "because I am a nice person." And he intentionally only showed half of his head, as he explained, "Only half of my hair is showing because it's not finished getting braided." He wrote that he wanted people to know that "no matter what goes on in life, I'm going to smile," and his hashtag was #nomatterwhatlifegoeson to emphasize that he was still living his life even while detained.

By: Jay

I used to go crazy, because I am in jail.
But now I just isolate myself to think.

I always talk to people.
But I never tell people my personal business.

I once cried,
But now I hold it in,

If I could leave and go home,
I would go home and never come back,

I never gave up
But I might stumble,

I won't stop
But I can go,

I won't fall,
But I might trip

I used to crash out,
But now I think more

Image 4. Jay's Poem

Considerations

Woodard and colleagues (2020) write, "recognizing the ways that adolescents' writing is embodied can provide insight into how writing is composed, why it is composed, and most important—what kinds of work it accomplishes" (p. 28). Having students compose selfies allows them to materialize their identities. Using their bodies as texts, allowed them to compose in ways that intentionally positioned their bodies as part of the meaning-making activity. Their selfie compositions had an intended purpose and audience, even though their audiences were a hypothesized one as the boys knew the images were being deleted.

Each boy designed their selfie considering how they wanted others to perceive them and considered what tools might help them convey their intended message. For example, Taka used the gesture of smiling to show people that he is positive even while detained, while Lavon used the filters to brighten the light on his face to show how he still views himself in a positive way. Nathaniel and Jay both considered the space of the detention center to highlight something about themselves. For example, Nathaniel standing in front of the window highlighted both the bars in the window and the plants outside. He wanted to juxtapose being in jail with still growing "strong" and be-

ing "healthy." And Jay stood in front of the wall to show the jail but smiling to show that no matter what happens to him, he will still be smiling. Additionally, Jay shielded the part of his hair that wasn't yet braided. In a side conversation, he told Lisa that he didn't want to feature that side of his head because "my hair looks bad." Even though he knew the selfies were being deleted, he seemed to see a sort of permanence in the photo and wanted to preserve a particular image of himself.

As we consider youth's bodies as texts, it is critically important that we consider the ways youth are positioned by and because of their bodies, particularly those youth who have been criminalized and victimized because of their bodies. Rios (2007) reminds educators that in "black and Latino communities, mass incarceration has become a youth phenomenon" (p. 18) as youth of color, particularly black males, are more likely to be arrested, charged, and receive harsher sentences than other populations of youth. In addition they are more likely to be tried as adults and incarcerated by adult courts (Brinkley-Rubinstein et al., 2014; Leiber & Fox, 2005; Noguera, 2003).

Woodard et al., (2020) write, "researchers' turning of their gaze toward youths' bodies is fraught with issues of power and ethics, particularly for White researchers engaging with youth of color" (p. 27). As educators, our long-term partnership with this particular space has provided us long-term relationships with many of the youth forced into this space. For example, we had the opportunity to work with these four youth throughout the Summer Learning Institute that we facilitate at the detention center. However, while our educational initiatives in this space are working to enrich the education in detention centers, we recognized that working to "improve the conditions" of education in detention centers "is not the same as, and may in fact be in direct opposition to, working to abolish the modern prison system" (Hinshaw & Jacobi, 2015, p. 84). Additionally, we recognize that Black males are marginalized so they cannot be seen, and that prison is the ultimate way our society does this. So, it was with caution that we implemented this lesson, particularly as these youth were in a space under confinement and control.

Rule (2018) contends that "writing activity is never not emplaced" (p. 404) as we recognize the importance of the space where the composing process occurs. In this study, the detention center served as

the backdrop physically for their selfies, but also a metaphor that the youth were intentionally working to counter. For some youth, such as Taka and Lavon, it was the perception of what they should be like in this space that they wanted to challenge and did so through their selfies. Nathaniel and Jay intentionally used the detention center walls, windows, and bars to make a statement about their own identities. The detention center served a dual role in that it became a material that they used to compose, while also serving as material for what they were composing. Their selfies sought to oppose the stereotypes they thought were associated with being detained. Their poems further contest the stereotypes. Lavon, Taka, Nathaniel, and Jay's selfies and poems address prison as a type of metaphor for how society has categorized them and how they resist these labels by composing selfies, hashtags, and poems that allow them to decide how they want to be positioned.

Furthermore, their poetry writing was drawn from their selfies. The "I Used to, But Now" poem structure positioned students to engage in identity work as they had to consider past-selves and reconsider current-selves, and in some instances consider "hoped-for selves" (Meek, 2011, p. 942). Meek (2011) writes that "possible selves are imagined scenarios for the self in the future and include hoped-for selves (selves that one would like to become), feared selves (selves that one is afraid of becoming) and expected selves (selves that one expects to become in the future)" (p. 942). In their poems, they included a thread of continuity from their past, present, and future; often within this posing was a realization tied to their time in the detention center.

Conclusion

When youth in educational settings are positioned to have ownership over their literacy practices, then literacy becomes a means for youth to engage in identity construction, reconstruction, and social positioning. This is especially important for the ways that literacy is taught in juvenile detention centers. Abrams and Hyuan (2009) contend that youth hold on to their prior identities as a means of self-preservation while detained or incarcerated. While we do not know for sure, the selfie activity may have provided a respite for some, however, brief from the positioning they experience while detained as they had the opportunity to express how they want to be seen, rather than how

others might see them. We argue that literacy instruction in detention centers should provide youth opportunities to compose their identities, push back against false narratives, and tell their stories.

Kristine E. Pytash, Ph.D.

Kristine E. Pytash is an associate professor in the School of Teaching, Learning and Curriculum Studies at Kent State University where she coordinates the Integrated Language Arts program. Her research focuses on the literacy practices of youth in juvenile detention facilities, in addition to how teachers learn to teach writing and the intersection of technology and literacy instruction. She published *Writing from the Margins: Exploring the Writing Practices of Youth in the Juvenile Justice System*. Her program Designing Identities (with Dr. Lisa Testa) won the Director's Award for Programming in Juvenile Detention Centers from Ohio's Department of Youth Services.

Lisa Testa, Ph.D.

Elizabeth "Lisa" Testa is an associate professor in the School of Teaching, Learning and Curriculum Studies at Kent State University where she coordinates the Masters in the Arts of Teaching program. She teaches both undergraduate and graduate coursework on teaching and learning, as well as courses in English education and literacy. She works closely with many local K-12 partners, providing opportunities for pre-service teachers to gain clinical field experiences in secondary schools. Her research interests include studying teacher education and pre-service teachers' conceptions of teaching writing.

References

Abrams, L. & Hyun, A. (2009). Mapping a process of negotiated identity amongincarcerated male juvenile offenders. *Youth and Society, 41*(1), 26-52.

Brinkley-Rubinstein, L., Craven, K. L., & McCormack, M. M. (2014). Shifting perceptions of race and incarceration as adolescents age: Addressing disproportionate minority contact by understanding how social environment informs racial attitudes. *Child and Adolescent Social Work Journal, 31*(1), 25-38.

Drakeford, W. (2002). The impact of an intensive literacy program to increase the literacy skills of youth confined in juvenile corrections. *The Journal of Correctional Education, 53*(4), 32-42.

Hinshaw, W. W., & Jacobi, T. (2015). What words might do: the challenge of representing women in prison and their writing. *Feminist Formations, 27*(1), 67-90.

Karger, J. & Currie-Rubin, R. (2013). Addressing the educational needs of incarcerated youth: Universal design for learning as a transformative framework. *Journal of Special Education Leadership 26*(2), 106-116.

Kirkland, D. (2019). *No small matters: Reimagining the use of research evidence from a racial justice perspective.* Retrieved from: http://wtgrantfoundation.org/digest/no-small-matters-reimagining-the-use-of-research-evidence-from-a-racial-justice-perspective

Leiber, M. J., & Fox, K. C. (2005). Race and the impact of detention on juvenile justice decision making. *Crime & Delinquency, 51*(4), 470-497.

McAdams, D. P. (1993). *Personal myths and the making of the self.* The Guilford Press.

Meek, R. (2011). The possible selves of young fathers in prison. *Journal of Adolescence, 34*(5), 941-949.

Milner IV, H. R. (2007). Race, culture, and researcher positionality: Working through dangers seen, unseen, and unforeseen. *Educational researcher, 36*(7), 388-400.

Noguera, P. A. (2003). The trouble with black boys: The role and influence of environmental and culture factors on the academic performance of African American males. *Urban Education, 38*(4), 431-459. https://doi:10.1177/0042085903254969.

Perry, M. & Medina, C. (2011). Embodiment and performance in pedagogy research: Investigating the possibility of the body in curriculum experience. *Journal of Curriculum Theorizing, 27*(3), 62-75.

Pytash, K. E. (2013). 'I'm a Reader': Transforming Incarcerated Girls' Lives in the English Classroom. *The English Journal, 102*(4), 67-73.

Pytash, K. E. (2014a). 'It's not simple': The complex literate lives of youth in a juvenile detention facility. In P. Dunston, L. Grambell, K. Headly, S. Fullerton, & P. Stecker. *63rd Yearbook of the Literacy Research Association.* Altamonte Springs, FL: Literacy Research Association pp. 216-228

Pytash, K. E. (2016). Composing screenplays: Youth in detention centers as creative meaning-makers. *English Journal, 105*(5), 53-60.

Pytash, K. E. & Li, J. (2014b). Youth's dispositions towards writing in a juvenile detention center. *The Journal of Correctional Education, 65*(3), 24-42.

Pytash, K. E. & Testa, E. (2019). Interrogating influence: Leveraging the power of social media. *English Journal, 108*(5), 39-45.

Rios V. M. (2007) The Hypercriminalization of Black and Latino male youth in the era of mass incarceration. In M., I. Steinberg, K. Middlemass (Eds.), *Racializing Justice, Disenfranchising Lives.* The Critical Black Studies Series. Palgrave Macmillan.

Rule, H. J. (2018). Writing's rooms. *College Composition and Communication. 69*(3), 402-432.

Woodard, R., Vaughan, A., & Coppola, R. (2020). Writing beyond "the four corners": Adolescent girls writing by, in, from, and for bodies in school. *Journal of Literacy Research, 52*(1), 6-31.

Chapter 12

Not Always "Being Bad"

Reading and Writing Under Strain

Charity Embley and William Toombs

We often consider adult literacy a malady, categorizing individuals as being "literate" or not (i.e., high school graduate versus high school dropout), an assumption based on academic assessments used to categorize their literacy skills. Although well-meaning in their approach because such diagnostic assessments (e.g., BEST Plus 2.0, Test of Adult Basic Education) could provide resources to meet the diverse needs of adult learners, if an adult is not fluent in the English language, we assume that this person is not literate enough (i.e., low language proficiency) to read, write, and speak in English. On the contrary, adult English Language Learners are quite accomplished in their own right, and in their own native language.

Prison inmates, on the other hand, have their own diverse needs based on their experiences. In data collected by the Program for the International Assessment of Adult Competencies (PIAAC) in 2014, 1,300 adult inmates, ranging from the ages of 18 to 74 in prisons across the United States, were assessed in literacy, numeracy, and problem solving (National Center for Education Statistics, 2016). The broad range of abilities of prison inmates were compared to the general/household population of U.S. adults. In particular, the PIAAC data reported the proficiency levels for literacy in the following levels: below level 1, level 1, level 2, level 3, and level 4/5 (National Center for Education Statistics, 2016). For instance, level 1 indicated the proficiency level of prison inmates who are not able to compare and contrast, while a level 2 indicated skills in identifying information from

a document. The PIAAC results demonstrated that there were, "no significant differences [measurable differences] in the literacy skills between the prison and general populations...[especially] prison and [general] household populations for Black adults, Hispanic adults, and adults at the same level of educational attainment" (National Center for Education Statistics, 2016, p. 5). This data alone tells us that prison inmates have literacy experiences prior to their incarceration that were developed from their previous schooling and previous employment. Thus, the performance of prison inmates from the PIAAC study could mean that their literacy reflects the types of challenges they encountered in their lives, which could be similar or different from the general/household populations in the U.S.

We want readers to know that assumptions on adult literacy in terms of being "literate" or not are misleading. Whether one is reading or writing in a different language, or is incarcerated, makes no serious difference in how adults approach reading and writing because these experiences are based on the demands of daily life. What is important is the effort of adult learners to read, write, and connect these experiences. Schwan (2011) even indicates that reading and writing in prisons helps prison inmates re-evaluate and reconstruct their lives. In other words, there is a distinct coping factor in reading and writing while incarcerated. Such an impact can be positive in terms of recidivism and how society can benefit as a whole (Schwan, 2011).

The following narratives of Dee and Frank are glimpses of how they approach reading and writing while incarcerated. Their literacy experiences may or may not resonate with the general public but they should definitely be acknowledged. If we fail to acknowledge the complexity of literacy challenges represented by both Dee and Frank, we may not be able to discover solutions to address these challenges.

The stories and ideas that follow were collected as part of two separate studies. Dee's (pseudonym) story was part of data used in a year-long narrative inquiry conducted on the literacy of sexual assault survivors. Dee was one of the participants in that research. Frank's (pseudonym) story was part of an informal query on the life and literacy of male incarcerated individuals in relation to an education module on delinquency. Further information on Frank's incarceration experiences was gathered solely for this chapter. The use of the term "inmates" was referenced by Dee and Frank. This was a term they

recognized as a description of themselves and the individuals in their prison campus.

Dee's and Frank's Story

Dee

Dee's life story is one that is probably made for the books. Dee was raised in an urban city in Texas by her grandparents because of an absentee mother. Her grandfather had a day job but was a bootlegger at night. Her grandmother was a homemaker and was a stern disciplinarian. Dee started drinking when she was 15 years old. As a teenager, she skipped school to drink at the park with her friends and snuck out from home every night. She eventually got tired of sneaking out, so she dropped out of school and married Joe (pseudonym). Joe wined and dined her when they dated. He would buy her candies and gifts. He even asked her grandmother before he could take her out. He was just an all-around nice man. After they married, Dee enjoyed her lavish lifestyle as a housewife. She was getting everything she wanted. She remembered wearing blue fox sequined dresses and expensive jewelry. However, six months later, Dee's suspicions were confirmed. Her husband was one of the biggest drug dealers in town. She was also six months pregnant. Moreover, Joe became abusive to Dee. Although their first two years were blissful, Joe became a monster. He was addicted to "speed bumps" (a combination of cocaine and methamphetamine).

All throughout her 11-year marriage with Joe, Dee was in and out of prison. She went to the state jail in Dallas for a year and then the Texas Department of Corrections (TDC) for another three years. After Dee's release from the TDC, she was on parole for the next two years, but everything stopped in 2011 when Dee cleaned up her act. After being incarcerated over 30 times in her lifetime, she realized that she had to do something to make life better for herself. Dee was uncertain if she was satisfied with the way things were or if she should go back to school, but after her parole officer suggested taking computer classes, Dee knew she wanted more.

Frank

Frank is a rather quiet, withdrawn man who avoids crowds at all costs. After graduating from a rural high school in Oregon, Frank went straight to work full time. He spent most of his life as a laborer, working primarily in the potato and onion fields or in a large frozen food packaging plant near the edge of town. At one point, he was married and raising five children in a quiet town in Idaho. Everything seemed rather normal until he began to have run-ins with the law. Starting around 2008, Frank began a roughly ten-year series of going in and out of incarceration in county facilities. The strain of serving time and placing whatever semblance of a life on the outside on hold led to his divorce, loss of employment, and declining mental health. Frank always seemed to come out of his stints with a new outlook on life and almost always a new "hero" who he credited for his newfound philosophy.

The circumstances that led to Dee's and Frank's incarceration and how they experienced incarceration were different. While incarcerated, Dee and Frank also had different experiences in relation to reading and writing. This essay explores the role reading and writing played in their lives throughout incarceration and after. In addition, prevalent underlying themes are examined in using their literacy skills while incarcerated.

Life and Learning Opportunities During Incarceration

Dee

Looking back at her incarceration experiences, Dee described prison life as "hellish." During her stay at the Texas Department of Corrections (TDC), there was noise, drama, and chaos every day. Inmates were fighting with each other; some were slitting their own throats because their girlfriends were going home to their husbands. Some were, "plain idiots," according to Dee.

While incarcerated at the TDC, Dee was assigned two jobs. One was in the kitchen serving food, washing dishes, serving the line, or whatever they wanted her to do in the kitchen; and the second was cutting grass in a field. The group that cut grass was called the "hoe

squad." The "hoe squad" was told to run to the field, pick up rocks, chop weeds at a certain pace (i.e., reciting "one on one, hoe squat, and chop") or whatever was in the field. The squad recited numbers so they could get into a rhythm of cutting grass lane by lane. After time was up, inmates had to run back quickly or else they got written up. Dee explained that there was this particular guard who refused to give them water after long exposures under the sun. She said that this guard was "a cruel mofo and it was against the law, too." One time, during "hoe squad" work, she almost passed out. Two inmates on each side lifted her under her arms and helped her stand up. If they had not done this, the whole squad would have received severe punishment.

According to Dee, food was better at the TDC than at the county jail where she was before being moved to TDC. While at the county jail, she found a maggot in her food. When she asked the captain, "what is this shit," they simply laughed at her, took her plate, and gave her a new one. While at the TDC, Dee recalled having eggs, cereal, coffee, and apple sauce all the time. The people who had money for commissary were better off eating in the commissary. If you have money, "you can buy chips, tuna - which was better than the single egg they serve us," according to Dee.

Dee also hated being in a place with other inmates who did not practice good hygiene. Some laid down for days without showering. For starters, nearly all inmates lacked enough money to buy personal hygiene products. The majority of the inmates were also too depressed to leave their cells. They did not care about anything or anyone around them. However, Dee found plenty of time to read and write. Reading was a respite from all the drama and chaos she encountered in prison. Whenever Dee read and wrote in prison, she forgot for a moment how lonely she was. It was better than staring into space or listening to other people's drama. People also left her alone if she was occupied with reading or writing.

Other than passing time reading magazines, Dee's time while incarcerated was usually spent attending General Educational Development (GED) classes because it was a requirement for those who had not completed high school. Dee and other inmates headed to a specified classroom to review for the GED test every Monday, Wednesday, and Friday morning, usually for an hour. Inside the classroom, Dee explained they had workbooks they followed during GED classes.

While in class they could use pencils, but they were not allowed to take anything in and out of the classroom. Dee said, "A pencil, the wire from a spiral, and even paper, because it cuts, is considered a weapon."

In the GED classroom, Dee explained that they would be assigned in groups to study. Dee said, "We would try our best to help each other out" and shared that they had an older lady who was a great instructor and really wanted them to succeed so they could get out of jail. However, Dee felt she could not study further after classes because she could not take anything with her to her bunk. She explained, "If I was lucky to check out a math or reading textbook, then I could study in my bunk." It was simply rare to find a textbook in the cart that was wheeled around because everyone wanted the same books. Dee reiterated: "I wished there were more educational books for us to check out. There were simply not for everyone." Back in her bunk, Dee would try to remember what she learned that day in her mind, recited it quietly to herself, and hoped that she would recall these concepts the next day.

Dee also mentioned finding writing and math incredibly challenging. In writing, Dee could not get the grammar correct. She would get the wrong verb tenses or would forget an adjective to add in a sentence. If she got frustrated, she would ask the GED instructor to help her with grammar. For spelling and definitions, she used dictionaries since she had already learned how to use them when she was in school. Dee said she would often help other people because they did not know how to use a dictionary, or some simply forgot how to use them. She confessed to also feeling very anxious and very fearful of failing. In math, for instance, Dee would work on word problems and equations, get the answer correct during practice, but would blank out during a practice test. Dee explained, "I knew the answer; but I would think to myself, 'what the hell—I'm not good enough!'" She also shared that if she were remembering details about what she was reading in a textbook in her GED class, she would forget right away after she put her textbook down; or if she were recalling what she read from her textbook, there were certain things that would make her recall her past experiences. "I felt I was a bad student," Dee said. She explained that she tried and would tell herself, "I am really doing the best I can—I would say, "I'ma do this!" Dee confided that her fear of failing stemmed from the abuse she experienced when she was a young girl. She associated

studying with her trauma, since her abuse happened during her school years. Often, traumatic memories like Dee's are compounded by fear and low self-esteem (Kellner, 2009: MacFarlane et al., 2002).

Dee wanted to be more educated so she could live a productive life after prison. Dee later confessed that she preferred learning math, science, history, and other subjects in an actual classroom, rather than solely learning how to pass the GED test. She wished to attend night school after her release from prison to complete her high school credits and receive her diploma. Looking back, Dee acknowledged that the only thing she enjoyed in prison was learning. Learning kept her occupied and gave her a reason to continue that learning after she was released. Dee said:

> Learning gave me hope that I could better myself. It seemed fun because it motivated me to try to get out and continue learning - which I did later on. That [learning] kept me out of trouble, instead of going out, partying and drinking. I looked forward to studying and going to school. It simply made me feel like I am walking with my head high up. You know how in the real world, it's your brain that makes you popular? Same thing in prison. You get respect!

She was released before she could finish the GED program.

Frank

Frank kept mostly to himself when he was in jail. He was not much of a talker. There was the occasional chit-chat with other inmates, but he never really struck a friendship with one of them. However, Frank liked the library because it was a change of scenery for him. Frank said, "I was shocked when I first served time in the county jail and was told there was a library on site I could use!"

He said the first time he saw it he thought it was one of the largest libraries he had personally seen. The library was no more than several long desks and a few hundred books and magazines on a variety of topics spanning automotive topics to children's books like the "Hank the Cowdog" series. Inmates could frequent the library no more than three times a week and had a maximum checkout capacity of two books or magazines, at any given time. Further, other than the magazines, the books were relatively older and in "spotty" shape and a non-fiction book that was not health related was a rarity.

As for educational opportunities like independent study for GED programs or resources to complete college-level courses online, they were non-existent. One time, Frank met a college student from a nearby university who was in jail for a driving while under the influence (DUI) charge. Apparently, the student needed at least an hour to access a computer with Internet access to take a final exam. Although inmates were allowed one hour per week of computer access, this particular student was denied access for purposes of personal gain. This incident with the college student made Frank realize that his chances of receiving a formal education while incarcerated, either one based in the vocations or liberal arts, were nil.

However, whatever the prison lacked in terms of academic opportunities, religious-based education was always available. Frank estimated that anywhere from two to three times a week someone from a different Christian denomination would hold a prayer meeting. Bible study, services, or a variety of counseling opportunities were available. Most would always disseminate literature—Bibles, brochures, flyers —and the inmates could keep this material in their cell as well. Frank shared he rarely, if ever, went to these meetings because he is a Roman Catholic and Catholic priests, nuns, or deacons never came to the county jail while he was there. Also, seldom did any of his cellmates or fellow inmates in his housing section ever attempt to "recruit," or proselytize him but many would always invite him to go along to one of their services or meetings. At times, some of his cellmates would be congregants of one of the church organizations that showed up and he remembered they would go and get updates about their families, friends, and community. Frank recalled, "I did not like this one bit! It was a loophole to secure 'extra visits.' They were given a chance to socialize while the rest of us were confined to our cells." Still, this potential outlet or loophole, which when exploited would allow the exploiter to interact socially with the outside world, did not entice Frank enough to attend.

Both Dee and Frank's incarceration experiences drew some differences in terms of educational opportunities. While Dee had opportunities to attend GED classes, Frank had none. Both expressed frustration over the lack of educational resources. Dee wished for more textbooks to check out, while Frank wished for more learning access using a computer for his own personal gain. In addition, there was no

library in Dee's prison campus, while Frank's campus had one. Despite all the differences in educational opportunities and the fact that a library was not always available to them, both Dee and Frank were able to have opportunities for reading based on their interests.

Reading Experiences

Dee

In both the county and state jail, Dee vaguely remembered not having any access to a library. Instead, an inmate would pass by the cells with a rack on wheels with books that they could pick. Dee read a few novels but could never finish a book. Ever since she was in middle school, she disclosed that she never had the patience to finish reading a book, whether it was fiction or nonfiction. Instead, she preferred reading magazines because there were a lot of interesting pictures. Her favorite was the Cosmopolitan magazine. She liked Cosmopolitan because she wanted to see the latest fashion trends. It reminded her of the clothes and jewelry she wore when life was good with Joe. Dee was aware she was not an avid reader and always had difficulty with reading comprehension, but magazines were easy for her to read and there were pictures that further explained the text. She also enjoyed reading the stories and jokes in Reader's Digest magazines; science and adventure stories in the National Geographic magazines; as well as spiritual wellness guides in Guideposts magazines. When she was in the county jail, she read the local papers. A friend of hers sent her a subscription of a local paper in Texas. Newspapers, according to Dee, were easy to follow and did not use "big words." This was reading that "did not give me a lot of headache!," as laughingly shared by Dee. Besides, reading the paper gave her insights into the outside world.

Dee barely had any visitors to bring her something to read. Her kids were too young to send her anything on their own. She had a friend or two who would send her money to use in the commissary, and that is all she got in terms of receiving any gifts—not books, magazines, or newspapers. All in all, Dee admitted to not reading a lot. Even when she was a kid, she was not inclined to reading. If Dee was not talking back to her teachers, she was getting into fights with other kids in her school. Her younger years were mostly spent in school

fighting and drinking instead of reading. Dee reminisced, "I wished I had paid more attention in school, than getting into fights or drinking, instead of trying so hard to forget the things that happened to me."

Frank

Similar to Dee, Frank had particular reading interests. His routine in the library was to purposely check out two types of magazines each time—hot rod magazines and men's health and fitness publications. Although there were tons of other magazines, the automobile magazines were a favorite of Frank's because he loved cars. At the same time, the automobile magazines gave Frank a sense of consistency, as this reminded him of something he would do on a daily basis before he was incarcerated. He was able to basically maintain his old routine of having a few alcoholic beverages at night and wind down with a new hot rod magazine. Replace the alcoholic beverage with a cup of instant coffee or hot chocolate and that was his usual nightly routine in jail, as Frank remembered. The other type of magazine—the men's health type—were sources of simple workout tips or programs, as well as editorials from somewhat famous men who offered their "secrets" to success or advice on a variety of topics. Frank was convinced that he had tapped into a vein of rare informational wealth. He realized, "If I could just commit myself to remembering these vital lessons, I know that things would be different once I got out."

This realization was likely the source of Frank's philosophical development that would be illustrated every time he was released. For instance, one time Frank read about the benefits of cutting alcohol from a magazine he read while incarcerated. Like other advice he learned from these health magazines, he started practicing it, but could never stick to it in the long run. It was the same for practicing healthy eating habits or working out muscles based on magazine readings he picked up while incarcerated. The motivation to practice these newfound discoveries would be at an all-time high after every prison release but would wane after a few weeks into the practice. Life happened to him and often led him to lose focus on these commitments. Although Frank could not recall the specific authors he liked or discuss the roots of their philosophical or theoretical teachings, he remembered that they gave him some sense of hope and offered a sort of redemption if he was able to stay committed to the program.

Both Dee and Frank admitted to reading more magazines than books. Dee's interest in clothes and Frank's interest in cars and health motivated them to purposely select the type of magazines they checked out while in their specific prison campus. Dee loved looking at clothes in Cosmopolitan magazines because it reminded her of the nice things she used to have before she was incarcerated. On the other hand, reading Hot Rod magazines gave Frank a sense of normalcy as he reminisced about his old routine of reading the magazine and sipping an alcoholic beverage every night before he retired for bed. Indeed, the reading habits of Dee and Frank were ways to connect to the old life or routine they had before incarceration.

Writing and Self-reflection

Dee

Dee admitted that she did not enjoy reading as much as writing. Given the choice, between the two, she chose to write. Writing was an occasion for Dee to reflect on her life. It allowed her to confront her demons and the atrocities she experienced with people she trusted in her life. Dee confessed that in prison, people from the outside had the opportunity to send stationary, but not Dee. She had no one to help her. Although she thought her kids would have helped her if they could, they were incredibly young and that was not possible. However, when asked where Dee got writing materials, she referred to, "getting a few sheets of paper through indigent," a term which refers to an inmate who did not have any money in his or her books in jail (Zoukis, 2013). During admission, an indigent inmate receives an indigent kit consisting of packaged food (e.g., ramen, coffee, seasoning, etc.; Bureau of Prisons, 1999). When prodded about how she got paper from individuals who were "indigent," Dee shrugged and did not have much information to add.

Writing for Dee was an outlet for her emotions, and so, she mostly wrote to herself. For instance, she would write, "I hate you! I hate what you did to me!" and then tear the paper into little pieces. A memory that got Dee so emotional and made her spew "hate" on paper was an incident with her ex-husband Joe. Joe had held their kids hostage because he was hallucinating. and thought he saw a man inside their

attic. Joe gripped Dee tightly by the neck and had a gun to her head. He told their kids, "Say goodbye to your mama!" The only way Dee and her kids got away was when Dee yelled, "Look! There's the man from the attic!" When Joe ran to get the man, they ran to the door and sought help from their next-door neighbor. Other times, Dee remembered the occasional beatings from Joe and the regular trips to the hospital to treat her bruises.

Writing about her emotions helped Dee remove some of the "bad thoughts" in her mind. When prodded further about these "bad thoughts," Dee shrugged and said, "Just thoughts that I messed up pretty bad... I am a failure. I let my kids down." When she wrote them, it felt like she was releasing or purging her pain somehow. She never kept any of these writings, but all she could remember was tearing them up after writing them. Dee wished for many things. She wished she spent more time learning in school instead of "being bad." More than anything else, Dee realized she would do anything for her children and would do anything to spare them from all these miseries she experienced in her life. Coming to terms with her emotions made Dee tear up a lot while incarcerated.

Furthermore, Dee reckoned that writing letters was the only way to connect to the outside world and to her children. She had a male friend she intermittently corresponded with and they would trade stories of what was going on in their respective lives. Dee wrote letters to her children, three girls and a boy, around two to three times a month. Her oldest daughter responded but her older son never responded and her two youngest girls were simply too young to write. Dee admitted she preferred writing to her children rather than frequent visits from them. She recalled:

> I would tell them I love them. I'd tell them to take care of themselves, to do good in school because education is the only way out. I would tell them that it was not right for anyone to touch them on their private parts no matter who they were and if they were touched, to dial 911. I would tell them not to get into trouble and things like that.

Dee was always adamant about reminding her children about inappropriate touching from adults because of the abuse she suffered as a child. She wanted to protect them at all cost. However, as much as Dee wanted to see her children regularly, she always felt guilty. She

felt guilty and embarrassed about all the wrongdoings she did in her life. She felt guilty for leaving them in the care of her in-laws. She was stuck in a hellish place and wanted more than anything to be with her children. Dee vowed she would do everything in her power to make up for this absence in her children's lives.

Frank

During Frank's interview, he shared that he rarely, if ever, wrote anything while incarcerated. Apparently not all that confident with his penmanship, vocabulary, or spelling abilities, Frank would avoid writing letters to his then wife or children. Frank shared he also did not receive anything as far as written correspondence while incarcerated. The overarching reason behind his unwillingness to write was that he was embarrassed and did not want a record amongst his loved ones regaling his time spent as a prisoner. Some family members insisted they never wrote to him because he would all but cut off communication while in jail and would limit conversation to weekly phone calls with his wife or older sisters.

He also never took notes on his pending cases, other than the occasional paperwork he had to complete. Frank also never mapped out in written form his plans or goals once released. Interestingly, Frank spent roughly forty-three months of his life behind bars and never wrote a single letter, journaled, or kept any written record about those "unfortunate years." When prodded further as to why he did not write for himself or take notes of his case, Frank simply shrugged and said, "I didn't want to." If it were about his case, he figured he could mentally memorize information instead of writing it down.

The writing experiences of Dee and Frank were like night and day. Dee sought writing to purge her hidden emotions and wrote to her children to remind them of their mother who was thinking of them. On the other hand, Frank refused to write to his family. Interestingly, what connected both Dee and Frank was the sense of embarrassment that both felt. Dee was embarrassed and guilty of what got herself in prison, so she did not encourage any visits from family. Frank felt the same way, even to the point that he cut off ties from his family.

Perspectives on Other Inmates' Reading and Writing Habits During Incarceration

Although Dee saw other inmates reading and writing, she confessed, "I didn't think much or felt anything about it." Dee kept to herself, so she barely cared about anyone around her. This was her way of staying out of trouble and of avoiding getting into ugly fights with other inmates. All Dee knew was that everyone had plenty of time to read in prison. Reading was simply a way to pass time and to keep everyone sane. However, Dee would hear a lot about other inmates because their family would write to them and they would share what was happening in their family. For instance, the lady in the next bunk named Pat (pseudonym) would tell her about her family. Pat shared about her kids doing well in school, and how her husband decided not to wait for her because she was in prison. Instead, Pat's husband ran off with another woman and left the kids with her mother. Dee said that Pat's story was quite common in her prison campus.

Dee said that all the writing was not always good news. Some people would find out that their children were taken away by the Child Protective Services because the people they thought were taking care of their kids were not actually supporting them. There were also stories about some of the inmates' children getting into drugs because there was no one supervising them. Then there were also family members who passed away leaving the children unsupported. Dee said, "I am lucky—even if my mother-in-law did not like me, she was there to take care of my girls."

Many people read in jail during Frank's detainment, more than Frank expected. He shared that people you would not expect to read would do nothing but read from breakfast to lights out. He remembered this one bruiser type, who looked like he was affiliated with some street gang, received two books in the mail about the Korean War and spent every day with his face buried in the pages. During some meal or recreation times, this man would recount what he had read and found interesting. He would get excited telling them about a particular story or battle and was always loud and animated when there was "action." Other folks read books that had been turned into movies—like "Holes," "IT," and "Old Yeller"—while a good majority of book reading was done with one of the free Bibles left over by visitors. Sports magazines were huge commodities and a few inmates

even liked to read gardening and floral magazines. Although most inmates would check out either a magazine or an occasional book, only a few would reach their weekly limit on library visits and even fewer would read enough to check out multiple books per week. A lot of inmates were like Frank, and only checked out and read magazines. Most inmates usually talked about particular pictures, such as cars or famous athletes, and this would entice others to check out the same magazines for themselves. If the magazines were all checked out, most inmates would not bother checking out books. They would rather wait for the magazines to be returned.

Compared to other inmates at this facility, Frank may have been somewhat of an anomaly when it came to extensively writing, either to others or for himself. He recalled always seeing others write during his stay and do so quite frequently. A lot would almost daily write romantic letters to their wives, girlfriends, or those they were interested in. They would share that they were "testing the waters" or "checking in" and would be all too willing to share intimate details of their letters or personal lives. Indeed, Frank had people around him share their letters, from pen pals to their loved ones, and he was happy enough to simply listen to them. Frank recalled two or three guys keeping a journal or log of their stay with scraps of recyclable paper. Some inmates kept their letters and journals close to them because there was a constant threat of someone stealing your journal and exposing embarrassing or sensitive passages to others.

In addition, some would draw pictures for their friends and family on the outside or provide blueprints for tattoo ideas for fellow inmates. They would always seek feedback and praise from fellow inmates or at the very least payment in the form of commissary snacks. Frank even commissioned some hot rod art for his cell wall from a fellow inmate and happily paid him with four small granola bars.

Dee and Frank preferred listening to what other inmates were reading and writing about instead of sharing what they found interesting from their readings or personal writings. It is indeed possible that some inmates were not embarrassed by their incarceration or others simply needed some folks to talk to. However, Dee and Frank might be an exception since both felt the embarrassment of being incarcerated. Dee and Frank have also previously expressed overwhelming low confidence in their reading comprehension and writing skills,

respectively. Furthermore, both liked to keep to themselves. This could simply be a personality trait that both shared.

Compelling Implications of Reading and Writing During Incarceration

Being compelled to read and write were prevalent activities for Dee and Frank. They had to read and write because that was the common option for both to pass time, even while in solitude. Even though Dee and Frank used both reading and writing to pass time, how they preferred to utilize their skills was also reliant on how they felt about their own literacy skills. Frank was not confident in his penmanship, vocabulary, or spelling abilities, so he chose to read more than write. For Dee, she could barely finish a book and was not confident in her reading comprehension skills so she preferred to write, whether it was writing to herself as an emotional outlet or writing to her children. Both could read and write, but the hesitation to utilize both at the same time was based on their confidence in their own reading or writing skills.

Dee and Frank also read based on the resources provided for them in their respective prison campuses. Frank had access to a library wherein he could check out books and magazines to read. On the other hand, Dee did not have access to a library and she could only choose reading materials that were available on a wheeled cart.

Based on narratives shared by Frank and Dee, it was established that they both liked reading magazines. Frank reveled in the cars and workout tips or programs he read in the magazines. Dee was delighted with the fashion magazines she read because she kept herself abreast with the latest fashion. Frank thought of the nightly routine he had prior to incarceration—the combination of a hot rod magazine and an alcoholic beverage. Dee thought of the clothes and jewelry she owned whenever she opened an issue of a Cosmopolitan magazine. The compelling aspect of reading a magazine was parallel to personal routines and possessions. At the same time, their ability to remember different realities motivated Dee and Frank to purposely select the magazines they continually read while incarcerated.

Frank and Dee also had different experiences with academic learning while incarcerated. Dee attended regular GED sessions, which presented her opportunities to study in a formal classroom setting

three times a week with an instructor who could assist her in math and writing. Indeed, opportunities for personal gain while incarcerated led Dee to pursue her education once she was released. Dee also benefited from the discipline she acquired during her GED sessions and from the motivation she received from her instructor, both of which further boosted her determination to attend a regular school after release. However, Frank did not have the same opportunities in his prison campus. He realized his chances for personal gain were minimal, so he gave up trying, even if a computer was available to prison inmates.

If prison campuses offered the same opportunity for personal gain across the board, although limited to academic learning, the same discipline and motivation to pursue formal education outside of prison could be a reality to ex-prison inmates like Frank. As Dee later shared after a follow-up interview, she received her high school diploma, and three months after graduation, she enrolled in a community college. Dee eventually graduated with her associate degree in business in spring of 2020. The underlying question in this case is: If prison inmates like Frank had the same opportunity for personal gain like Dee, is it possible that he could have pursued a degree in the long run? Based on their learning perspectives, there is considerable possibility that opportunities for personal gain, such as taking college-level courses and GED preparation/review, could lead to a solid foundation of self-discipline and motivation for further education after prison release.

In addition, both Frank and Dee shared that while they were incarcerated, they noticed that other inmates liked to share news from letters they received from their loved ones. For instance, Dee was not comfortable with sharing letters or striking up a conversation with anyone about her personal life, but she would join others as they listened to good and bad news from letters received by other inmates. It was evident that if ex-inmates like Dee and Frank were not comfortable sharing letters or personal stories with other inmates, they were more likely to be inclined to simply listen to other inmates' stories. Listening to others' stories rather than sharing a letter from a family member was a better option based on Dee's and Frank's perspectives. Having to read and share news about family to other prison inmates embarrassed them and exacerbated the guilt and shame they already

felt while incarcerated.

Writing as an interest and pastime were based on different motivations for Dee and Frank. Based on Dee's perspectives, writing was two-fold: to constantly remind her children that she was coming back for them (redemption) and to write to herself to purge buried emotions (self-healing). Dee envisioned hope and promise by writing to her children monthly because of the looming reality of reuniting with them someday. At the same time, Dee also wrote to herself regularly to potentially provide emotional healing from her own trauma. Nevertheless, none of these writings were ever saved. Holding on to any piece of writing while incarcerated was a constant reminder of the guilt and shame while incarcerated. In a follow-up interview, Dee even explained, "Once you get out of prison, it's kinda like [an unspoken] rule to leave everything you have there, including letters and writing stuff. You throw them away!"

As for Frank, he felt similar shame and guilt to what Dee experienced. He was indeed mortified of being in prison, but he did not relish the idea of writing letters as a way of engaging his family with his time spent in prison. However, here is where both Dee and Frank differ when it comes to their viewpoints on writing while incarcerated. Dee used writing as an expression of recovery for her past actions. For Frank, writing about prison life was a complete embarrassment. There was already a stigma attached to being incarcerated because of the shame brought on his family by his crimes. Cutting off communication was an inner vendetta for being "worthless" because his own actions led him to prison. There was also the insecurity of "nothing-to-say" since prison life is mundane. After a while of postponing writing while incarcerated, the matter of not writing becomes all together a convincing excuse. For instance, Frank would not be pressured into apologizing for his actions nor promising anything if he never wrote to his family. Cutting off communication with his family was a better coping mechanism from the personal shame and guilt he brought on to his family.

Overall, Frank's and Dee's experiences with reading, writing, or educational opportunities while incarcerated are likely not all that uncommon. Some folks engage with these opportunities differently, as well as for different reasons. Some are trying to escape the monotony of prison life, while others are seeking to improve their lot in life either

while incarcerated or upon their release. Still others use these types of opportunities to remain connected, or reconnect, with the outside world. The stories shared by Dee and Frank offer brief glimpses into the lives inmates left behind. Their stories can also serve as catalysts for substantive change. For instance, prison campuses around the country should consistently have the same opportunities for further learning, such as access to college-level courses, GED preparation materials, and a library or study area. The availability of educational materials to further education could be factors to motivate inmates to become productive citizens after their release.

If possible, it is also encouraged that prison campuses should not solely be the dumping ground for worn out textbooks and other fiction and non-fiction books. Encouraging organizations or schools to donate books in good conditions to prison campuses could also be an ideal endeavor. If books were in better shape (e.g., no missing pages, no loose binding to hold pages), it would have enticed prison inmates like Frank to read and learn more content not just in magazines, but also in books. There is no bigger disappointment than reading a book with missing pages. You do not get the whole story. If one sees a book that is not physically in good shape, one will not pick it up because it would most likely have missing pages. Nonetheless, these recommendations may not exhaustively change the entire population of ex-offenders, but it is worth it to see the changes in some people's lives.

Charity Embley, Ph.D.

Charity Embley is a full-time Associate Professor in the Teacher Education Programs and ESL Instructor at Odessa College. She also teaches bilingualism and multilingualism at the University of Texas of Permian Basin. Dr. Embley earned her Ph.D. in Curriculum & Instruction from Texas Tech University with an area of concentration in Language, Diversity and Literacy Studies, with supplemental study on Spanish Language and Culture from Universidad Pontificia De Salamanca in Salamanca, Spain. She also serves in the International Advisory Board for the Journal of Ethnic and Cultural Studies, and as an At-Large Director for the Texas Association for Literacy Education.

William Toombs, D.A.

William Toombs is currently the Chief Research Officer for the Eastern Oregon Center for Independent Living, Institute for Disabilities Studies and Policy. Prior to this position, Dr. Toombs was an Assistant Professor of History and Government at Odessa College in Odessa, Texas. He received his Doctor of Arts in Political Science from Idaho State University.

References

Bureau of Prisons. (1999). *Inmate information handbook federal bureau of prisons*. Retrieved from https://www.bop.gov/locations/institutions/spg/SPG_aohandbook.pdf

Kellner, D. (2009). *Confronting the trauma-sensitive writing of students*. American Reading Forum Annual Yearbook [Online], Vol. 29.

McFarlane, A., Yehuda, R., & Clark, C. R. (2002). Biological models of traumatic memories and post-traumatic stress disorder – the role of neural networks. *Psychiatric Clinics of North America, 25*(2), 253–270.

National Center for Education Statistics. (2016, November). *Highlights from the U.S. PIAAC survey of incarcerated adults: Their skills, work experience, education, and training program for the international assessment of adult competencies 2014*. https://nces.ed.gov/pubs2016/2016040.pdf

Schwan, A. (2011). Introduction: Reading and writing in prison. *Critical Survey, 23*(3), 1–5.

Zoukis, C. (2013, October 14). *What are indigent federal prison inmates provided?* https://www.prisonerresource.com/prison/what-are-indigent-federal-prison-inmates-provided/

Chapter 13

Education is a Foundation

Kei'lani Gomes

Education is a foundation that many are privileged with as they age. Please note the two key words in this sentence: privilege and many. Not everyone has the opportunity to receive an education in their lifetime. There are a plethora of reasons as to why someone might not be able to go to school or obtain a General Education Degree (GED)/ High School Equivalency Testing (HiSET). Without an education in the era we live in, there is a minimal chance of success in life. Most minimum-wage jobs require a high school diploma or an equivalent degree after age eighteen, so less people are able to acquire jobs to support themselves. One person taking care of himself or herself on a minimum-wage job has much stress to deal with, but parents taking care of a family have at least twice the amount of stress. That does not include single parents. When faced with such large amounts of stress, especially when it comes to taking care of a family and bills, people can be pushed to extremes. Those are just the people who are literate and have some educational background, but there are those who never learned how to read or write and never had the opportunity to get a basic job. Usually these people find money in illicit ways, such as robbery, prostitution, human/drug trafficking, along with other illegal activities. The same outcome goes for those who have jobs but still struggle financially. You do not need to read in order to sell drugs to pay for food nor do you need to quit your part-time job to mug someone late at night for the rest of your rent money. It all leads to incarceration, because even the best are caught eventually.

In the Oklahoma prison I am incarcerated at, once out of the As-

sessment and Reception (A&R) individuals are sent to orientation and given a pass to take a Tests of Adult Basic Education (TABE test). If they do not have their diploma, they are given the option to enroll in the education program offered. The placement test is then processed, and the tester is given their score. If they wish to become a student, they send an Inmate Request and are sent a pass for another set of TABE testing to determine what level of education they need to begin with. In this prison, we offer three levels: Literacy (Grades K-6), Pre-High School (grades 6-8), and High School (Grades 9-12).

In my time here at the education building, I have watched many testers come and go. Some enroll, some do not, and some do not know what they want to do because they feel like they cannot do it. The ones who feel worthless tug at something deep inside me. I was once one of them, dropping out of high school not only because the pace was too slow, but also because I got pregnant. I sold drugs, robbed people, and hung around with the worst, but while I was absent a lot, I continued to go to school until I became pregnant at sixteen, still a freshman in school. I never went to fourth, fifth, or eighth grade, but I was always able to test into the grade I was supposed to be in, because I was a smart kid, or maybe just a good guesser. However, you learn essential information in each of those grades. I am one of those "repeat offenders" everyone talks about; I first was locked up at fifteen for an assault charge. At eighteen, I was waiting to be extradited from Arizona to Oklahoma. When I came into prison at 19, I went into the education building to test, as many of us do, ready to feel like a Neanderthal. I could not even divide whole numbers at this time, but I longed for my education. I just never thought it was possible for someone like me, a convict who cannot stay out of trouble no matter how hard they try. However, the story ended differently, and I received my HiSET with honors. I dropped to my knees and started crying, because who I thought of as a failure, finally did something correct. That same day I was asked to become a language tutor, and I began changing lives as mine was changed.

Many inmates share my same story: quit school, get arrested, get sent to prison, try doing something productive by attempting to get a GED or HiSET. Now, not everyone can obtain their diploma quickly; as I mentioned before, some people come in here unable to write anything more than their name, Department of Corrections (DOC)

number, and date of birth. In fact, when illiterate people come in to test, they panic. I have watched countless women break down in tears because they could not read the test and admitting that to someone, even a total stranger, is so shameful they want to instantly leave the building. We talk them down and have them fill the test in, just so we can record a score, and then we speak to them about the Literacy class. We encourage them to enroll because life is so much more when you have the ability to feel worthy, the ability to look down at a diploma and say, "I earned this." When someone who came into the education building unable to read comes up to you and shows you the chapter book they now love to read because you helped them simply enroll in school, that is something that words cannot describe. They are in a state of disbelief because they went their whole life unable to read a simple sentence, and now, they can read a whole book. Watching one inmate who is loving and patient and willing to tutor another inmate whose eyes are downcast and pink tints their face in shame is amazing. It does not seem like much, but no inmate is higher than another is, and respect is hard earned in prison. You either buy your respect or you crawl from the bottom up for it; there is no in-between.

I do not work with the literacy students; I work with the HSE students. I occasionally see and assist the ones in the lower levels, but my primary job is to tutor the higher-level language. We specialize in the HiSET here, so we focus on an argumentative essay format, which is harder to tutor in than expected. They are very similar to opinion-ated essays, but the twist is that you must recognize and refute the other person's argument. Most inmates are very opinionated, which is a good thing, until they get to the counterclaim and have to ar-gue for the opposing side. Helping people understand that everyone's opinion matters in such a biased setting is difficult, and when giving essay prompts, we have to avoid controversial subjects so no one gets offended. Offense can lead to fights, and we want our building to be a place of peace and safekeeping, not violence and judgment. Tutoring in a prison is much more difficult than in public education, not only because of the respect issues or the level their mind is at, but also be-cause of the varying personalities. In order to tutor so many different people with varying levels of understanding, you must be adaptable. One student may need you to illustrate how a sentence is constructed while another must have it verbally broken down. It is hard to teach

a single format in a thousand different ways, so I adjust to each class. Some students understand the prestigious way I speak, but many do not and therefore I have to adjust how I speak to that particular student. The most important aspect, however, is not making sure that they understand, but it is making sure that students feel, as a dear friend of mine says, "wanted, needed, and loved." Without a sense of worthiness, people will have no drive to continue.

Inmates come into this building broken down and believing that they can achieve nothing. They do not believe that they can write a four paragraph essay or solve for x. Why do they not believe this? The answer is painful and simple: either the people they grew up around did not tell them anything different or they were the ones planting these poisonous seeds in their head. If a child shows their parental figure their drawing and they dismiss them by saying that it should have been done neater, the child most likely will try again, and the process will repeat. Finally, the child gives up trying and will believe that they are not good enough. This is just the beginning of a vicious cycle that leads to people believing they will never be able to succeed. When they come into our building, we realize that they need someone to tell them that they did an amazing job on their math homework or that they are not stupid. We try to break them of those self-deprecating habits and replace them with uplifting ones. We take "I can't do this!" and tell them again and again that they can, until finally they look at their achievements and say, "I did this by myself!" That alone is worth the long hours, bad attitudes, and repetition. Watching the spark of life in someone's eyes as they understand a concept that was foreign to them is breathtaking. Standing in front of a group of people and showing them how to write is a privilege I never thought I would have the opportunity to experience. Helping people learn and giving them the freedom to leave this prison with an education and knowledge is worth every year I will spend here. Prison is not the end of life unless the inmate chooses it to be. Actually, prison starts lives for many people. We do not choose to come here, but it happens this way and people should take this opportunity to make a better life for themselves. After all, we have nothing but time.

Education is an important aspect of life, and life does not stop when a person is incarcerated. Incarceration can be the best or worst thing for someone. For over two hundred people in the two years I

have worked at the education center, their lives have been made better. Over two hundred people, myself included, have graduated from the HSE program in the past two years. Finally, to conclude this, with a quote from those at Poetic Justice that describes any inmate incarcerated around the world, do not forget that "we have a voice, we have hope, we have the power to change."

Kei'lani Gomes

Kei'lani Gomes is twenty-two years old and grew up in Hacíula, Hawaii and later moved to Mesa Arizona where she attended Westwood High School until she became pregnant and dropped out. After getting arrested, she worked to obtain her HiSET. Kei'lani has always had a fascination with literary arts and is excited to become a published author.

Section 3

Hope for Tomorrow

"My hope emerges from those places of struggle where I witness individuals positively transforming their lives and the world around them. Educating is a vocation rooted in hopefulness. As teachers we believe that learning is possible, that nothing can keep an open mind from seeking after knowledge and finding a way to know."
—bell hooks

"I want to leave my writing behind for when I am gone and the question of who I was enters people's minds. If I am executed, there will be some who believe I deserved it. But those who want to try to make sense of it will see, through my writing, a human being who made mistakes. Maybe my writing will at least help them see me as someone who felt, loved, and cared, someone who wanted to know for himself who he was. My writing will hopefully show those people that they could easily have been me."
—Jarvis Jay Masters

"Winter is the time for comfort, for good food and warmth, for the touch of a friendly hand and for a talk beside the fire: it is the time for home."
—Edith Sitwell

Chapter 14

Orange is the New Truth

Women of the 2019 summer workshop, Poetic Justice: Onstage

ORANGE IS THE NEW TRUTH *was developed and written during an eight-week Poetic Justice summer workshop in 2019. The workshop was facilitated by Bailey Hoffner, Sandy Tarabochia, and Julie Ward.*

The play was first presented on Tuesday, August 13, 2019 at Mabel Bassett Correctional Center in McLoud, Oklahoma for an audience of more than 120 people. It was directed and performed by the authors, with the following cast (in order of appearance):

JAMIE	Jamie Postoak	NARRATOR	Angelina Cicone
TINA	Tina Morgan	HAWNDA	Reshawnda Durham
SHA	Sha Wade	TIYANNA	Tiffani Shaw
PAM	Sarah Ganis	POLICE OFFICERS	Sha Wade and Toni Hall
GRANNY	Toni Hall	SHAREE	Sharee Asberry
HUCK	Tiffani Shaw	MOM	Sarah Ganis
DANNIE	Jessica Moore	SHIANN	Jessica Moore
SHERRY	Angelina Cicone	TREVONN	Angelina Cicone
UNCLE ARTHUR	Jamie Postoak	JAQUALIN	Sha Wade
HOMIES	Sharee Asberry and Angelina Cicone	JUDGE	Reshawnda Durham
BOOM	Toni Hall	DAD	LaDonna Ward
DONOVAN	Tina Morgan	MS. J	Toni Hall
ANNOUNCER	Tina Morgan	ANGELINA	Angelina Cicone
STEVE	Angelina Cicone	WOMAN NEEDING TISSUE	Tina Morgan
LADONNA	LaDonna Ward	WOMAN ON FLOOR	Sharee Asberry
JESS	Jessica Moore	WOMAN PACING	Jessica Moore
TONI	Toni Hall	GUARD	LaDonna Ward
SARAH	Sarah Ganis	MARCUS	Sha Wade
OPRAH WINFREY	Tiffani Shaw		

Prologue

Jamie Postoak

JAMIE *enters, stands front and center.*

JAMIE: (*Addressing audience.*) Orange is the New Truth. It is a sad fact that nearly every family is touched by "orange." We hope that our performance allows you to look past the orange and see us as women who are mothers, daughters, and sisters. Today's convict will be to-morrow's business owner and neighbor. We hope that we are able to soften the view of what orange truly looks like. Let's blur that line. Enjoy.

JAMIE *exits.*

Scene 1. Dear Mom and Dad

Tina Morgan

TINA *sits at a table with a Dr. Pepper and Twizzlers. SHA sits across from her.*

TINA: Hi, Sha!

SHA: Hi, Tina!

TINA: So, I wanted to ask you something… I know you said you had adopted your daughter, and I wrote a letter to my parents, who adopt-ed me. Could I read it to you and would you tell me what you think?

SHA: Sure.

TINA: (*Reading letter to SHA.*) Dear Mom and Dad. So I have de-cided to write you a letter because I am not always the best at verbally expressing my thoughts and feelings. So I remember that growing up I always thought that I was "cooler" than the other kids because my mom and dad chose to adopt and love me; you guys weren't "required" to love me like other kids' parents were. I was probably a little naive about parents loving their kids then. I mean sure, I knew that my cous-

in Shonda's mom was not the best mom and yeah, she threw a boot at her face and left a scar, and then years later after her trip to prison when I saw her she was a complete mess, but it never dawned on me that maybe her mom didn't love her. Coming to prison has really taught me a lot. Susan—(*to SHA*)—that's my twin sister—(*continues reading*) —and I have had the best parents ever, the parents that everyone that is adopted longs to have. We were gifted with a childhood that made us never doubt if we were loved. Here in prison, I have met quite a few people that have been adopted but their stories are horror stories, parents that beat them, neglected them, and even one set that decided when the daughter was about 16 that they did not want her anymore. I could not imagine for a 16-year-old anything more heartbreaking than being "sent back." I remember you telling me that, yes, you on a few occasions had to assure us that we were not going back. We had all the hugs, kisses, and love that every child dreams of. Of course, we also were typical teenagers and gave you guys a hard time (although not as bad of a time as I have heard around here), yeah, we were and are still a little—well, in my case, a lot—bratty. I could not imagine what kind of life we would have had if it were not for you guys. I remember the huge off-white/ivory-colored dresses that we wore for our dedication and the little ring that has the cross that I got for the dedication. I definitely remember losing the ring once out in a rock pile; I'm pretty sure you probably wanted to strangle me! Of course 26 years later the ring still fits my pinkie. I remember that time we went to Branson and I feel like it was March-ish time of the year and we talked Dad into taking us down to the swimming pool even though it was too cold outside, but hey it was the best swim ever shivering with goosebumps all over us. Then of course there are all those embarrassing times that I was too little to remember but that you so fondly have relayed to me… When the random lady asked me if I was ready for Santa Claus and my reply was that he's dead, I'm sure that the horrified look on her face was epic, or the time in Mardel—(*to SHA*)—that's a huge Christian bookstore in Tulsa—(*continues reading*)—when I was talking to the little precious moments figurines and told the one that if she didn't get her A-S-S over here I was going to whoop it. Pretty sure you wanted to fall through a hole in the floor. There are all the super sad moments in my life that you've held me for and wiped all my tears for. Like the day that Nathan, my fiance, was buried. Even though I didn't cry that

day, you guys were still there for me. The day that Michael was born and you, mom, told me that it was okay for me to cry, which I did, and you held my hand while I cried and then while I pushed out Michael. Then of course the day that Michael died and the days following me burying him you held me while I cried. The day that the jury verdict came in and they said I was guilty I know you cried that night, but I didn't but I knew then and still know that I can't completely lose it because I can't watch you guys go through falling apart anymore than you already have. All I know is that you have given me the best family ever and that I wouldn't change my parents for a single second because then I wouldn't be who I am today.

TINA puts down the letter. To SHA.

Does that sound like something my parents would like to receive?

SHA: Well, yes, and it reminds me of the happiest day of my life when I adopted my daughter.

TINA and SHA exit.

Scene 2. The Perfect Gift

Sha Wade

It is Christmas. SHA enters GRANNY's family room. PAM, GRANNY, and HUCK are sitting around and talking. SHA notices a cake on the table that says, "Happy Birthday, Jesus." SHA receives a phone call from DANNIE.

SHA: (*Talking on the phone.*) How far out are y'all?... Okay, great. Traffic is not bad. (*She hangs up and walks into the house.*) Merry Christmas, everybody.

PAM: Congratulations on the new addition.

SHA: Thank you.

PAM: Your father and Sherry should be here at any minute.

SHA: Great. Why is there a cake that says Happy Birthday, Jesus?

PAM: You know your grandmother has a new boyfriend, Huck, and she is trying to impress him.

GRANNY: Sha, come meet Huck.

SHA: (*Moves to shake HUCK's hand. HUCK shakes SHA's hand without speaking.*) Hello, sir.

GRANNY: Where is the baby?

SHA: With Dad. They should be here soon.

PAM: (*Looking outside.*) Sha! Your dad is here.

DANNIE enters the house with SHERRY and the new baby, CERA. Everyone freezes. SHA, carrying the baby, moves.

SHA: You are a star, a bright shining star. Your rays brighten the universe. A ray of hope. A ray of joy. A ray of love. You come from Mommy's heart, not Mommy's belly. You are loved.

Action starts again.

DANNIE: (*Looking at the cake.*) Happy Birthday, Jesus? Why is there a birthday cake for Jesus?

SHERRY: Maybe to impress the new boyfriend?

GRANNY: Shame on you. You know we get a cake for Jesus every Christmas.

EVERYONE rolls their eyes, except HUCK, who is now sleeping.

SHA: Well, here is the new addition, Cera Elizabeth Harley Wade.

SHERRY: She is beautiful.

DANNIE & PAM: Perfect.

GRANNY: God's gift.

PAM: (*Looks out window.*) Uncle Arthur has arrived.

UNCLE ARTHUR walks in and looks at cake.

UNCLE ARTHUR: Happy birthday, Jesús? Who the heck is Jesús?

EVERYONE laughs.

All exit.

Scene 3. Love Without Terms and Conditions

Jamie Postoak

A trap house where a few HOMIES mime shooting dice. BOOM is looking at something on his phone.

JAMIE: (*Calls MEMA on phone. Sound of a phone ringing.*) Hey Mema, is Donovan there? (*pause*) Can I come see him? I'm just around the corner. (*pause*) I know it's late, I'll be right there. (pause) Thank you, Mema.

JAMIE turns towards HOMIES.

Hey I got $20 for someone to give me a ride around the way.

HOMIE: Yea, I got you.

BOOM: I got you, Smiley. Don't worry about it. Keep your $20. You going to see Donovan?

JAMIE: Yeah, it's been a while. I need to see his face.

JAMIE and BOOM get in a car made out of two chairs.

Thank you, Boom! You don't know what this means!

BOOM: Yeah, I do.

JAMIE gets out of the car, goes through the door and gets DONOVAN.

JAMIE: Donovan, let's go outside and look at the stars.

Stage clears. JAMIE and DONOVAN go outside. JAMIE and DONO-VAN sit on stage and "look at stars," never at each other.

What have you been up to, Donovan? I've missed you so much.

DONOVAN: I've missed you, too, Momma. Where have you been?

JAMIE: I am sorry I haven't been home. Momma isn't doing good. I

145

gotta get better before I can come back home. Baby, I'm so sorry that I haven't been there. You and your sister deserve a good Momma!

DONOVAN: But Momma, you're the best Momma. You know why?

JAMIE: (*smiles*) Why?

DONOVAN: Because you're our momma!

JAMIE: I love you, Donovan...The Whole World!

DONOVAN: I love you, Momma… All of God's Heaven!

JAMIE: (*Stepping out of scene, addressing audience.*) At that moment I found out what unconditional love was. No matter what I do or don't do my children love me. Because I am theirs. I am learning now... after all I've done, God also has this, no terms and conditions on love for me. Because I am his. Agape love...

Scene 4. The Kiss Decision

LaDonna Ward

The stage is bare for the 1984 Junior High Queen Contest in the Junior High School gym.

NARRATOR: (*Offstage*) The winner of the 1984 Junior High Queen Contest is LaDonna Girdner.

LADONNA and STEVE enter, smiling. She acts surprised and excited. LADONNA walks, turns, and returns to STEVE, taking his arm as they move to center stage. He crowns her and starts to kiss her. Everyone freezes. LADONNA looks at the audience.

LADONNA: Okay, so listen. Let me explain what's going on here. I'm in 7th grade and Steve here (*pointing to STEVE*) is the only boy in my class tall enough to be my escort for the Junior High Annual Queen Contest. He's an okay guy, and I know that if by chance I win there will be a short kiss between Steve and I. But I did not expect him to come at me like this—(*motions with hands at his open mouth*) —with his mouth opened wide, leading with an outstretched tongue surrounded by spittle. And here I am standing in my moment of glory

—I just won—(*Loudly*) I am the Queen! Now faced with the biggest dilemma of my young life… Do I let this spit-riddled, slobbering tongue violate me? I mean, that's what's supposed to happen—right? That's part of this thing… If I want everyone to clap and cheer and tell me how beautiful I am—FOREVER!—then that's what I have to do—Right? (*pause*) Or. (*pause*) Do I stand my ground? Remember, it's 1984 and women were still for the most part held captive to the social conventions that have held us hostage for so long. Standing my ground will mean that I choose to lay down my Ms. Popularity Beauty Queen Crown and be booed, laughed at, and ridiculed—FOREVER! Standing up for yourself or someone else is the hard choice. But really, in 30 years will it matter more to me that I won the Junior High Annual Queen Contest of 1984? Or that I won the real victory of self respect and forged for myself the true crown of TRIUMPH!

LADONNA looks back to STEVE, who unfreezes. As he moves in for the kiss, LADONNA pushes him away and shakes her head "No!" STEVE looks horrified, and LADONNA nods happily at the audience.

Scene 5. Rise

Jessica Moore

JESSICA is seated on the floor, centerstage.

JESSICA: (*Quietly and a bit shaky she speaks.*) First it was the anger. (*She looks up at the audience as if to clarify, speaking quietly.*) Not my anger—(*then hesitantly*) but hers. (*Nervously, almost like she's afraid the person she's speaking of could hear her.*) I was just a little girl. (*bites lip*) And she was always mad. (*pause…then quietly*) And I could never understand why. I always thought she was abused and it made her angry so she abused us and I became angry… (*gesturing with hand*) and on and on… (*Speaking without bitterness, her voice lowers and she averts her eyes.*) But she never admitted it. Everyone thought she was so sweet and we (*after putting emphasis on "we" she looks at the audience*) were such good kids— (*Eyes roll, she shakes her head and once again her eyes are downcast and her voice softens.*) Really we were scared. (*JESS bites lip, a memory rises up in her mind. Looking off as if remembering.*) There was this one time I had this terrible headache. (*deep breath*) She told

147

me I was evil (*deep breath*) and tried to cleanse me from my sins… (*She takes a deep shaky breath and shakes her head as if shaking away the memory.*) I never told anyone. I was just a little girl and I was scared and confused. It didn't have to be that way. But it was and I couldn't do it. I don't know what happened but (*quietly*) something inside me snapped. She was dead. (*Quietly and tearfully.*) It wasn't supposed to happen. So I did what I always do and tried to ignore the pain. What right did I have to feel pain? But when my brother died I felt that pain, then all the other pain. Remorse, guilt, loneliness. It weighed me down and I couldn't breathe… I got everything I deserved! Lost my family, my freedom, my life… all in one day. Rock bottom. How could I survive? (*Slowly rising*) By doing the only thing I know how… (*Standing upright*) Face everything and rise!!

JESSICA sings "Rise" by Katy Perry.

Scene 6. Pure and Holy Hands

Toni Hall

At the Pure and Holy Hands hair salon. A mirror and a table with a chair in front. Pictures are displayed on the table. Butterfly clips, a comb, scissors, hair dryer and straightener on the table. TONI is onstage, arranging items at her station. SARAH enters.

TONI: Hey, Sarah. I'm glad that I could fit you in for a color and trim.

SARAH: Thanks, Toni. I really needed this relaxation. I have had so much on my mind here lately.

TONI: Girl, just have a seat and we will get started.

SARAH: (*Sits down. TONI begins combing her hair. Smiling as she is asking the question.*) What's new in your life, Toni?

TONI: Well, I have been exercising more so I don't have to…

SARAH: Oh my goodness! Is this a new picture? Oh, wow! You have many new pictures.

TONI: I thought I showed you this one of my dad, Mr. Hall, Cynthia,

my son Robert, my daughter Ukiah, me, and Ellen at my Cosmetology Graduation.

SARAH: No, friend. You didn't show me. Wow! You look very emotional in this one.

TONI: Well, let me tell you, the kids were truly funny, slapping me on the back of my neck too. They are really funny.

TONI shows SARAH how they slapped her neck.

SARAH: Okay. Bet you had fun.

TONI: Yeah. Then my oldest son was graduating from high school that day too.

SARAH: I bet this pic is your favorite—of all your kids and your dad.

TONI: Yeah. It was right before my son, Jeff, got locked up. It looks like my dad snuck into the pic. It's funny.

SARAH: I can't help but keep going back to this pic of Ellen and your kids, your dad, and your cousin. This was truly a moment.

TONI: Yeah. The kids were emotional, but they told me the tears that they were crying were joyful tears. Girl, Ukiah's nails were so long I don't know how she was able to wipe her tail. Robert was so tall I was like, "Who is this tall grown man in front of me?" Ellen was so excited to see the reunification of my family. She was smiling hard. I was excited to introduce them to her. Turn your head this way so I can make this trim right.

SARAH: Sorry, I am just so excited to see these pics. I ain't really worried if you cut me a chili bowl cut. (*Smiling.*)

TONI: (*Mimes spraying product into SARAH's hair.*) I'm just going to finish you up with some of this chicken-fried Paul Mitchell. Girl, you know I am glad that we got a chance to catch up. Since I see you doing big things now.

Scene 7. A Success Story

Sarah Ganis

On the set of the OPRAH WINFREY show. Two empty chairs.

OPRAH: (*Walks on stage and sits down.*) My next guest is a woman who has made an incredible journey from victim to survivor. Tomorrow is the grand opening of her PIT/KIT center. It's quite the success story.

SARAH stands up and moves to the side of the stage.

OPRAH: Please welcome Sarah to the show.

AUDIENCE claps. SARAH tilts head in silent prayer. Takes visible deep breath. Pauses. Walks across the stage smiling and waving at the audience.

OPRAH: (*Stands and smiles as SARAH approaches. The two women hug and sit down.*) It's good to have you, Sarah.

SARAH: Oh, my goodness. (*Puts her hand to her mouth.*) It's an honor to be here. (*Smiles.*)

OPRAH: Tell us about the PIT/KIT center. What exactly is it?

SARAH: Well. (*Pauses.*) It's a center made up of various programs that are designed to educate, motivate, and empower. The goal is to help parents and kids transition into their best selves.

OPRAH: That sounds amazing. (*Leans back, relaxes.*) What was your motivation behind the center?

SARAH: (*Leans back.*) I was abused for many years by my father. I grew up full of secrets and shame. I believed I had no value, no worth. (*Pauses.*) I believed that my existence had no significance, and every decision I made reflected those beliefs. I ended up losing everything. I had a mentor a few years ago who had encouraged me to write a letter to my dad and expose the secrets of my past. I discovered the power of my voice through that letter. That's when I was really able to begin healing. (*Sits up, facing the audience.*) I just want to use my experiences to help others. I want to make a difference and impact the lives of

other people.

OPRAH: (*Puts hand on SARAH's arm.*) What an overcomer!

AUDIENCE claps.

SARAH: Thank you. (*Smiles.*)

OPRAH: (*Faces SARAH.*) This letter... (*Pauses.*) ...can we talk about it?

SARAH: (*Nods.*) Yes, of course.

OPRAH: You expressed in vivid detail all you went through, and then you asked your dad some very explicit questions regarding the abuse.

SARAH: (*Takes a deep breath.*) Yes, I did.

OPRAH: It must have been difficult to write such a letter.

SARAH: Oh, absolutely. (*Nodding head.*) It was very hard—and scary. I had never spoken out like that before.

OPRAH: To hold all of that in for so long. (*Shaking head in amazement.*) How did you do it?

SARAH: (*Eyes wide.*) Oh, there were times I wanted to tell, but I loved him so much. (*Shrugging shoulders.*) He was my father. I didn't want to hurt him or get him in trouble. I was always more concerned about making sure everyone else was safe and happy... even him. I didn't want to be the reason our family split apart.

OPRAH: You carried all that responsibility. (*Shaking head.*) And it was never even yours to carry. (*Looks SARAH in the eyes.*)

SARAH: I know that now.

OPRAH: Now... your dad took his life shortly after receiving that letter. Do you regret sending it to him?

SARAH: (*Sitting up straight, shaking head.*) No. Absolutely not. (*Looking at the audience.*) I firmly believe that a person should always say what they need to say—without attachment to the outcome.

OPRAH: (*Facing audience.*) That's all the time we have. (*Turns back*

toward SARAH. Very sympathetic.) Thank you, Sarah, for sharing.

SARAH: I hope it helped someone.

Both SARAH and OPRAH stand and shake hands.

OPRAH: Good luck to you.

SARAH: Thank you. It's been a pleasure.

OPRAH exits stage. Chairs are removed. Lights go out except a spot light. SARAH walks to the front center stage for a monologue. SARAH unfolds a letter and begins to read.

SARAH: What made you prefer your 6 year old daughter over finding yourself a real woman? My childhood was supposed to be the foundation for a happy and productive life. You stole that from me! You gave me, instead, the perfect foundation for a life of dysfunction and self-destructive chaos. Do you realize what you took from me? The poisonous residue from your tainted hands permeated my entire being… My relationships, my friendships, my sexuality, even my parenting. You stole my innocence. You violated my right to say no, and you took away any sense of control I had in the world—even over myself. You distorted and perverted my views of love and intimacy. You taught me that sexual attention and love go hand in hand, and so I seek that attention in order to feel loved. I blame you, and the lasting effects of the abuse, for ending up in prison. If you hadn't given me such a cracked and tilted foundation to build my life on—maybe I would have had a healthier self image. Maybe I would have been able to establish healthy boundaries and make better decisions. Your actions have had control over every facet of my life. Not anymore. I am taking my life back. I am letting go of shame. I have nothing to be ashamed of—you do. I was just a little girl who loved her daddy and you took advantage of that. I am no longer a victim. Today, I am choosing to be a survivor. I am standing here today in spite of what I went through and because of what I've overcome. (*Looking up.*) Dad, I have forgiven you. What you did was not okay, it was horrible. I won't minimize that. Forgiving you means I am releasing the power that your actions have had over me. I will allow the pain of my past to be a step stool for others. I am using my voice and my story to make a difference.

Scene 8. Once There Was Two Girls

Reshawnda Durham and Tiffani Shaw

-I-

NARRATOR stands at the center of the bottom of the stage steps. NARRATOR readjusts eyeglasses, hair pulled back in a ponytail. NARRATOR takes a sip of tea or water, clears throat, and then smiles. In a low, depressed, serious tone, looking straight ahead toward the audience, NARRATOR speaks. Birds sing in the background.

NARRATOR: It's a Monday afternoon, and the noonday sky is streaked with sunlit clouds, with birds cheerfully singing along. Meanwhile, two best friends who grew up together met up and confided in one another during recess on the schoolyard. This is their story.

TIYANNA seizes HAWNDA's hands to engage in play, and while playing she steps to center stage to recite a poem. HAWNDA continues playing the hand clapping game alone while TIYANNA speaks.

TIYANNA: My name and age

Tiyanna, 14

Under the spell of my stepfather's fist

Then the brainwashing magic tricks

Being nice instead of mean

His agenda becoming clear

Touches and kisses replacing the slot time for

Fear

Dear Self, I only wanted to be a girl just like all the other girls

But my stepfather took that away from me

Having sex on multiple occasions, left alone constantly

When whoosh, all it hits the fan

Instead of my mother taking my hand

She hides

Behind

The man who raped her child

She continued to stand by

She continued to take his side

Turning a blind eye

My reaction, I hide

Run away love now my name

My name has no love, I run away

Judicial system should go up in roars, wars

But everything goes silent, case closed

My heart cries tears frozen cold.

TIYANNA returns to the hand game with HAWNDA.

HAWNDA: (*Steps away from clapping game, walks to center stage, pacing, dejected.*)

My name and age

Hawnda, 14

Surgeon General's Warning

Yes, this will hurt you if you want to try it

First, it just started off with one little puff of

Mom's cigarette, then, it was Daddy's Swisher cigar, and wanting

To fit in around all

(*Air quotes*) "Big" kids

Soon

I was learning how to roll, and puff, puff, pass a joint

And really, at this point

I had started chasing any drug that would

Obey my thirst

So that I could get high as a kite.

Popping pills like it's skittles, and drinking alcohol

It's having me start to

Believe I can fly

Dare to say No—What? To all this smoke.

Yeah, right, ha ha ha, that's a good joke.

I'm saying goodbye to all toys, and games

This pipe right here, girl

(*Walks back towards TIYANNA. Continues clapping.*)

It's the real thing, wanna play it?

NARRATOR: Both of the girls skip school and are off to go get high.

-II-

Stage is split between TIYANNA and HAWNDA's separate residences.

NARRATOR: Let us fast forward 10 years later in the days and lives of Tiyanna and Hawnda: thus we get a glimpse into how these young women are doing.

(*TIYANNA sits on a chair by a table, mimicking smoking. HAWNDA absently pages through a book trying to read, but apparently unable to focus. She picks up a huge telephone and calls TIYANNA. Sound of the phone ringing.*)

HAWNDA: I'm waist deep in my addiction, because I've been exper-
imenting

I'm doing meth, coke, heroine, ecstasy, PCP

Girl, I'm just curious for what trip the next high will bring me

On the daily, hitting nightclubs and block parties

I'm still sipping on gin and juice and Bacardi

Taking shots back to back and being loose as a goose

I don't know how to act

Every other morning, I'm waking up to my

(*Counting on fingers*) 1. Alarm clock, 2. Hangover, 3. Surgeon Gener-
al's Warning, 4. And this dude that's loudly snoring.

Sometimes, I get fed up; I want to change my ways

But why? Ptsh, I'm the life of the party.

TIYANNA: (*Twirls cup, takes a sip*) And I'm like, girl... I've been
drinking since 16

I know what I'm doing

I'm moving my hips, swayin' these curves

Making money, playing men, drinking, promiscuous, smoking.

Middle-class, high-priced whoremonger

High-priced, middle-class druggin'

12 Steps meetings with rooms of smoke and despair

Not working

Treatment, detox, and sober living

Fighting and stealing

Trailing comfortable chaos all over

At the same time, POLICE OFFICER 1 beats hard on TIYANNA's door and POLICE OFFICER 2 beats hard on HAWNDA's door. The girls drop their telephones.

POLICE OFFICERS: Police! You're under arrest!

OFFICERS arrest TIYANNA and HAWNDA.

HAWNDA and TIYANNA: (*Struggling to break loose from the OFFICERS while being hauled off. In unison*) Until I got locked up, when I took the time to get sober.

ALL exit the stage.

-III-

NARRATOR: (*Smiles, standing and gesturing.*) Let's see what these girls are up to now. Both are locked up; Hawnda and Tiyanna reevaluate their actions that led them to Mabel Bassett Corrections.

HAWNDA and TIYANNA walk together, talking, smiling, making thinking actions. As they recite the lines they get louder with each day of the week.

TIYANNA: Monday - Within my reach

Teached me the words that my soul seeked.

HAWNDA: Tuesday - Victims Impact

Teached me how to go about getting my life back.

TIYANNA: Wednesday - Mommy & Me

Teached me the true way to be a family.

HAWNDA: Thursday - Anger management aka Cage my Rage

Teached me on how to approach my problems in a healthy way.

TIYANNA: Friday - Thinking for a Change & NA

Teached me how to switch my addictive-behaviored brain.

HAWNDA: Saturday - Women in Transition

Teached me boundaries and how to make a difference.

TIYANNA and HAWNDA: (*In unison*) Sunday - Sabbath Day

Alone in my room I pray

That all my character defects

Fade away.

-IV-

The two women are on a beach vacation, after being released from incarceration.

NARRATOR: (*Continues to stand, looks serious.*) Again, let us fast-forward to ten years later. The years have been triumphal and have shown the girls favor. The scene takes place on a beach with a waiter. No alcohol, but piña colada flavor.

TIYANNA and HAWNDA relax on the beach, splashing in the water.

HAWNDA: Our journey has been tough, but it has not been in vain.

We did it only because of the Lord God's name.

TIYANNA: Once there were two girls, now two women.

We've come through triumphant. Let's cheer to our new beginnings.

GIRLS clink glasses in a toast.

Scene 9. Repairer of the Breach

Sharee Asberry

SHAREE is sitting in a chair on the phone. All other voices come from offstage.

SHAREE: Don't bring my kids up here.

MOM: Sharee, they are asking questions. You've got to see them.

SHAREE: No, do not bring them up here. I don't want them to see

me like this.

SHIANN: Momma...

SHAREE: Yes, Shiann.

SHIANN: I'm not mad at you, and I understand.

TREVONN: Momma, I don't know you anymore.

SHAREE: Yes, you do, Trevonn, you know Momma. You just haven't seen me.

TREVONN: Can this window open?

SHAREE lightly pushes on the window in front of her.

JAQUALIN: Momma, you said that you were coming home, and I've been waiting and waiting.

JUDGE: We find the defendant guilty.

Sound of gavel slams.

TREVONN: Momma, do you really have to do 38 years?!

MOM and DAD come from opposite sides of the stage and then turn their backs to each other. SHAREE looks at her DAD.

SHAREE: You know what Dad, you're the reason why I'm here. I was never good enough for you! (*Turns to her mother.*) And you know what, Mom, you are also the reason why I'm here. You act like you hate me.

DAD: (*Turns to face MOM's back, pointing.*) You're the reason why she's here. You act like you don't like your own daughter!

MOM: (*Faces DAD.*) Me? No, you're the reason why she's here. She can't even talk to you!

SHAREE: Mom, Dad, stop it! (*DAD throws hands up and walks off.*) Dad, where are you going? (*MOM rolls her eyes and walks off.*) Come on, Mom, don't leave. (*Sits down in the chair.*) I'm the reason why I'm here.

MS. J walks on and sits next to SHAREE.

MS. J: What is that on your face? Dry up those tears. Forgive yourself and allow God to heal you, and then you'll be able to forgive everyone else.

SHAREE: I'm trying, but it's too hard.

MS. J: Nothing is too hard for God, honey. The Lord is raising you up to be a repairer of the breach in your family, but you've got to get out of the center.

SHAREE: My family is crazy. They ain't gonna listen to me.

MS. J: Seek God and He will give you direction and the words to speak. This is an open door, so get yourself together. It's time to set some things straight, starting with you.

SHAREE: Yes Ma'am. (*MS. J exits. SHAREE picks up the phone.*) Mom, I need to see you and the kids on the 26th. It is important. (*Hangs up. Picks up the phone again.*) Dad, come on the 26th, I've got to talk to you about something. It's important. (*FAMILY walks into the visitation room looking at each other crazy.*) Thank you for coming. I know that things have been rough and you all rode with me to the best of your ability all of these years. I called everyone together because between us there should not be any secrets or lies. We're family and we love each other. This is blood and nothing should come between us. There's always been an uneasiness when we are all together in the same room and it shouldn't be that way. I want to start off with saying forgive me for all that I have put you through.

DAD: Aww, it's okay.

SHAREE: No, it's not okay and I know it. That is the whole purpose of this meeting. To be real and not go on like nothing is wrong and this is normal. So I am apologizing and repenting for all that I've done to hurt you.

DAD shakes his head. MOM smiles.

DAD: I'm proud of you. Well, let's get something to eat.

DAD, MOM, and TREVONN go to the vending machines. SHIANN and JAQUALIN freeze at the table.

SHAREE: (*Walks behind SHIANN and speaks to her.*) Queen, when I missed your graduation, though I acted as if I was okay, I bawled like a baby. It was bittersweet, though. I just couldn't believe that I wasn't there, but I was so proud of you. What you don't know is, in about six months, after enrolling in college, a bad experience will provoke you to drop out. You'll meet a knucklehead and end up getting pregnant. Your longing will grow deep, as you yearn for the presence of me and your father. And in the wee hours of the morning, the Lord will encounter vigorous prayers invading the heavens on your behalf. And I will watch the declaration of your healing manifest victoriously. (*Walks over to JAQUALIN.*) You'll be graduating soon and I'll be missing that, too. But afterwards I'll be asking you to make a decision about college while your grandfather tries to get you to enlist in the military, which I am totally against. But the pressure will drive you further away to the wrong crowd. You'll experiment with hard drugs until you're unrecognizable. Nineteen years old, you're just a baby. From the deep core of my aching soul, I will cry out to the Lord with a petition, appealing with groans and utterances too deep for words. He will deliver you from the snare as you become a young man of valor. (*Moves front and center*). Before the foundation of the earth, created in the mind of Excellency, we are a particular family—ordained in the blueprints of a God who reigns and creates without shame. We now stand, only by the strength of His hand, held in the palm of His plan. Not meant to survive—oh, no!—but viciously rise... We will not die, but live and declare the works of the living God.

Scene 10. Reasonable Doubt

Angelina Cicone

Scene opens on ANGELINA standing in front of three inmates positioned around a "cell." One lies on the floor (WOMAN ON FLOOR) with her shirt wadded up for a pillow. One is frozen, mid-pace (WOMAN PACING) and one sits next to the toilet staring at it (WOMAN NEEDING TISSUE). ANGELINA faces the audience while making a "phone call." All are frozen behind her while she speaks. GUARD is standing frozen "outside" the cell.

ANGELINA: Mom? Mom, (*Lets out a long breath*) they offered me 20 years. (*pause*) He says trial is risky. (*pause*) Thank you for believing in me, but I'm terrified. How can I put my life in the hands of 12 complete strangers? (*pause*) I don't know what I'm gonna do. I'll talk to you later. (*pause*) Love you, too. (*Hangs up phone. Addresses audience.*) Have you ever had to make a decision? I mean, like, a really important decision? One that would determine what your life would look like next? Have you ever found yourself in the middle of a moment that would give way to your entire future?

ANGELINA sits in the cell as all unfreeze. Her head is in her hands.

WOMEN NEEDING TISSUE (*WNT*): There's no toilet paper. (*Sounding disappointed.*)

WOMAN ON FLOOR (*WOF*): I miss my kids.

WOMAN PACING (*WP*): I really hope something good happens in the courtroom today.

ANGELINA: (*To self.*) God, please let my attorney show up!

WP: (*Stops, head jerks toward ANGELINA.*) You got a paid attorney?

All heads turn towards ANGELINA. Everyone freezes as she turns to the audience.

ANGELINA: (*Addressing audience.*) Saying you have a paid attorney around people in county fighting cases can be the equivalent of confessing you just happen to have a lamp in your back pocket containing a wish-granting-genie. The sad truth is paid attorneys show up and fight. Public defenders are hit or miss—ensuring that there will always be subtle ways to oppress the poor. (*INMATES unfreeze as she turns back. To WP*) Yeah. (*Looking slightly embarrassed.*)

WP: Thank God for the Great American Dollar, huh? (*Smiling sarcastically.*)

GUARD: (*Opens cell door and yells.*) You're all going back! Public Defenders rescheduled.

Collective "Awwwww," grumbling.

WNT: Can we please get some tissue?!

GUARD slams the door. ANGELINA leans back with her eyes closed. At this point, MARCUS walks onstage and mouths silently to guard. GUARD opens the cell door.

GUARD: Inmate twelve-hundred, six-hundred? (*ANGELINA sits up abruptly, then stands.*) Your attorney's here.

WNT: (*To GUARD.*) Ma'am? We really need some tissue.

GUARD: You might as well stop asking. I'm only going to keep ignoring your basic human needs.

GUARD grabs ANGELINA by the arm and takes her from the cell, shutting the door behind. Once she's in front of MARCUS, MARCUS extends hand for a handshake, while GUARD returns to "post." All freeze while ANGELINA addresses the audience.

ANGELINA: My attorney's hair is braided into a rat-tail. He's a jiu jitsu fighter by night, a tattooed defender of the moderately wealthy by day. He's wearing Armani shoes. Today is the day of my trial.

MARCUS: (*As they shake hands.*) You look ready.

ANGELINA: I am... I think. How can you be ready for something like this?

MARCUS: Good question. The D.A.'s made another offer. (*ANGELINA looks angry. MARCUS puts hands up defensively.*) I know, I know. (*Placating.*) But I think you should hear it. (*ANGELINA raises her brows in question.*) Five—violent. She says it's a "gift," and that you should take it while she's in the mood for giving.

ANGELINA: (*A look of anger and disbelief*) Did she? (*pause*) Would I have to plead "guilty?" (*MARCUS nods. ANGELINA moves to center stage to address the audience and MARCUS freezes.*) Does justice ever really seek the truth? Is the real concern conscience, or a conviction? Who is helped when facts aren't followed but arranged around a preconceived notion? When does the fight for the truth become a fantasy—unwise and dangerous? Just how far do you go in the name of unraveling a lie? (*Walks back over to MARCUS and continues addressing the*

audience.) A long moment stretches out… a moment like a crossroads, like history in the making. A moment a lot like fear, but more like courage. It is a precipice—an intersection with destiny. (*Unfreeze.*)

MARCUS: How old are you now?

ANGELINA: 29.

MARCUS: How old will you be in 20 years?

ANGELINA: 49. (*Silence. Deep breath. ANGELINA stands.*) You tell her she can keep her "gift." We're going to trial.

ANGELINA turns, MARCUS leaves, and the GUARD opens the cell door and closes it behind ANGELINA. All unfreeze - WP continues pacing, WOF readjusts, etc.—as ANGELINA is seated. WOF begins singing "Closing Time" and snapping her fingers. She stops and looks around.

WOF: Nobody?

ANGELINA: (*Addressing audience.*) We hold these truths to be self-evident…

WP: (*Stops. To Audience.*) That all men are created equal…

ANGELINA: (*Looks up.*) That they are endowed by their creator with certain unalienable rights…

WO:F That among these are Life…

WNT: Liberty!

ANGELINA: And the pursuit of happiness.

Finale

Entire cast joins hands across the stage, facing the audience.

ALL: (*In unison*) We have a voice! We have hope! We have the power to change the world!

Chapter 15

Opportunities for Hope are Created

Students and Melissa Švigelj

I couldn't possibly imagine a more imposing, sterile, drab, or tragic construction of space than the place where I taught the last four years of my twenty-year career as a high school teacher (1998-2018). The majority of the county juvenile detention center's (JDC) walls were concrete blocks painted a squint-inducing white as if to remind everyone of the incessantly glaring yet mysterious eyes that were viewing screens linked to cameras watching everything and everyone whether moving or still. However, within our classroom, learning and literacy endured and developed in a variety of forms that I was privileged to witness and accompany. This is an offering of the many hues of love and insight that dared to encroach upon the bare walls at the JDC, converting them into a canvas.

Although the abolition of the prison industrial complex, and the dismantling of the oppressive systems and structures that contribute to it, is what I ultimately advocate and strive towards, I also took incremental and strategic actions to transform our classroom space at the JDC. This transformation provided the illusion of a reprieve from the violence of captivity and removal from loved ones that was the actual existence encountered while I was an educator there. Trust was hard-earned, and deservedly so, as these young male students ages 15-19 continued to be betrayed by many systems designed to do exactly what they are doing—although the stated missions of these various institutions may contradict the material realities they unequally dispense. Schools, the police, courts, child services, social services, wages, housing; the unequal consequences for some children and their fam-

ilies living within structures designed to re/produce an inequitable, segregated, white supremacist, heteronormative, patriarchal, ageist, monolingual, and ableist society are blatantly evident in the midwestern county where I lived and worked for twenty years.

This chapter is escorted by an intention to uplift the art and literacy of the youth who engaged with artists during a collaborative project between our classroom at the JDC and multiple arts organizations. Accepting scholar Eve Tuck's invitation to join her "in re-visioning research" (2009, p. 409), and to avoid being another layer of surveillance in communities already highly surveilled by various apparatuses of the state, this submission humbly seeks to be situated in visions similar to scholar Kim TallBear's (2014) conception of more ethical methodological innovations in research and publications. Operating within norms of the biological sciences, TallBear describes her efforts to "stand with" and inquire "in concert with" colleagues and the people the research is intended to represent. In agreement with TallBear's assertions, although acknowledging my own deficiencies and limitations, I also "find it doable to attempt to combine theory with practice for institutional change" (2014, p. 6). Although multiple factors contributed to their graduation from high school beyond opportunities for art, the quotes included in this submission are from students who graduated from high school while intermittently attending a JDC, which is significant to acknowledge because that accomplishment has been described as a rarity.

The culminating art event from the students' biweekly artistic experiences at the JDC was in the spring. It included one wall of an art gallery dedicated to displaying their creations during an exhibition that featured local community artists. It was also an opportunity for the youth to be celebrated while entangled in a system constructed to render them deficient and delinquent, even as the youth and their families resisted these damage-based assessments. Access to the art workshops in our classroom at the JDC was made possible by a grant I received from the NoVo Foundation whose stated mission on their website is "to foster a transformation from a world of domination and exploitation to one of collaboration and partnership." Bringing the arts to the JDC was no small feat as there are endless restrictions regarding what can be brought into the facility and what can leave the classroom (every pencil was supposed to be accounted for before

students left class). Our leading partner organization, SPACES, and their community coordinator, Michelle Epps, were wonderfully accommodating and creative and introduced a variety of mediums that students could engage and experiment with. Without these biweekly art workshops, young people had no access to any system-approved form of artistic instruction or outlet.

Create it Forward: Realizing the Potential in our Incarcerated Youth

Is a collaborative project bringing arts programming into the classroom of teacher **Melissa Marini Švigelj-Smith's senior class** at the Cuyahoga County Juvenile Detention Center. This program brings together art organizations and artists to provide art making activities. Organizations and artists include SPACES (lead partner), Art House, artist Josh Usmani, Twelve Literary, Zygote Press, Culinary artist Bea Švigelj, Donovan from *The Cooler Boys*, and Creative Fusion artist Michela Picchi. This program has been made possible from a grant from the NoVo Foundation, whose mission is to foster a transformation from a world of domination and exploitation to one of collaboration and partnership.

Image 1. Realizing the Potential in our Incarcerated Youth

One of the restrictions the school district and county collaboratively enforced was a ban on anything and everything that could potentially be linked to gang activity, including the names of streets which were only significant if those streets were known to be located in certain areas of the city. These youth were denied all access to the slightest or teensiest bit of capital, including gang significations, yet they resisted and subverted often through their art. Unfortunately, some of their boldest subversions had to be repurposed in order for them to be publicly displayed so we created a sign from some of the letters students painted. The sign was placed on one end of the wall during the public exhibition in the spring art show along with the other sign entitled "Realizing the Potential in Our Incarcerated Youth."

Image 2. Lettered sign

Although many people within the school district and in the county were completely unaware that there was a school at the county juvenile detention center, the students were quite aware of the forces of disposability and the differential access to childhoods allocated and coordinated against them. Young people commonly named the oppression they continuously resisted and renounced while never giving up on imagining alternatives imbued with opportunity, family, relationality, and community.

Learning, literacy, and graduation happened while these youth were simultaneously surviving a system that functions as an apparatus to traumatize and enclose. On these next few pages, their words will accompany the art they formed. The visuals and words offer a glimpse into the multiple literacies the youth possessed and expressed as they resisted the narratives surrounding the socially and culturally constructed "delinquent."

"It's hard to mold a classroom into a good environment."

—Cameron , former JDC student/high school graduate

Image 3. Clay pot making with Lauren Herzak-Bauman

168

Image 4. "My momma keeps me going and that's my biggest supporter. I'm a family person. My momma...
If I don't get back to anybody else, I gotta get back to my momma."
—Taylor, former JDC student/high school graduate

Image 5. "One thing about me is that I can't trust nobody but my mother... I can't depend on nobody but
my mother because every time, EVERY time... she's the only one that be there." - Jordan, former JDC
student/high school graduate

"Just taking care of my child and my mom, that's the only thing I
care about, for real for real."
—Dana, former JDC student/high school graduate

169

Image 6. Día de los Muertos Masks painted by students with Italian muralist Michela Picchi and on display at the gallery during the spring show

Image 7, 8. Día de los Muertos sugar skulls decorated with Mark Yasenchack from Art House

"A lot of people stereotype young black males."
—Dana

171

Image 9, 10. Painted by students with Italian muralist Michela Picchi and on display at the gallery during the spring show

"Everybody is a follower but you gotta be a follower to become that leader you wanna be... Yeah I'm a leader. For sure."
—Taylor

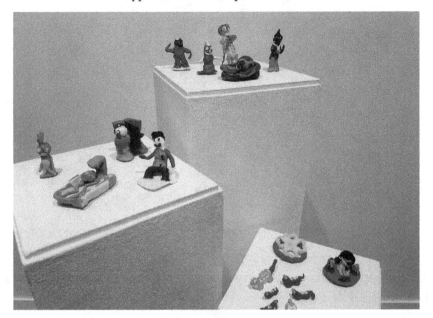

Image 11, 12. Student creations from sculpting with Josh Usmani on display at the art gallery

Image 13. Students cartooning with Josh Usmani

"Everybody in here got something good about them, you feel me? But it's just we are labeled"
—Dana

"I know it be hard, and sometimes you feel like it ain't for you, but it's very important because without your education, especially getting your diploma, it's hard to do a lot of stuff."
—Cameron, offering advice to a younger student

Image 14. Students decorated cupcakes with culinary artist Bea Machado to share with younger students

"Growing up my color, coming out the womb you a target, so you gotta fight that target."
—Taylor

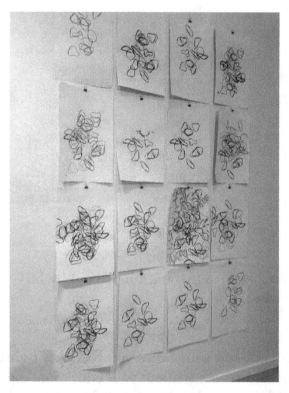

Image 15. Student creations and art gallery display from silk screen printing with Zygote

Image 16, 17. Silk screen printing

It is my contention after twenty years of teaching in city high schools that in order for any literacy or learning to occur, classrooms must be facilitated with compassion, be trauma-informed, and include spaces for creation and community. My experiences also shepherd my asser-tion that students whom the state stashes away in captivity and labels as "failures" and/or "criminals" embody spirits of resilience, brilliance, and an insatiable desire to express gratitude and give generously. They deserve much, much more than what they are offered/denied. This "much more" includes the abolition of juvenile detention centers along with the abolition of the prison industrial complex and schools. In their places, a re/construction of the landscape can manifest without walls or borders that contain and without labels that categorize, rank, and punish. Better ways of living and being are not only imagined but possible as the youth represented in this chapter demonstrate. Yet, as Taylor shared during his podcast, "You gotta just keep fighting. This is a war you're in. We are at war and I live in this war but you gotta keep fighting."

Keep fighting and know that you're not alone.

Melissa Marini Švigelj

Melissa Marini Švigelj was an award-winning educator before re-tiring from teaching in Cleveland public high schools and is now a Ph.D. student in the Education Department at UC Santa Cruz. She explores through her non/art how we might create im/possibilities for becoming through critical pedagogies in a praxis of relational learning and care.

References

TallBear, K. (2014). Standing with and speaking as faith: a feminist-indigenous approach to inquiry. *Journal of Research Practice*, *10*(2), no. 17. http://jrp.icaap.org/index.php/jrp/article/view/405/371

Tuck, E. (2009). Suspending damage: A letter to communities. *Harvard Educational Review*, *79*(3), 409-428. doi:10.17763/haer.79.3n0016675661t3n15

Chapter 16

Sunday Morning

Jax

Freshly mown grass
and trees fully leaved;
a small breeze teases my hair
 and caresses my face
 and dances over bare legs;
tipped back in the chair,
journal in my lap,
 the sun peeks out
 from behind clouds thinning
 to spun-sugar wisps;
earphones plugged in,
organ music feels nostalgic,
 comfortable, appropriate—
I'll take two servings of Bach this morning,
 thank you;
flower beds fighting for attention—

who plants Bachelor's Buttons and Morning Glories

in the same space?

The elderly push the infirmed

to the early Sabbath service.

This is a very particular crowd.

Watching them go to worship,

I am almost jealous

 of their shared experience;

however,

being the proverbial square peg

in a round hole,

there are so many, many reasons

I would not fit there

 (Some even of my own choosing).

No, this natural sanctuary is mine,

and I claim it

 daily,

making prayer the best way I know how

to the god of All of the Above

 and None of the Above,

a part of everything

 and nothing,

even the razor wire

I refuse to see

This lovely Sunday morning.

Jax

After more than twenty years in prison, Jax remains dedicated to the success of her peers. "When they leave here," she says of her friends and students, "they take a small piece of me out in their back pockets. Their success is my success. Their newfound independence is my freedom."

Chapter 17

Epistemic Assets

Raymond Banks

After violating parole in 2006, I was sent to San Quentin Prison, West Block, where prisoners are held before they reach their final destination. During the day and into the evening, I heard the phrases "hot water on the line" and "no hot water on the line." Having plenty of hot water for my soups and coffee, I was not really worried about it and mentioned to my cellee that there seemed to be a lot of plumbing problems here at San Quentin, because there is a lack of hot water. He laughed and said, "No fool, hot water is the police."

Even though I had a cognitive or literal understanding of the phrase "hot water on the line," I did not have the socio-cultural context to understand the term. I did not understand the social and cultural context of the phrase because I did not understand the San Quentin prison discourse. This experience underscores the argument that cognition alone is not necessarily sufficient for understanding (Mirabelli, 2009). Rather, Mirabelli contends that one also needs to be aware of the social and cultural context in order to have understanding. If individuals do not understand the social and cultural context in which a phrase is used, then it is unlikely that they understand the full meaning of the phrase or discourse. More precisely, students know the meaning of a statement, phrase, or proposition if and only if they understand the social and cultural context in which the phrase is embedded.

This experience led me to the realization that what I am calling *epistemic assets*, lived experiences from familiar discourses, such as prison and incarceration, can be used as metaphors and/or arguments by analogy to interpret, explain, and analyze unfamiliar discourses

such as academic theories and paradigms. Supposed knowledge deficits manifest when non-traditional students are perceived as lacking the skills and knowledge needed to understand and navigate these academic discourses. Put differently, because students have been in institutions such as prison, they are seen as lacking the knowledge required in order to be successful academically and socially in the university environment. However, I will argue that because of their lived experiences, formerly incarcerated students do not necessarily suffer from knowledge deficits, but have *epistemic assets*; their lived experiences based on encounters with institutions have epistemological and academic value.

This paper explores a constellation of theoretical frameworks and practices in order to demonstrate the relationship between lived experience, academic theories, knowledge, skills development, and literacy. It will also show the inextricable link between my incarceration and my pedagogical approach to tutoring, mentoring, and teaching practices. Throughout this paper, I will demonstrate that non-traditional students, such as justice-involved students, do not suffer necessarily necessarily from "knowledge deficits" but have epistemic assets, which need to be recognized and valued in the classroom.

Theoretical Frameworks

Knowledge Deficits

For the purposes of this paper, "knowledge deficit" is the idea of "[an educational] system's tendency to focus on a student's weaknesses (e.g. "learning disability," "cognitive, impairment," "emotional-behavioral disorder") rather than a student's strengths" (Wasburn-Moses, 2017). A knowledge deficit can also be described culturally. According to Silverman (2011), "A cultural deficit perspective consists of two parts: (a) the attribution of an individual's achievement to cultural factors alone, without regard to individual characteristics; and, (b) the attribution of failure to a cultural group. In other words, a cultural deficit perspective is a view that individuals from some cultural groups lack the ability to achieve just because of their cultural background." Another way to understand knowledge deficits is to say that non-traditional students are believed to lack the knowledge of the discourses required to suc-

cessfully and effectively navigate institutions such as universities. In short, people like incarcerated individuals are not exposed to academic discourse; hence, the perceived knowledge deficit.

Perhaps, the best way to illustrate the distinction between knowledge deficits and the term I am introducing, *epistemic assets*, is to employ Freire's (1972) distinction between the Banking Model of Education and the Problem-Posing Model of Education. According to Freire, The Banking Model of Education:

> leads the students to memorize mechanically the narrated content. Worse yet, it turns them into 'containers,' into 'receptacles' to be 'filled' by the teacher. The more completely she fills the receptacles, the better a teacher she is. The more meekly the receptacles permit themselves to be filled, the better students they are. Education thus becomes an act of depositing [knowledge], in which the students are the depositories and the teacher is the depositor. (p. 72)

This theory implies that students are fundamentally "tabulae rasae" or "clean slates" (Lexico, n.d.). In other words, students, especially non-traditional students from underserved and underrepresented backgrounds, lack the knowledge of the discourses of academia and do not have anything to offer the campus community. More precisely, continuing the banking metaphor, non-traditional students, such as justice-involved students, are epistemically bankrupt; they do not have any epistemological capital/currency or epistemic assets.

In contrast, the problem-posing model of education posits "people develop their power to perceive critically the way they exist in the world in which they find themselves; they come to see the world not as a static reality, but as a reality in process, in transformation" (Freire, 1972, p. 83). Freire also contends "problem-posing theory and practice takes the peoples historicity as their starting point" (p. 84). Similarly, epistemic assets also take a student's history or lived experiences as their starting point. One can interpret Freire to mean that lived experiences, which are the content of epistemic assets, have multiple benefits.

For example, epistemic assets serve a social function. Instead of feeling isolated in the classroom, students can now use their epistemic assets as a lens of explanation, interpretation, or analysis. Because of this, students can now offer alternative interpretations or explanations of theories, which in turn allow them to contribute to and

be a part of the campus-learning environment. In fact, Freire implies that non-traditional students, such as the so-called impoverished communities that he worked with or the justice-impacted students I work with, have a first-hand experience or knowledge of institutional structures such as hunger, prison, homelessness, and discrimination. Whereas researchers or academics use their theoretical imagination as a way to understand and address social, political, and philosophical issues, individuals from non-traditional communities are better positioned to utilize their epistemic assets to pose problems that their community thinks are important and resolve them.

Discourse

The second theoretical premise is based on Gee's (1991) notion of discourse. He defines discourse "[as] a socially accepted association among ways of using language, of thinking, and of acting that can be used to identify oneself as a member of a socially meaningful group or "social network" (p. 3). According to Gee, there are two discourses, primary and secondary. He claims that primary discourse "is the one we are born into. This is the language of the family, and this way of communicating is acquired as opposed to learned" (p. 5). In contrast, he states, "Secondary discourses, however, involve intentional, formal teaching, analytic thinking and the ability to critically reflect on the discourse being learned. Secondary discourses typically are the kind of language use we find in classrooms and workplace training programs, and are connected to 'secondary institutions' including schools, types of workplaces, businesses, government offices and churches" (p. 8).

Gee (1987) also notes, "it is of course a great advantage when the secondary discourse is compatible with your primary one" (p. 8). Gee is suggesting that for the middle and upper class, the Primary and Secondary Discourses are more like concentric circles, overlapping each other, which gives individuals an advantage when they enter institutions such as college. In contrast, for populations such as the previously incarcerated, there is a huge lacuna between Primary and Secondary Discourses. According to Mirabelli (2009), to master a secondary discourse for Gee is to be literate.

However, I disagree with claims that analytic thinking and the ability to critically reflect happen only in Secondary Discourse. Instead I propose that an agent can critically reflect in both discourses.

Therefore, for the purposes of my work, I posit that Primary and Secondary Discourse are analogous to familiar and unfamiliar discourses, respectively. More precisely, I suggest that one can use their epistemic assets, the Primary or familiar discourses, as metaphors and/or arguments by analogy to be literate in, analyze, explain, and/or understand Secondary or unfamiliar discourses such as academic paradigms or theories.

Metaphor

The third theory is based upon the Aristotelian notion of metaphor. In his treatise on rhetoric, Aristotle (1984) wrote, "To learn easily is naturally pleasant to all people, and words signify something, so whatever words create knowledge in us are the pleasantest. Metaphor most brings about learning; for when [Homer] calls old age "stubble," he creates understanding and knowledge through the genus, since both old age and stubble are [species of the genus of] things that have lost their bloom" (1410b). In Rhetoric III, Aristotle holds, ". . . Metaphor especially has clarity and sweetness and strangeness, and its use cannot be learned from anyone else. One should speak both epithets and metaphors that are appropriate, and this will be from analogy. If not, the expression seems inappropriate because opposites are most evident when side-by side with each other" (1405a). I take Aristotle to mean that metaphors have value if and only if they are based upon analogy, the process of arguing from similarity in known respects to similarity in other respects. Crockett (personal communication, 2016), defines analogy as "when two things are similar in many important and relevant ways, they are probably similar to each other in the way at issue." In other words, if metaphors are based upon analogy, then they can also be understood as the basis or foundation for arguments from analogy. If metaphors are not based upon analogy, then the metaphors are inappropriate, incoherent, or seem inapplicable. I also understand Aristotle to mean that if metaphors are a natural way of learning, then one does not necessarily need formal education to acquire or understand the notion and application of metaphor. Therefore, I posit that metaphors are a natural or informal way to bridge or promote understanding between Primary/familiar and Secondary/unfamiliar Discourses.

Each of the above theoretical frameworks provide the foundations

for understanding how epistemic assets or the idea that lived experiences from Primary or familiar discourses, such as prison or incarceration, can be used as metaphors and/or as arguments by analogy to interpret, explain, and analyze Secondary or unfamiliar discourses such as academic theories and paradigms.

Analysis

Epistemic Assets

To further develop this idea of epistemic assets, I return to the example of hot water on the line. While the phrase "hot water on the line" means the "police" in San Quentin prison, in the San Francisco county jail, the place where inmates are held before they are sentenced to prison or convicted, the term hot water on the line means that the trustees are bringing hot water so that individuals can make their soups and spreads. There are at least two meanings for the same phrase because of the different socio-cultural contexts.

In other words, if one employs epistemic assets, then one can have a different explanation for that theory or idea. I ask the reader to recall the proposition that learning and literacy are social and cultural phenomena. To illustrate this point, Mirabelli (2009) draws from two newspaper articles, one from New Zealand and the other from the United States, focusing on cricket and baseball respectively. In the United States, most people have a social and cultural context for baseball, but not cricket. The lack of background knowledge about the sport of cricket has a dramatic impact on one's ability to read or understand the news article. After reflecting on these examples, I realized that I could substitute the phrase "hot water on the line" as a way to explain the theory that "learning, like literacy, is a sociocultural phenomenon" (Mirabelli, 2009, p. 15). Both the example of "hot water on the line" and cricket have explanatory power and neither one is essentially better than the other. However, and this is the important point, each example may resonate with one community and not necessarily the other.

"Hot water on the line" made me realize the potential, importance, and value of epistemic assets as a way to explain academic paradigms or theories. More specifically, this example shows that my epistemic

assets regarding the phrase "hot water on the line" used in prison could be utilized as a way to understand academic theory, such as Mirabelli's (2009) theory of learning. These experiences were something that I could build on, instead of assuming that justice-involved students, like myself, and operating from the position of knowledge deficits. Conversely, epistemic assets can make a person uniquely qualified to critically assess a wide array of institutions and social issues such as racism, gender inequity, mass incarceration, and other injustices of social import, providing the opportunity for a top-down and bottom-up analysis when combined with formal educational opportunities.

Epistemic assets should be legitimized by the canonical discourse of higher education in order for their full value to be realized. To reiterate, non-traditional students do not necessarily suffer from knowledge deficits, but rather these students' lived experiences have epistemological capital or are epistemic assets. As Freire posits, everyday, personal, or lived experiences, interactions with institutions such as poverty, prison, or patriarchy are now seen in terms of existential exemplars, which can engender alternative ways of understanding what it means to be a part of one's community or the university. In sum, if epistemic assets can promote social awareness and create epistemological and pedagogical capital, then it seems clear that their value has been demonstrated.

If one accepts the axiological importance or value of the idea of epistemic assets, then it seems to follow that there should be an attempt to design a curriculum that accentuates these assets or fosters the use of existential exemplars from familiar discourses based upon lived experience as a model or as way to navigate the campus and understand academic discourses, theories, and paradigms. By doing so, one can promote an inclusive and empowering curriculum which in turn can create a sense of love and belonging to the campus community. To illustrate the viability and practicality of such a curriculum, I shall use the example "peeping game" or "con" in order to explain critical thinking, and the metaphor of a court case and writing a letter home to a family member as a way to understand philosophical writing.

Peeping Game or Con—A Metaphor for Critical Thinking

I apply the principles of utilizing epistemic assets in curriculum

through an example that helps explain critical thinking or analysis to justice-involved students. Highly specialized definitions like the one from the Scriven and Paul (as cited in The Foundation for Critical Thinking, n.d.) assert, "Critical thinking is the intellectually disciplined process of actively and skillfully conceptualizing, applying, analyzing, synthesizing, and/or evaluating information gathered from, or generated by, observation, experience, reflection, reasoning, or communication, as a guide to belief and action." Rather than using a highly technical definition, which is complex and could be difficult for someone new to academia to understand, I introduce the idea of "peeping game" to my students as a different approach to critical thinking. Critical thinking is presented as a way of structuring your thoughts around questions of "truth, meaning, and justification" (H. Sluga, personal communication, September 2016). Building on this idea, I add instantiation—instances or examples, and/or counter-examples and agreement. More specifically, do I agree or disagree with the claim and perhaps most importantly, why do I agree or disagree.

Although there are a variety of ways to interpret the notion of the peeping game, I will share one from my lived experience as a justice-involved heroin addict. I had to learn how to tell what an individual's true intentions were; how not to be conned, or how to peep game. To explain it another way, I tell my students to read and listen carefully in order to ascertain an author's true intentions. When reading, one is trying to discover what or why the author, for example the author of a theory, is either trying to talk you into believing or out of believing. More precisely, using the metaphor of peeping game; peeping a thesis, argument, or conclusion, as a way to explain critical thinking is really asking why one should adopt a belief system or what the reasons or premises are for doing so and if the conclusions follow from those premises. Does the con work or not and why? Peeping game is a metaphor for rigorous scrutiny or analysis and can be applied to prison or the university.

Peeping game, or critical thinking, is a way to organize one's thoughts around meaning, truth, justification, agreement, a set of basic questions or precepts, or general rules intended to regulate behavior or thought. Peeping game is examining what a theory, article, argument, or topic means and asking if it is true, false, or plausible. Peeping game involves asking if I can provide any instances, examples,

or counter-examples and questioning the arguments for and against that particular concept. Whenever people are employing these practices they are playing the peeping game. For example, whenever students ask whether or not theory X is true, they are playing the peeping game. Whenever students ask what the arguments for and against a theory are, they are playing the game. When students ask what a theory means, they are playing the game. Whenever they state or explain why they agree with a claim or argument, they are playing the peeping game, and whenever they find a counterexample to a theory, then they are most certainly playing the peeping game.

I further contend that these fundamental principles of peeping game or critical thinking can be adapted to other principles or practices such as—annotating texts, finding an example or counterexample of a theory, posing problems and answering them, putting arguments and definitions into one's own words, and determining the truth or falsity of statements and propositions. Furthermore, whenever students are pre-reading, identifying the thesis and conclusion of articles before reading the rest of the text, they are constantly posing questions as to why and how the author arrived at the conclusion.

If justice-involved students put arguments and definitions into their own words, then they are thinking critically or playing the peeping game. If they are signposting premise and conclusion indicators while reading an article, then they are playing the peeping game by discerning the logical structure of the articles. After being taught these principles by way of a curriculum, whenever students play the peeping game, they are reflexively applying the above axioms and realizing them with the aforementioned practices. Through using their epistemic assets, their knowledge of the peeping game, I am able to help them bridge these experiences to practices in the university classroom.

Metaphors to Explain Philosophical Writing

Court Cases

Through metaphor, epistemic assets can also be incorporated to help develop skills such as academic writing. For example, the metaphor of a court case can be seen as a way to explain the structure and content of philosophical writing. At first glance, a court case and how to

write a philosophy paper seem dissimilar. However, critical reflection shows that there are similarities in the structure, their constitutive elements, and content. For instance, a defendant in a criminal case and the thesis in a philosophy paper are metaphorically interchangeable. Additionally, the primary actor in a court case is the defendant and in a philosophy paper it is the thesis, and both can be attacked and defended.

Stated another way, the overall structure and composition of a court case and a philosophical paper are similar. They introduce an argument, present the argument, and conclude the argument. Both share a similar goal, which is to get your professor, essay reader, audience, interlocutor, judge, or jury to accept your position or conclusion. In one instance, the focus is on whether the defendant is guilty or innocent and in the other the question is whether your thesis holds or not. Of course, guilty or not guilty and the idea that a thesis holds or does not hold are not necessarily identical, but their ends are similar which is to persuade the audience beyond a reasonable doubt. They both, however, seem to engender a similar outcome, acceptance or denial of the claim or argument, which can translate as acceptance or denial of a defendant's guilt or innocence. Both arguments for or against a defendant or a thesis are something that can be criticized and defended.

Closer examination shows that an opening statement is similar to the introduction of a philosophy paper. Whereas the court case introduces its argument or claim of innocence or guilt with an opening statement, the philosophy paper does so with an introduction as a road map for the essay. In both instances, they outline what they plan to demonstrate, prove, and eventually convince their audience to accept or deny. Next, they both present their arguments in detail, providing reasons, evidence, or analysis to support their opening or thesis statement. In the court case, this includes witness statements, scientific analysis, expert witnesses, and precedents to exonerate or convict the defender. In contrast, in the philosophy paper, the author reconstructs the philosophers' views and explains why the philosopher held them. This can be summarized as an exposition or explanation of the philosopher's position, which is analogous to reconstructing the scene of the crime of a court case. Then, the analysis of the evidence in the court case can take the form of cross-examination and objections

when noticing claims, which are inconsistent or false. Similarly, the analysis section of a philosophical paper also looks for flaws in reasoning, false claims, contradictions, erroneous or hidden presuppositions, or possible objections.

Finally, the philosophy paper and the court case end with a conclusion and closing argument, respectively. The attorney claims that they have shown or demonstrated the innocence or guilt of the defendant, while in the philosophy paper, the philosopher asserts that they have demonstrated that their thesis follows from the analysis. The jury, judge, or the instructor weigh the evidence and if the students or lawyer articulate their position well, then they receive a good grade or win the case. Perhaps there is one distinction. With a philosophy paper, the students can be either the defense attorney or the prosecution by defending or attacking their own thesis or the philosopher in question. However, the structure, introduction, presentation of evidence, and the conclusions result in a rough outline by which a person can organize their thoughts for a paper. This idea of metaphor is relevant because it is based on the epistemic assets of justice-involved students because many have experienced varying degrees of courtroom proceedings and these metaphors allow them to build on these assets in the practices of academic writing.

Letters Home

Another metaphor that I use to illustrate and explain academic writing is writing letters home to loved ones. This is a lesson I learned from an individual who spent an extended period of time in solitary. Like the court case, the components of a letter can mirror that of an academic paper. For example, in order to structure or organize their thoughts for essays, students could pretend that they are writing to their mom or other friends and family. However, in this case, instead of sharing what is going on in prison, they could write about what is going on in school. The following is an example of how a letter home could be structured.

"Dear Mom, today in class we learned about and discussed theory X. It can be defined in the following way. Here is an example of theory X. However, some object to theory X. However, I agree with the plausibility of theory X because of the following reasons. Nonetheless, still some may object to my

view. However, I would respond by asking them to consider this alternative."

This sample letter contains an introduction, analysis, and conclusion, generating a basic essay template. Like the court case, the letter home provides a bridge between the students' experiences and new academic practices.

One might assert that epistemic assets "dumb things down" for students. However, I contend that my model elevates the academic process because of the amount of critical thinking required in finding the "similarity in dissimilars," (Aristotle, 1984, 1459a) or involved in making the metaphorical linkages work in order to have sufficient explanatory power or provide a different explanans for the same explanandum. I have seen my justice-involved students utilize metaphor to respond to issues and theories. One student wrote that he disagreed with the idea of an infinite regress. Using prison as an example, he argued that there are foundational beliefs whose truth does not require another proposition to justify. Another student used the metaphor of a prison shot-caller to explain why forced or coerced covenants by Hobbes are justified. Using her epistemic assets, being in prison and as a student at Cal, her top-down, bottom-up view suggested that the four primary sentencing theories of incapacitation, deterrence, rehabilitation, and retribution are flawed because these theorists lack empathy since those doing the sentencing have not been incarcerated. They blame the individual instead of also looking at societal influences such as literacy and poverty. The epistemic assets or prison experiences of these students became a point of analysis and not a deficit, allowing them to enter into and participate in academic discourses that were previously closed off to them.

In these examples, I use the metaphors to connect to students' epistemic assets in order to explain paradigms and practices with which they are unfamiliar. My aim is to show that familiar skills and techniques, like letter writing, are transferable to the realm of academic discourse and the campus environment. This is to say that the academic discourse can be demystified by pairing it with previously acquired skills and knowledge.

Conclusion

Before I close, I wish to suggest a number of takeaways. First, the

above analysis has demonstrated how incarceration has shaped my approach to various tutoring, mentoring, and pedagogical practices. Incarceration has influenced my understanding of various educational, linguistic, philosophical, and social theories that I have encountered, and my creation of self-learned or created literacy and learning models and practices. In contrast to viewing me, and other justice-involved students, through a deficit perspective, my experiences demonstrate how the epistemic assets gained through incarceration can provide a lens for understanding theory. Scholars and educators can choose to see the value in what justice-involved students bring to formal educational spaces or they can continue to contribute to their minoritization on campuses by positioning them as deficient because they do not already have experience with formal academic practices.

In conjunction with valuing the epistemic assets of justice-involved students, I have demonstrated how those assets can have pedagogical, political, and social value. Through drawing on students' epistemic assets, such as through peeping games, court cases, and writing letters home, educators can help students develop academic practices such as critical thinking, constructing and deconstructing arguments, and annotation. This type of education represents a form of transformative knowledge, "[the knowledge] required to guide and support the process of human/social transformation" (Vargas, 1987, p 48). Like Vargas' concept of razalogia, "knowledge of and for the people," (p 48) epistemic assets are a way to advance knowledge of the group for advocacy and advancement of the collective. Through valuing what justice-involved students bring to the classroom, epistemic assets have the potential to transform students from passive to active learners because now they have the foundation to engage in conversations, communicate, and build bridges with other students, staff, and faculty. By engaging in these conversations, students can experience a sense of love and belonging, which according to Maslow (1943) leads to self-actualization or in this instance a successful matriculation. In the end, valuing and utilizing the epistemic assets that students bring to the classroom can contribute to the development of self-reliant learners who function comfortably across diverse academic discourses and environments using the metaphor of lived experience to do so.

Maybe most importantly, if epistemic assets are combined with formal education for justice-involved students, this provides the op-

portunity for a top-down, bottom-up view of the relations between institutions, theories, practices, laws, and policies that they have encountered or will encounter. Those with epistemic assets have a unique perspective because they have been through the system, both in terms of education and incarceration, and have experienced the flaws in these systems. They have seen how systems such as the prison, parole, probation, and re-entry promote recidivism. Reflecting Vargas' (1987) razalogia, as new graduate students, researchers, sociologists, and philosophers, armed with knowledge learned through formalized education along with our epistemic assets, we can postulate new theories and provide innovative policies that eliminate the flaws of the old systems. In other words, our lived experiences and academic background make us uniquely qualified to critically assess a wide spectrum of institutions and social issues such as gender inequity, mass incarceration, racism, healthcare disparities, and other injustices of social import.

To close, I am reminded of how Freire (as cited in Diaz, n.d.) proclaims, "I'm an intellectual who is not afraid of being loving. I love people and I love the world, and it is because I love people and I love the world that I fight so that social justice is implemented before charity." Freire reminds us that we cannot just exercise our minds, but also must exercise our hearts. If you open your mind, you must open your heart and if you sharpen your mind, then you must soften your heart. The ideas I have expressed in this paper would not have gone from *becoming into being* if it had not been for people and spaces on campus here at the University of California Berkeley like the Athletic Studies Center Tutoring Program, Philosophy Department, the Berkeley Underground Scholars, Tony Mirabell, Tim Crockett, Niko Kolodny, Hans Sluga, R. Jay Wallace, and Azadeh Zohrabi, all of whom not only cared about my intellect but also about my heart. These spaces and individuals were open to new ideas and different ways of seeing the world.

Thus, transformation is a collective effort and requires justice-involved students, staff and faculty to come together in order for the transformation of individuals and institutions to be successful. The epistemic assets of justice-involved students, like myself, are valuable to the student and the institution and should be encouraged and developed to generate practices, theories, policies, and laws that reflect our intellect as well as our humanity and commitment to social justice.

I hope more research will contribute to further understanding what the epistemic assets are that justice-involved students bring to their educational experiences and how those assets can be better integrated into curriculums that nurture justice-involved students' strengths and contribute to positive societal change.

Raymond Banks

Raymond Banks, born in West Philadelphia, is a justice-involved Navy veteran who earned an undergraduate degree in Philosophy from the University of California, Berkeley. He piloted the first cross-enrollment program with dedicated academic support for veteran and system impacted community college students in spring 2015 with Dr. Tony Mirabelli, which is designed to "Demystify Cal by Experiencing Cal." Now he does so for the Berkeley Underground Scholars and Cal's Philosophy Department. Special thanks to Aaron Harvey for help clarifying Epistemic Assets. Currently, Raymond tutors Cal athletes in philosophy and formerly chaired the veteran's committee of the Oakland NAACP.

References

Aristotle. (1984). *The rhetoric and the poetics of Aristotle.* (W. R. Roberts & I. Bywate, Trans.). Modern Library.

The Foundation for Critical Thinking. (n.d.). *Defining critical thinking.* Retrieved December 14, 2020, from https://www.criticalthinking.org/pages/defining-critical-thinking/766#top

Díaz, K., (n.d.). Paulo Freire (1921-1997). In J. Fieser & B. Dowden (Eds), *Internet Encyclopedia of Philosophy: A Peer-Reviewed Academic Resource.* Retrieved December 14, 2020, from https://iep.utm.edu/freire/

Freire, P. (1972). *Pedagogy of the Oppressed.* Herder and Herder.

Gee, J. (1987). What is Literacy? *Teaching and Learning, 2,* 3-11.

Gee, J. (1991). What is Literacy? *Journal of Education, 171*(1), 18-25.

Maslow, A. H. (1943). A theory of human motivation. *Psychological Review, 50*(4), 370-396. https://doi.org/10.1037/h0054346

Mirabelli, T. (2009). Pedagogy, peer tutoring and the at risk student. *Widening Participation and Lifelong Learning, 11*(3), 13-19.

Lexico. (n.d.) Tabula rasa. In *Oxford English Dictionary.* Retrieved December 14, 2020, from https://www.lexico.com/en/definition/tabula_rasa

Silverman, S. (2011). Cultural deficit perspective. In S. Goldstein & J. Naglieri (Eds), *Encyclopedia of Child Behavior and Development.* SpringerLink. https://doi.org/10.1007/978-0-387-79061-9_750

Vargas, R. (1987). Transformative knowledge. In *Context: A Quarterly of Humane Sustainable Culture, 17*(Summer), 48-51.

Washburn-Moses, J. (2017, February 14). *What is the deficit model in education?*. https://www.quora.com/What-is-the-deficit-model-in-education/answer/Jered-Washburn-Moses

Chapter 18

Postcards and Chemistry Books

Immigrant Detention Literacies

Stephanie M. Madison and Mikel W. Cole

Amadi is in his early twenties and has travelled to the United States from an African country. He and I are using a phone to talk because we are separated by a thick pane of reinforced glass set in concrete. At the time of my visit, he is being detained in a large immigrant detention center for adult men.

Amadi comes from a country that has been in civil war for a long time, and his family is from the half of the country not in power. While studying chemistry in college, he worked as a mechanic in an automotive repair shop. One day, the military walked into the shop and accused them of working on a car that belonged to the rebels. They shot his father and brother in front of him, bound him, and carried him away where they tortured and sexually abused him. When they were done, they threatened to kill him and his entire family if they ever found him "causing trouble" again. For fear for his own life and the lives of those he loved, he fled the country immediately.

Eventually, Amadi found a travelling companion and proceeded to Ecuador with him. They travelled by foot mostly, sometimes catching a ride from someone or taking a bus, as they moved from country to country. They spent four days walking, sleeping on the ground in the jungles of Panama. Remote though they were, they nevertheless encountered trouble when they ran in to a group of violent men. His money, passport, and birth certificate were stolen from him, and he was beaten badly. Providentially, the Panamanian border officials had previously insisted on making a photocopy of these documents, and these copies, he kept.

After a few months of arduous and dangerous travel, Amadi made it to Mexico, where he found a convent that took him in and gave him the first steady food and shelter he'd known since fleeing his home country. He stayed with them for 18 days. Every day, they would take 10 people to the border to seek asylum. When his turn came, he presented himself at our border and requested asylum. He told me the border patrol "wrapped him in chains," took the copy of his documents, and loaded him onto a bus that drove everyone to a plane. When he landed, he saw signs announcing the city and state where he was being taken into custody. He has since learned the name of the facility from signs posted on the walls.

Amadi had been detained for over two months at the time of my visit, and he had yet to meet with an attorney. He complained of having chest pains, and two electrocardiograms confirmed he was having heart palpitations. The facility requested a visit to a specialist, but so far, Immigration and Customs Enforcement (ICE) had not granted that request. He was taking no medication nor receiving any other treatment. Like every other detainee we've spoken to, he told me that often he could not eat the food because "it is rotten." He said he had only gone outside twice since he had been there because he was too sad and "only wants to breathe the air of freedom, not live in a cage."

For fun, he read Plato and a chemistry textbook. During our conversation, I couldn't help but notice that he spoke casually in the way poets write after many revisions. The chemistry book, in particular, was a treasure to Amadi—at once an escape from the miseries of his current confinement and a source of hope for the future of which he still dreamed.

The profound humanity of this young man's resilience in the face of relentless suffering is powerful, and yet, there are literally thousands of similar stories from detainees who have been confined at just this one facility. To understand the magnitude of this phenomenon and the forces that make these stories increasingly common, we open this chapter with a brief overview of immigration policy that explains how the United States has become home to more immigrant detainees than any other country in the world. We then consider the few published, scholarly glimpses of literacy in immigrant detention centers in the United States. Finally, we provide reflections of our own experiences working in an immigrant detention center as a way to illustrate

a few ways literacy operates in these spaces.

A Brief Overview of Immigrant Detention in the United States

In 2019 alone, the United States detained 510,580 immigrants and asylum seekers. However, since 2004, the burgeoning criminal immigrant detention system has imprisoned more than five million people in total (Nowrasteh, 2020). The mass detention of immigrants in the United States we see today is situated in the historical context of U.S. immigration policies. Not only are today's policies a linear extension of centuries of exclusion and criminalization, but the barriers to literacy in these spaces are also daunting because they are the instantiation of a long-standing desire to "other" particular groups of people in ways that deny them the basic human rights afforded only some Americans.

The historical context of immigration policy: Racism and xenophobia. President John F. Kennedy famously dubbed this country a "Nation of Immigrants." However, like many of our nation's imagined ideals, the historical record finds our policies and practices have never lived up to the tenets we champion as our most defining qualities.

Immigration to the United States has occurred in waves since the 17th-century, though First Peoples populated the continent for millennia before that, including migrations into the Pacific Northwest at least 14,000 years ago. European explorers and early colonies appeared along the Eastern seaboard in the early 1600s. This voluntary immigration was coupled with the involuntary immigration of African slaves as early as 1607 (Landsman, 2006). Inequity in American immigration practices is literally as old as the country itself.

Subsequent waves included Irish immigrants in the early 1800s, Chinese immigrants in the late 1800s, and more recent waves from Latin America. Immigration policies followed these waves, driven largely by nativist and xenophobic sentiment. The Naturalization Act of 1790 was the first federal immigration policy, and it granted citizenship only to "free, White males living in the United States for at least two years." The Chinese Exclusion Act of 1882 banned an entire nationality of immigrants and asylum seekers. Time and time again, policies arose to target and bar entrance to the current wave of immigrants, and instead provide access to predominantly White, Christian, and wealthy individuals. Against this historical backdrop, President

Trump's "Protecting the Nation from Foreign Terrorist Entry into the United States" policy in 2017, the so-called "Muslim Ban," was simply a continuation of a long history of targeted exclusion focusing on race, national origin, and religion.

Image 1. A long history of immigrant detention. Angel Island, between 1910-1919

The contemporary context of immigration policy: From deportation to detention. Immigration enforcement in the United States has shifted dramatically in recent decades, with unprecedented levels of deportation marking a shift from a "Nation of Immigrants to a Deportation Nation" (Rumbaut, 2014, p. 26). As policies of exclusion have multiplied, the numbers of undocumented immigrants have risen, with roughly 25% of all foreign-born individuals in the United States estimated to be undocumented. The xenophobic strands of American society that have always existed are now especially focused on the expulsion of undocumented immigrants in ways previously unknown. Now, even gainfully-employed undocumented individuals find no shelter in employment. Rather, their workplaces are targeted sites for the identification, collection, and deportation of undocumented individuals (Douglas & Saenz, 2013).

The bombing of the World Trade Center in 1993 prompted President Clinton to militarize the U.S.-Mexico border as a form of deter-

rence against terrorism. Over the next 6 years, the Immigration and Naturalization Services budget tripled, and more than 500 anti-immigrant state-level bills were passed (Douglas & Saenz, 2013). This trend was compounded by the terrorist attacks on the World Trade Center buildings in 2001 when President Bush established the Department of Homeland Security and Immigrations and Customs Enforcement, and Congress passed the PATRIOT Act. In 2006, deportation policy shifted to one of detention as "catch and release" became "catch and detain." Currently, the United States operates over 200 immigrant detention facilities, with 70% of detainees held in private, for-profit facilities. Today, the "Land of the Free" holds the ignominious title of operating the world's largest immigrant detention system.

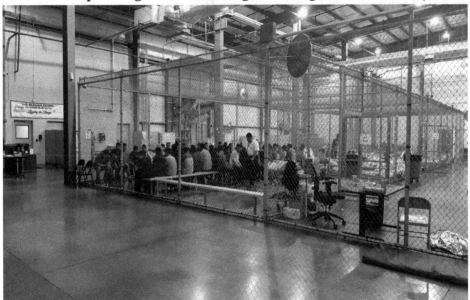

Image 2. Contemporary immigrant detention, McAllen, Texas 2018

Education and Literacy Instruction
Inside Immigrant Detention Facilities

There is a genuine dearth of literacy research in immigrant detention centers. We hope that this chapter and this book reach the desks of other scholars who are interested in literacy and attuned to the harms present in the current state of large-scale, privatized detention of immigrants in the United States. Recently, the editors of Reading Research Quarterly (Goodwin & Jiménez, 2019) used their column to

call for more research in these spaces:

> ... we add our frustration that individuals, particularly children, are not being educated. Images, reports, and media coverage have suggested that these vulnerable individuals remain in conditions that lack access to reading materials or educational materials more broadly and that dehumanize immigrants such that their identities and likely language and culture are undermined in ways that will affect their long-term literacy learning. (p. 449).

The United Nations High Commission on Refugees (2018) found that the educational needs of children and adults in these carceral spaces, especially those in immigrant detention centers with fewer resources and rights than the formal prison system, are urgent and supported broadly by human rights guarantees. Their four principles largely reflect our perspective, though we assert these are human rights, broadly speaking, and not just relevant for children or refugees:

Education is a basic human right, enshrined in the 1989 Convention on the Rights of the Child and the 1951 Refugee Convention.

Education protects refugee children and youth from forced recruitment into armed groups, child labour, sexual exploitation and child marriage. Education also strengthens community resilience.

Education empowers by giving refugees the knowledge and skills to live productive, fulfilling and independent lives.

Education enlightens refugees, enabling them to learn about themselves and the world around them, while striving to rebuild their lives and communities. (paras. 6–9)

The lack of peer-reviewed scholarship in detention centers is compounded by a general lack of access to these spaces. Our own work as volunteers inside an immigrant detention center is mirrored in the reports of other volunteers who find it difficult to gain regular access to provide literacy programming (Chang, 2018; Chin, 2010). The scant scholarship available documents that even access to basic library services varies widely. For example, in Chin's (2010) survey of prison facilities and library access, the few responses he received were from places that housed only non-immigrant detainees. These facilities did, however, house individuals found guilty of a crime in the traditional judicial system. Thus, these facilities are in many cases required by law

to provide library services whereas the largely privately-run facilities that detain only immigrants have no such legal mandate. Further supporting these findings, Chang (2018) published a case study of six recently-released immigrant detainees that focused on their preparation and filing of defenses for their immigration cases. The portraits compiled in this study documented a system full of inequalities and widely disparate processes and outcomes, even within the same detention facility. Some of the participants attended a legal orientation session upon arrival and made visits to the law library, but others did not. Those with attorneys received translation services and were consequently able to submit the required documents on time and in English as required by law. Also, the attorneys were able to explain everything to the judge in English during hearings. Perhaps more importantly, detainees with attorneys were more successful in not incriminating themselves unintentionally. Multiple participants were presented with self-incriminating forms to be signed on their first day in detention and all reported being told that if they signed them they would be released, only to find out it became a legal document used against them in subsequent proceedings. Moreover, individuals without attorneys often failed to submit required forms either because of lack of procedural knowledge, lack of English proficiency, or because of lack of first language literacy.

Overall, these two studies paint what prison researchers characterize as "pixelated, disconnected snapshots" (Chang, 2018, p. 88). As it stands, we know very little about literacy services and practices in immigrant detention centers from the academic scholarship. In the remainder of this chapter, we share our own observations as visitors and volunteers in a large immigrant detention center. We have spent more than a year working towards receiving the requisite background checks, visitor applications, and trainings required to provide language and literacy services in this facility. Thus, we share our personal observations and reflections but are careful to distinguish this work from formal, Institutional Research Board-approved research.

Our Positionality

As co-authors, we remain committed to centering the voices of incarcerated individuals, but we are deeply aware that there are other challenges that come with doing this work. Some people may not safely be

able to use their real name or share details of their story publicly. With this in mind, we have made every attempt to share their stories as authentically as possible while also acknowledging we are telling the stories through the lens of our own interactions with these individuals. As such, we approach our work cautiously with the understanding that people of color have often been exploited and misrepresented in white scholarship, that many times the perspectives of white researchers are privileged over the voices of the people they research, and that researchers' perspectives and positionalities are inextricably entwined with the outcomes of their studies (Milner, 2007).

Milner provides a framework for conceptualizing the dangers of ignoring the impact of researcher positionality: dangers seen, dangers unseen, and dangers unforeseen. These dangers arise as researchers make important design and implementation decisions without considering the perspectives and interests of the participants and communities they study. We would like to examine some of the applications of this framework to the unique situation of our work in an immigrant detention center. Below are examples, not exhaustive, of the ways in which we remain vigilant about the influence of our positionalities as both editors and volunteers working with vulnerable individuals in carceral contexts.

- A seen danger is the racial, cultural, political, and historical imbalance of power between us and the people with whom we are working. Our privileges are vast, and we are keenly aware of the white savior phenomenon (e.g., Brown, 2013) and the harm done by researchers who pilfered the stories of the vulnerable to make a name for themselves. Moreover, while privilege is often cast in capitalistic terms as something to spend or something to hoard, it is also described in terms of a military operation. White women, in particular, have routinely weaponized their privilege during conflicts, real or imagined, with people of color by skillfully positioning themselves as a helpless victim. If privilege can be weaponized to maintain power within social structures, what if the opposite were also true? What if privilege could be weaponized as a tool of sabotage, a way of pushing the "self destruct" button on these same structures? Gaining access to immigrant detention centers and hearing the stories of the people experiencing detention means we can

then take action to share the realities of the situation, formulate plans to alleviate suffering, and, ultimately, work towards abolishing detention centers altogether. Our hope is to shift the imbalance of power and close the vast gap between ourselves and the people we visit.

- An unseen danger is we don't know what we don't know. There is not a well-established knowledge base for doing work in these spaces. Even though we strive to be reflective, intentional, and cautious in our work, we are certain to make mistakes. There are individuals with whom we should speak to better understand the realities of this space but that we do not know about, and there are undoubtedly methods and interventions that will prove more effective but for which there is no research to guide us.

- An unforeseen danger is the possibility that our work will be used to further limit the access to language and literacy resources available to detained immigrants instead of offering more. When we argue that literacy is a form of empowerment, it is possible those in positions of power may then explicitly seek to limit this form of empowerment. This outcome is a risk we are willing to take after carefully weighing the potential benefits against the potential harm of our work. Another unforeseen danger is possible repercussions to individuals who shared their stories with us. With this in mind, we tell the stories of those who lived them while using our privileged positions as a shield. We will continue to do so until it is safe for people experiencing detention to use their real names.

Carceral Literacies in an Immigrant Detention Center

Denying access to literacy education and practices in immigrant detention centers is one way that the history of xenophobic immigration policy persists in the United States. Yet just as literacy can become weaponized, the opposite is also true—literacy can become a tool of resistance. It can be a way to restore human dignity instead of stripping it away.

Literacy practices encompass different ways of knowing, connecting, and navigating situations and contexts. Knowing where to look for a sign on a wall, how to fill out a form, and who to contact for in-

formation are literacy practices that remain shrouded in secrecy when it comes to immigrant detention centers. These gaps in information contribute to feelings of confusion and helplessness for detainees and visitors alike. At the same time, the cards, letters, and drawings that make their way to and from detention centers represent literacy practices that empower.

When detention centers limit access to reading materials and educational opportunities, they are limiting access to what is clearly a valuable resource that benefits people experiencing detainment in ways both tangible and intangible. For-profit corporations have little interest in spending money, time, or effort in these areas. As a result, we have found that our offers to facilitate educational services have been repeatedly ignored. Institutional arguments about cost are countered by volunteers offering time and resources for free. Safety concerns are addressed by background checks and volunteer training. Books? We have friends who work in publishing. Lessons? Poets and authors are eager to sit down with us in class. English language learning? Years of experience and a dogged determination characterize our approach to desperately needed English-language teaching in an immigrant detention center.

The needs are vast and the solutions vary widely from one detention center to the next, so we are careful not to assert that these stories are representative. The following examples of carceral literacies in immigrant detention centers are drawn from our time working with an immigrant advocacy organization and participating in humanitarian visits to immigrant men experiencing detention.

Literacies of Access. Literacy is an essential tool for accessing those detained in immigrant detention centers and a critical tool for those being detained to access legal and other services (Janks, 2000; Morrell, 2015; Wilson, 2004). When volunteers visit with men experiencing detention, the first stop is the home base of the immigrant advocacy organization. The organizers open the doors wide for new and experienced volunteers alike. Snacks and coffee are always available, and large windows let the sunlight in. Seated at a massive kitchen table long enough to seat more than twenty people, volunteers are briefed on how to behave in the facility, instructed on the types of questions to ask, and given information about the man they are scheduled to visit. They are prepared as much as possible with the

logistics, but it is difficult to prepare volunteers for the emotional toll of a conversation held through a glass barrier with a staticky phone.

One of the most striking things about the detention center is how to behave; gaining access for a visit is neither intuitive nor straight-forward. The literacy practices associated with visitation at a detention center can be complex indeed. Families there to visit may not know the identification number their loved one was assigned at the facility. Family members may be hesitant to list their own address on the pa-perwork, especially if they marked the box indicating they were not a citizen of the United States. The paperwork must be requested at the front desk, a photo identification provided, and the dress code met. Each and every time we have visited, we have helped someone in the waiting area with these details. Sometimes we explain the process in Spanish or fill out the form for a person who cannot read the small print. Sometimes we listen to the story of how they located their loved one and found their way to the facility. Always, the difficulty stems from the cumbersome practices of gaining access to the coveted visi-tation room.

The literacies associated with access do not stop at the waiting room nor do they only affect families and volunteers there to visit. The men experiencing detention are also at a disadvantage. Because the center is not required to share information with these men about their cases, they rely on phone calls, visits, and letters to learn their status in the process. Lawyers visit when they are allowed. Families and friends offer information when they have it. Yet the lack of access to their own documents is a profound barrier to men navigating the complex immigration process.

The problem isn't only with the lack of information relayed to the men in detention but extends to their ability to comprehend the pro-cess and their place in it. Time and again, these men have requested help with their English development in order to understand what lit-tle paperwork is provided to them, as well as what the guards, lawyers, and judges are saying in English around them. By withholding infor-mation and linguistic comprehensibility, the literacies associated with immigration remain out of reach. Historically in the United States, this is precisely where immigrants are intended to be—othered, mar-ginalized, and beyond the reach of institutional supports.

Access to literacy education related to immigrants' rights and the

legal process of immigration could be transformative for many experiencing detention. The uncertainty and chaos often lead to anxiety and despair. We have met with men who can no longer sleep due to constant worry about whether or not their children are getting enough to eat. They are consumed by guilt and feelings of failure, exacerbated by the uncertainty of when they would be released and where they could be sent. We have also met with men who wept and were unable to stop. One man was devastated because he could not get information about his wife and daughter; he had convinced himself they had been killed by gangs.

Conducting humanitarian visits allows us to bear witness to the suffering. By bearing witness, we can offer kindness, strength, humor, or shared sorrow. We can also pinpoint what is needed for these particular men in this particular space. In this case, they require knowledge and transparency. They require the literacy skills to communicate in English, understand the immigration process, and identify their options. And, they require access to legal and other key information in a language they can comprehend.

Literacies of Empowerment. Literacy is much more than a skill for gathering knowledge or accessing carceral spaces; literacy is fundamentally a source of deep personal empowerment (Cummins, 2000; hooks, 2014; Pytash, 2013). For people experiencing detainment, being denied access to the language and literacy practices of their surroundings is intentional and by design. Seldom, if ever, are efforts made to provide instruction that the detained immigrants so desperately need. However, the language and literacy practices that detained immigrants *already* possess can serve a crucial role in restoring dignity in a dehumanizing space.

One of the ways the men we visit are dehumanized is through the loss of work and, as a result, their ability to provide for themselves and their families. As many of the men were picked up by ICE while working at their job, it is a particularly bitter pill to swallow. The impact of this loss of income is swift and severe. As family members and children visit, a common topic of conversation in the waiting room is money; for many, paying the bills and buying groceries have become a constant worry, and an unexpected school field trip is enough to keep them up at night. The stress, suffering, and sacrifices of families on the outside are not lost on the men being detained. The feeling of failure

as a father, as a son, or as a partner can often become debilitating, leading to depression grounded in helplessness and shame. We see these feelings reflected in the tears on their faces every time we visit.

Jobs for detainees are common at detention centers, but the situation is seldom clear-cut. Some detained men have reported they have not been outside to the yard for weeks, because their shift in the laundry room doesn't allow it. Some have said they work overtime in hot kitchens, week after week, even though they have asked not to be scheduled. Some have been placed in solitary confinement for refusing to work their assigned job. On the other hand, some detained men have requested a job and been denied. The guards and administrators of the facility have complete control over these decisions, and justification is not required. Even though the detained men are paid very little for their work, often no more than a dollar per day, money is exchanged nonetheless. This money is essential for survival in a detention center where the food is often inedible and commissary snacks are the only way to stave off hunger. Phone cards to call family, personal hygiene products, and stamps for letters all come from the commissary. Without a job, these essentials are often unattainable.

And yet, we have met several men who found a way to reclaim their sense of dignity through work on their own terms. These men exchange their literacy services for products or credits at the commissary. They write cards and letters for fellow detainees, read the mail, and manage the exchange of information between the men and their families. Artists might contribute by adorning the card with a drawing. In return, the men who have jobs trade items from the commissary or transfer money to the accounts of the men doing the reading, writing, and drawing. Literacy empowers by giving these men an outlet for productive work. The tangible benefits, for both parties, are obvious. The intangible benefit of allowing men to regain their dignity is an act of resistance.

Literacies of Connection. At its core, literacy is the exchange of ideas between an author and a reader, and literacy is a primary source of human connection for individuals in carceral spaces (Appleman, 2013; Lankshear et al., 1994; Winn, 2019). Father's Day and Christmas are particularly difficult at detention centers. We have seen, time and time again, men weep when telling us about their children and the overwhelming hopelessness and defeat they feel by being sep-

arated from them. Yet card-writing campaigns have provided these men with words of encouragement and compassion as thousands of hand-written cards, postcards, and letters make their way to the detention center.

Nationwide, immigrant advocacy groups, religious institutions, and other organizations participate in various versions of card-writing campaigns. The organizations provide instructions to ensure the cards are compliant with the detention center rules, such as no stickers or glitter, as well as emphasize special requests, such as cards written in Spanish. The cards are collected and mailed in large envelopes so the organization's volunteers can sort and forward the cards to people experiencing the loneliness of detention instead of the warmth of their child's hand held in theirs.

Some men have said they don't always understand the words written in a language other than their own, but cherish them all the same. They tell us how they spread the cards on their beds and look at them over and over. They say the cards serve as tangible proof that someone is thinking of them and they are not forgotten. Even men who have been deported have said these cards remain their treasures, still revisited often as a reminder of kindness in a place of darkness.

One weekend at the immigrant advocacy center, a family with small children, their mother, and their grandmother appeared at the door. The grandmother's primary language was Spanish, who, after hearing about the postcards and letters sent to the men experiencing detainment, stayed up late into the night writing one card after the other. She wrote with tears in her eyes, knowing that her words would be held in the hands of a heartbroken person. She prayed over the cards before handing over the stack. The act of putting pen to paper was an act of resistance to the loneliness and despair of the detention center; this grandmother was determined to bring light in.

Concluding Thoughts

There are undoubtedly more literacies being practiced in the immigrant detention center where we work and at other detention centers across the country, and these categories are early conceptions with which we are still wrestling. In closing, we would like to consider some of the ways we see these literacies at work in the story of Amadi, whom we introduced at the beginning of this chapter.

Literacies of Access. Knowledge of literacies of access was demanded of this young man long before he reached the U.S. border. Not only did he need to possess a passport and birth certificate, the additional hidden copies that Amadi possessed proved invaluable after the originals were stolen during a mugging in the jungle. Knowing that he needed to make them and keep them hidden were additional practices required to ensure he made it to the United States with the documents he would eventually need for an asylum request.

On his way to the United States, Amadi travelled through multiple countries on multiple continents. The ability to find and communicate with fellow travellers, to try to avoid criminals and official personnel, to find work, food, and shelter, and to negotiate moments of being apprehended all required him to employ multiple languages and considerable wit. He had to rely on the institutionalized knowledge and relationships in place at the convent in Mexico in order to make an official attempt to request asylum and he had to rely on the foresight of the policy in Panama that serendipitously ensured he had a photocopy of his documents. It was Amadi's lack of knowledge of U.S. Customs practices that contributed to his incarceration when he presented himself at the border, as he was unaware of shifts in policy that changed the risks associated with requesting asylum under the Trump administration. His ability to read English signage enabled him to know where he was being detained, but lack of access to an attorney left him under-informed about the status of his legal case. In fact, it was only through the institutionalized practices of a local non-profit that we had access to visit him to hear his story.

Literacies of Empowerment. Access to books was a godsend for Amadi; his chemistry book, in particular, was a tangible source of pride, connection to his home, and a source of hope for the future. He told me he wanted to someday be a chemist in the United States, but that even if deported, he planned to be a chemist wherever he lived. Especially because his depression kept him isolated from other detainees, books like the volume of Plato provided a welcome respite from the sufferings of his imprisonment and loneliness. Nonetheless, lack of access to a library and restrictions on how books can be purchased for detainees were structural barriers to the pleasure and promise of books for him.

Literacies of Connection. Amadi's only communication with his

family was through a handwritten phone number. Opportunities to talk to his family in the United States were limited by local policies of access to the phone, and his family had to learn to add money to his account for phone calls. Worse, he had no way to get in touch with his mother at home, and more than anything, he wanted to talk to her. Amadi's lifeline was the holiday postcards created and distributed by the local non-profit's card writing campaign. He looked forward to, and actually requested, more cards. Also, the interaction during the visit was clearly welcomed, and he requested more visits in the future. Even separated by thick glass and concrete, the humanity of the most basic interactions offers a form of connection in these spaces of isolation.

In this chapter, we have tried to foreground the words and experiences of incarcerated detainees, but for structural reasons, we find ourselves in the position of having to tell these stories on their behalf. We hope that changes in presidential administrations, state and local policy, and the unfolding relationships with facility leadership will make it possible for detainees to speak for themselves more directly in the future. Ultimately, our work in these spaces is absolutely centered on making literacy materials and programming more broadly available to detainees with the belief that they will use literacy to improve their lives during and after detention.

Stephanie M. Madison, Ph. D.

Stephanie M. Madison is the Project Manager for Clemson University's Teacher Learning Progression, an initiative designed to match teachers with focused professional development to meet the needs of their students. Her research focuses on instructed second language acquisition, social justice integration in language classrooms, and the relationship between language, literacy, and power.

Mikel W. Cole, Ph.D.

Mikel W. Cole is an Associate Professor of Bilingual and ESL Education at the University of Houston, and his scholarship centers on multilingual students, including issues of culturally-sustaining pedagogy,

in- and out-of-school language and literacy practices, and language in education policy. Incarcerated literacies are increasingly becoming a focus of scholarship, though work in immigrant detention centers remains more of a human rights concern than an academic pursuit.

References

Appleman, D. (2013). Teaching in the dark: The promise and pedagogy of creative writing in prison. *The English Journal, 102*(4), 24-30.

Brown, A. (2013). Waiting for Superwoman: White female teachers and the construction of the" neoliberal savior" in a New York City public school. *Journal for Critical Education Policy Studies, 11*(2), 123-164.

Chang, D. A. (2018). *The management of illegal immigration through immigrant detention and the experience of applying for relief while detained.* University of Colorado at Denver.

Chin, S. L. (2010). *Library services in US immigration detention facilities.*

Cummins, J. (2000). Biliteracy, empowerment, and transformative pedagogy. In J. V. Tinajero & R. A. Devillar (Eds.), *The power of two languages: Effective dual-language use across the curriculum* (pp. 9-19). New York.

Douglas, K. M., & Sáenz, R. (2013). The criminalization of immigrants & the immigration industrial complex. *Daedalus, 142*(3), 199-227.

Goodwin, A. P., & Jiménez, R. T. (2019). Literacy and human rights. *Reading Research Quarterly, 54*(4), 449-450.

hooks, b. (2014). *Teaching to transgress.* Routledge.

Janks, H. (2000). Domination, access, diversity and design: A synthesis for critical literacy education. *Educational Review, 52*(2), 175-186.

Landsman. N. (2006). Migration and settlement. In D. Vickers (Ed.), *A companion to colonial America* (pp. 76–98). Blackwell Publishing.

Lankshear, C., McLaren, P. L., & McLaren, P. (Eds.). (1993). *Critical literacy: Politics, praxis, and the postmodern.* SUNY Press.

Milner IV, H. R. (2007). Race, culture, and researcher positionality: Working through dangers seen, unseen, and unforeseen. *Educational Researcher, 36*(7), 388-400.

Morrell, E. (2015). *Critical literacy and urban youth: Pedagogies of access, dissent, and liberation.* Routledge.

Nowrasteh, A. (2020). *Eight people died in immigration detention in 2019, 193 since 2004. CATO Institute.* Retrieved from https://www.cato.org/blog/8-people-died-immigration detention-2019-193-2004.

Pytash, K. E. (2013). "I'm a reader": Transforming incarcerated girls' lives in the English classroom. *The English Journal, 102*(4), 67-73.

Rumbaut, R. G. (2014). Crossing borders, changing places: Immigrant America in a world on the move. *East-West Cultural Passage, 14*(1), 24-56.

United Nations High Commissioner for Refugees. (2018). *Education.* Retrieved from https://www.unhcr.org/en-us/education.html

Wilson, A. (2004). Four days and a breakfast: Time, space and literacy/ies in the prison community. In K. Leander

& M. Sheehy (Eds.), *Spatializing Literacy Research and Practice*, 67-90.

Winn, M. T. (2019). *Girl time: Literacy, justice, and the school-to-prison pipeline.* Teachers College Press.

Chapter 19

The Art and Resilience of Detained Immigrants

Amilcar Valencia

On the edge of Lumpkin, a small town in Southwest Georgia with a population of 1275, hidden from view, is Stewart Detention Center (SDC), which houses about 2,000 immigrants who are in deportation proceedings. If you are not careful, you will miss the sign that directs you to CCA Road. You will see a big water tank that provides the water for the whole city. Behind it, you will see the barbed wire-topped, chain-link fences surrounding the detention center. The gates are a cruel reminder of where you are: a place built to crush everyone's dreams. Many lose months and years behind the concrete walls; the time isolated from their loved ones they can never get back.

In 2010, together with a group of volunteers, I started visiting detained people at SDC. By talking to families and friends in the waiting room, we learned how hard it is to travel to visit their loved ones. Some of them drive 600 miles or more for one hour visit per week. We decided to do something. We opened a hospitality house named El Refugio, "The Refuge." El Refugio is located two miles from the detention center. We offer free lodging, meals, and friendship to anyone visiting a loved one at Stewart. El Refugio volunteers visit those whose family members and friends are not able to visit them or don't have relatives in the Southeast. Through our visitation program, we have been able to establish strong relationships with detained people. We have learned from them about their struggles, their suffering, their joys, and sorrows inside this facility. Through the numerous visits, letters, and phone calls, we get to know them and see them as they are—human beings, with dreams and aspirations like any of us. Many are

subjected to a number of abuses and mistreatment. They are stripped of their dignity and humanity.

Stewart has a library from which detained individuals can borrow books; however, it lacks reading materials in Spanish or other languages. Many people detained are not bilingual, and even if they are, they prefer to read in their native language. Many learn some English inside of Stewart's walls out of necessity since only a few guards speak Spanish. Immigrant detention centers like Stewart lock up people from all over the world, which means there is a wide variety of languages spoken and the personnel in these facilities are not equipped to communicate effectively, much less have books in all the languages possible. Their business model is one that is focused on making profits and cutting costs, It is clear that CoreCivic, the for-profit corporation that operates SDC, is not going to invest in such materials.

At the request of people detained, El Refugio started to send books. Many wanted to read novels that helped them to escape through the book's pages their crude reality. Others requested religious books like bibles, the Koran, and most recently a person detained requested the Torah in Russian. People also requested drawing pads, but a vast amount of them requested English learning books and dictionaries. A popular one is "Inglés para Latinos" (English for Latinos). We gladly have been sending hundreds of books during the past 10 years. It is clear to us that people have a desire to learn and educate themselves, reflect on their reality in the light of religious texts, or simply have a good time reading. Many find inspiration through the words of Mandela in Long Walk to Freedom or similar books.

Image 1. Cuba 100%

ICE and the for-profit corporations lock these detainees up and keep them hidden from the public, far from their family and community support; despite all the effort to isolate these men, their resilience is strong! Their artistic expression defies the system that keeps them captive; cages cannot contain their thirst for freedom. They can bend iron bars through drawings; their art can pass through the concrete walls, and the razor-wire fence cannot contain their poetry. Their art gives them hope that one day, they too will be able to be free.

One of those pieces of art I always carry with me is a wallet a person detained at Stewart sent to me. As you can see from the pictures below, he used candy and chip bags and folded carefully using some pieces of blue tape to glue some of the ends. I have another one made of M&M's bags.

Image 2. Chip Wallet

Image 3. M&Ms Wallet

Every time I open my wallet, I remember him. Once in a while, his ex-wife sends greetings via WhatsApp. They went through the most horrible time while he was in detention. He was taken into custody and while in detention, he got ill. He suffered kidney failure and other serious medical issues and abuses. The last time I saw his ex at the SDC parking lot, she gave me a few more art pieces he made for me. One of them is this bracelet made of empty toothpaste tubes and plastic bags. He engraved my name and my wife's name on it. He fought a long battle, but the detention was too much for him, and he ultimately ended up deported, leaving behind his family.

We at El Refugio believe relationships are transformative and see every detained individual as a person with inherent dignity that cannot and should not be erased. The immigration system crushes dreams and tears families apart, but to my amazement, the system is no match for their hope and resilience.

Below there is a collection of art people detained at Stewart have sent to us through the years. We are not adding descriptions or identifying information of those who created them.

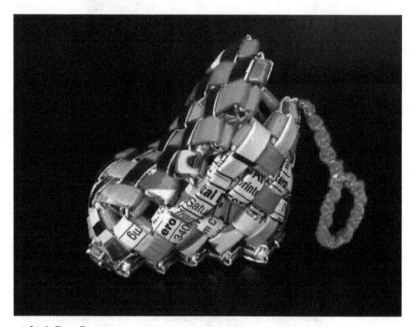

Image 4. Little Boot Ornament

Figure 5. Charro boot ornament

Image 6. "Dios te bendiga" Plastic Bag Ring

Image 7. El Camaleón (The Chameleon)

Image 8. The Cell

Image 9. Thanks

Figure 10. Collaboration between a person detained and a visitor volunteer

Amilcar Valencia

Amilcar Valencia is co-founder and Executive Director of El Refugio Ministry. Amilcar along with his wife Katie Beno-Valencia and a group of advocates founded El Refugio, a ministry of hospitality and visitation at the Stewart Detention Center in Lumpkin. Through his work with El Refugio, Amilcar oversees El Refugio's programs and alongside local and national organizations and is working to expose and end the inhumane and unnecessary detention of immigrants.

CPSIA information can be obtained
at www.ICGtesting.com
Printed in the USA
LVHW021556300423
745689LV00009B/1005